Interpreting Cézanne

SIDNEY GEIST

Interpreting
CEZANNE

HARVARD UNIVERSITY PRESS

CAMBRIDGE, MASSACHUSETTS, AND LONDON, ENGLAND 1988

Published with the assistance of the Getty Grant Program.

This book is printed on acid-free paper, and its binding
materials have been chosen for strength and durability.

Library of Congress Cataloging-in-Publication Data

Geist, Sidney.
Interpreting Cézanne / Sidney Geist.
 p. cm.
Bibliography: p.
Includes index.
ISBN 0-674-45955-5 (alk. paper)
1. Cezanne, Paul, 1839–1906. 2. Painters—France—Biography.
3. Painting, French. 4. Painting, Modern—19th century—France.
5. Painting, Modern—20th century—France. I. Title.
ND553.C33G4 1988 87-35368
759.4—dc19 CIP

Designed by Gwen Frankfeldt

Sous quelle latitude pouvions-nous bien être,
livrés ainsi à la fureur des symboles,
en proie au démon de l'analogie . . . ?

André Breton, *Nadja*

Preface

Cézanne is justly admired as one of the seminal artists of the modern era. We are astonished by his pictorial range, his constant painterly invention, and his formal strength, and awed by his dedication. At the same time we recognize a great expressive reach, an intensely observed still-life often achieving a grandeur like that of the studies of Mont Sainte-Victoire.

But Cézanne is even more than the creator of an endlessly engrossing oeuvre, more than a paradigm of the artist; he is the standard by which we measure ourselves as modern appreciators of art. In a sense we have learned to look at art formally—surely the hallmark of appreciation for the past half century—through his example. For in this artist, we are persuaded, subjects have been denatured, have become pretexts, scaffoldings for pure painting. Such views, held for a hundred years, at first illuminated, then limited our understanding of Cézanne, and ultimately succeeded in immobilizing it. This book, an essay in interpretation, proposes a way out of the impasse of formalism. Of course, interpretation itself is suspect in many quarters, being regarded as a fourteen-letter word for "skating on thin ice," a passage on the slippery route between "subjectivity" and "overinterpretation."

In the second decade of the century Maurice Denis said of Cézanne, "certainly his painting and ideas ask to be interpreted." Denis' own writing makes it safe to say that he did not have in mind anything like what Meyer Schapiro suggested in 1959 when he stated, in the introduction to an exhibition of Cézanne's paintings, "I do not doubt that the personal content of this classic art will in time become as evident as the aesthetic result." Nor did this prediction of the emergence of the personal anticipate the particular revelations to come—those in Theodore Reff's article of 1962 "Cézanne's Bather with Outstretched Arms," of which more later.

And Schapiro's famous, long, learned article of 1968, "The Apples of Cézanne: An Essay on the Meaning of Still-life," developed only guarded insights and a limited proposal for interpretation. My own approach differs from and sometimes conflicts with that of the writers just mentioned and of others besides. Plainly, the few workers in the field are at variance with each other not only in their findings but in their methods. The path of interpretation is beset with inherent obstacles and the brambles of disagreement.

Yet, for the last thirty years and in spite of a lack of consensus, it seems that the project of a deep reading of Cézanne—deep only in the sense of going below the surface—persists among a small number of devotees of the artist, spurred on by the intuition of a content beyond that of the precious picture plane, indeed, of significance lying behind, hovering over, or woven into that palpable surface. At stake is a new understanding of an extraordinary pictorial imagination.

Interpretation here will sometimes take the ancient form: A stands for X, B stands for Y; implying not a secret language, but a system of symbols or graphic metaphors. I shall have recourse to popular symbolism, to the artist's statements, to the data of his biography and the history of his epoch, and besides to techniques of analysis that have only rarely been employed. Interpretation as pursued in this book proceeds on the conviction that a work holds more than meets the eye. For this submerged content to be apparent, however, the reader will be required to exercise a scrutiny more intense than is commonly the case.

In anticipation of instances that may prove difficult, a number of schematic versions of the photographic plates have been included in the Appendix. These are usually photocopies that I have manipulated to empha-

size and reveal certain pertinent features of the paintings. Once identified, these features can be seen to better advantage in the plates, or indeed the paintings themselves. I ask not only for attention, but also for patience, and imagination. We are studying an artist of unusual complexity whose works hold depths and devices undreamed of in our aesthetics and still to be explored by unimagined means.

Two sections of this book have appeared in somewhat different form in journals, and I am grateful to the late James Fitzsimmons, editor of *Art International,* and to James Faure Walker, editor of *Artscribe,* for publishing the original articles. Before sessions of the College Art Association in 1975 and 1985 I read papers on Cézanne. I have had the opportunity to air my views at the New York Studio School, Boston University, and Vassar College, and before several groups of artists and psychoanalysts in New York and East Hampton, as well as in London, at the Royal College of Art, Goldsmith's College, and the Chelsea School of Art. A grant from the Rockefeller Foundation permitted me to spend the summer of 1980 studying Cézanne in Europe.

Jacques Ferrero has been my assiduous guide to Cézanne sites and sources in Aix. I have benefited from the help of Elizabeth Laget, and of Gabriel Landau, Pierre Colas, and Stanislas Lélio, in matters relating to French language. The interest of Barbara Burn and Seymour Hacker has been a great encouragement. In the more than dozen years with my subject, I have talked it over (and over) with friends and with that special friend, my son Daniel. Their perspicacity often equaled their forbearance: several made valuable suggestions that are incorporated here and duly acknowledged.

Contents

Note

Unless otherwise indicated in the List of Illustrations, all works are oil paintings. Illustrations identified as figures appear in the Appendix.

V. followed by a number indicates the listing of a work in Lionello Venturi, *Cézanne, son art, son oeuvre,* 2 vols. (Paris: Paul Rosenberg, 1936).

C. followed by a number indicates the listing of a work in Adrien Chappuis, *The Drawings of Paul Cézanne,* 2 vols. (Greenwich, Conn.: New York Graphic Society, 1972).

R. followed by a number indicates the listing of a work in John Rewald, *Paul Cézanne: The Watercolors* (Boston: New York Graphic Society, 1984).

For general biographical data on Cézanne I have relied on Gerstle Mack, *Paul Cézanne* (New York: Alfred A. Knopf, 1935), and John Rewald, *Paul Cézanne* (New York: Schocken, 1968).

Interpreting Cézanne

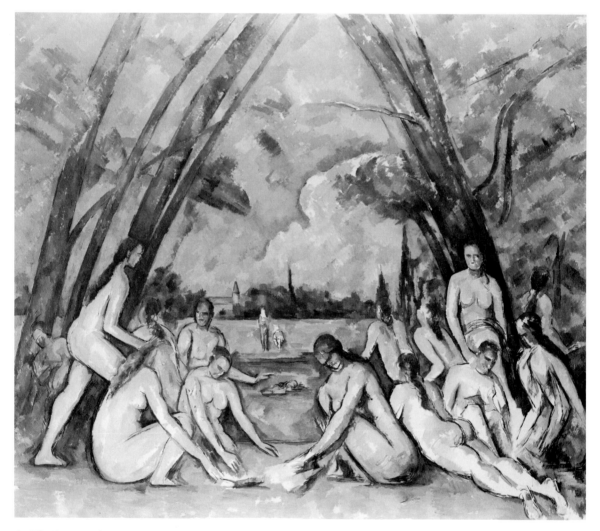

1. *The Large Bathers*, 1906 (V.719)

Cézanne the Francophone

The middle of Cézanne's *The Large Bathers* (pl. 1), painted in the last year of his life, is occupied by the "hidden image" of a woman's head. It looks slightly to the right, the tall slanting trees that constitute its hair falling to frame the oval of the face. Here the symmetrically curving arms of two crouching nudes at center form the chin; the mouth lies along the pale stretch of water near the farther shore, where two small creatures in the space of the upper lip serve as ridges of the philtrum. The white cloud's topmost edge defines an eyebrow that overhangs the blue round of the iris, situated on the left of some foliage and punctuated by the dark pupil.

This head may be difficult for some to discern, but it has been seen by hundreds of observers to whom I have pointed it out in the course of lecturing on the matter, and once seen, it may be recalled. It is a startling image to be imposed on a landscape-with-figures, all the more so for appearing in a work by Cézanne, an artist who is the touchstone of painterly purity in our time. It is not an accidental result: the eye on the right is rendered and placed with anatomical precision, and the drawing is classical in a manner consistent with Cézanne's manifest portraits. Nor is it a conscious product: nothing that we know of Cézanne leads us to think that he willed it or knew that he made it.

Whatever may be the eventual explanation of the phenomenon, the woman's head cannot easily be dismissed, not only because of its size—it is six feet tall—but because of its relevance to the Cézannian universe. The consequences of the existence of this image are very disturbing to a generally accepted idea of Cézanne and to a large body of criticism; so disturbing, in fact, that one writer has sought to dismiss the "hidden" head by referring to "those historians who see a portrait of Cézanne's wife in the void between two trees." The resemblance between the head and Mme. Cézanne is a matter about which there may be disagreement. It is

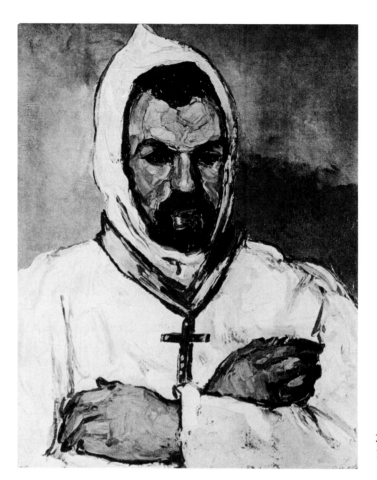

2. *Uncle Dominique,*
1866 (V.72)

certain, however, that a large area of a picture, covered with paint and occupied by trees, leaves, clouds, water, people, and a building, is not a "void between two trees."[1]

Since discovering the head in *The Large Bathers* I have found hundreds of other such images, which I call "cryptomorphs."[2] And I have come upon other no less astonishing features. While studying Cézanne's *The Black Clock* I slowly realized there were verbalisms of all kinds hovering around the picture, and gradually came to the conclusion, contrary to expectation, that Cézanne's imagery, including the cryptomorphs, is accompanied by puns and other wordplay, and occasionally by rebuses. Needless to say, the language of this verbal presence is French. As a result, in this study—departing from our usual practice of looking at Cézanne in

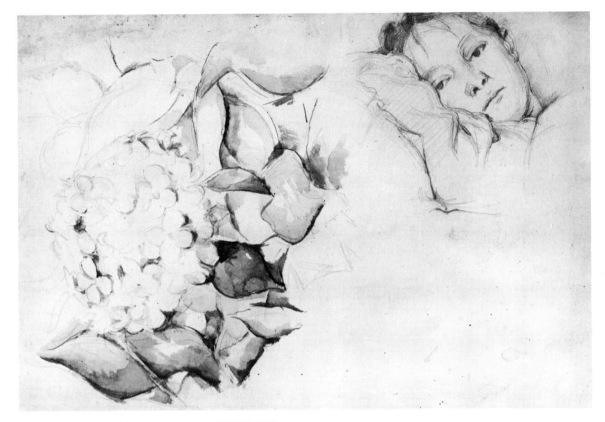

3. *Mme. Cézanne and a Hydrangea,* ca. 1875 (R.209)

English, so to say, just as in Sweden they look at him in Swedish—we shall look at the paintings in French. The phenomena I have mentioned throw an unexpected light on the works of Cézanne, on the working of his mind, and possibly on artistic imagination in general. However that may be, it is certain that in Cézanne there is often a correlation of word and image.

There is evidence in the Cézanne literature that the interplay of word and image, and the existence of cryptomorphism, have been observed by scattered individuals but pursued only rarely. In his study *Cézanne* (1953), Meyer Schapiro pointed out that *Uncle Dominique,* 1866 (pl. 2), shows a man wearing the robe of the *Dominican* order. But the correspondence between the name of Cézanne's uncle and that of a religious order is not

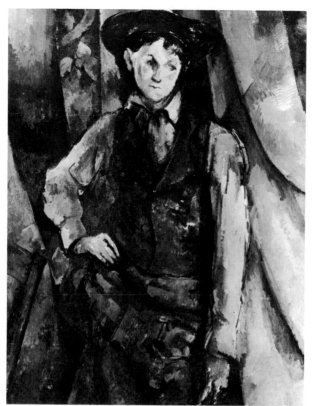

4. *Boy in a Red Vest,*
1890–5 (V.682)

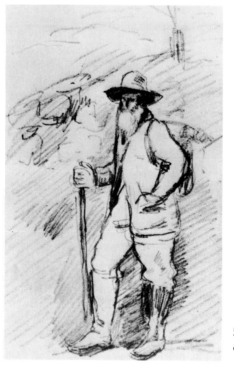

5. *Pissarro on His Way to Work,*
ca. 1874 (C.300)

4

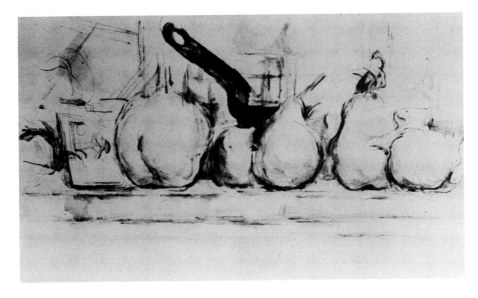

6. *Still-life with Casserole,* 1900–4 (R.565)

the only such correspondence in this painting. There is another, if less erudite, play of word and image: Dominique wears a cross (*croix*) and has his arms crossed (*croisés*). A sheet ca. 1875 (pl. 3) contains a watercolor of a flower on the left and a pencil drawing of a woman on the right; the flower is a hydrangea (*hortensia*) and the woman is *Hortense* Fiquet, Cézanne's companion.[3] The name of the young man who wears a *red* vest in several paintings of 1890–5 (pl. 4) was Michelangelo di *Rosa*.[4]

None of these pictures looks like a play of word and image, like a visual/verbal pun. But just as a literary pun is recognizable only when the several meanings of its key terms are known, a knowledge of matters related to the pictorial material is necessary in order to recognize the verbal interplay in the paintings. In the works mentioned above such information consists in the names of persons and things; in other cases it is biographical, historical, or literary data.

A linkage of word and image similar to those just examined, but more amusing and subtle because it employs a cryptomorph, is to be found in a drawing of Camille Pissarro, ca. 1874 (pl. 5), made after a photograph. Here, on the trouser leg at the left, an unmistakable phallus occurs at the anatomically correct place, though its appearance is unexpected on a fully dressed figure. Adrien Chappuis noticed it and wondered whether "in our permissive age, one is allowed to regret that Cézanne should have amused

5

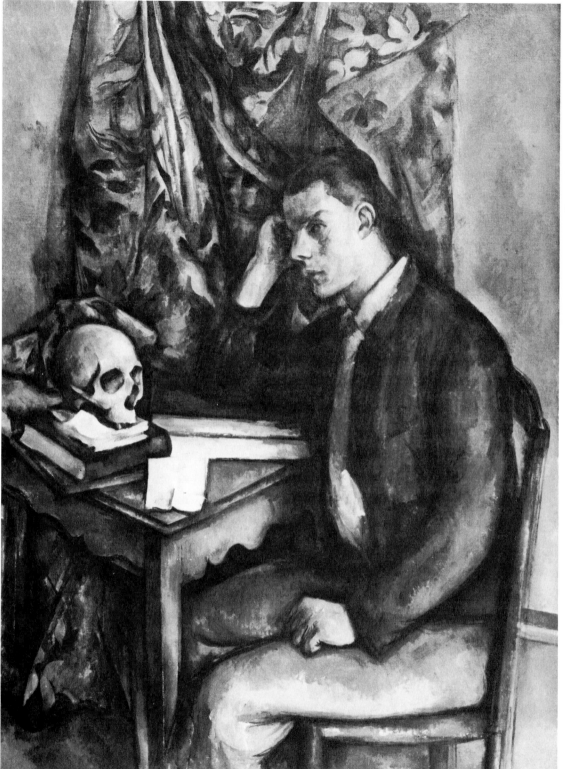

7. *Young Man with a Skull*, 1894–6 (V.679)

himself with an unequivocal interpretation of a trouser fold."[5] Although it is clear that Chappuis believed Cézanne drew this phallus intentionally, there is no evidence that its presence is other than unintentional, unconscious, like that of the countless other cryptomorphs in the oeuvre. Yet its appearance in the drawing is consistent with Cézanne's feelings about Pissarro: he looked on the older man, who was teaching him the Impressionist method and painting pictures for which he had the greatest admiration, as a father-figure. Indeed he said, "As for old Pissarro, he was a father to me."[6] But of special interest here, as in most of the examples that will be cited, is a verbal aspect of the image that takes the shape of a pun: one of the functions of the organ delineated—*pisser,* French—echoes the name of the man of whom it is a part.

Hidden sexual allusions abound in Cézanne. But one can hardly call "hidden" the significance in a watercolor (pl. 6), of the saucepan handle (*queue de casserole*) that rises from the parade of ripe fruit—a form resembling that *queue* defined in dictionaries of argot as the "*membre viril.*" The phallic handle among the feminine fruit suggests the vulgar expression *passer à la casserole* (to get layed).

In *Young Man with a Skull,* 1894–6 (pl. 7), often taken incorrectly to be a portrait of the artist's son, we will have to look closely at some puzzling pictorial features. For example, in the middle of the drapery is a forked fold that seems to rise from the man's head and suggests a horn.[7] Are we dealing here with a cuckold? We note that the visiting card in front of the books is unstable; it seems now to lie down, now to stand up. When up, it affixes itself to the edge of the two books behind it, and the combined white areas form a pistol (*pistolet*) pointing at the man's chest. The apron of the table is cut in a series of curves which suggest that they were designed with the help of a "French curve" (*pistolet*). The young man him-

7

8. *Man with a Book,*
ca. 1894 (V.678)

self may be seen as an odd type, a "character" (*pistolet*). He turns up again in a painting of the same period (pl. 8), which recasts three of the themes in the preceding work. Thus, a kind of horn seems to rise from the left side of his hat; a book rests on his lap; and a very obvious necktie (*cravate,* with the association of "noose" in French as in our "necktie party") goes around his neck (*cou*—?*cocu,* cuckold)—suggestions of violence associated with adultery.

If the case we have just examined is relatively subtle, there are paintings where the play of word and image is much simpler, once the image is identified. Floating in the sky of *The Seine at Bercy,* 1876–8 (pl. 9), are two clouds, to the right of the central barge, which have the semblance of female heads looking to the left. The corner of the painting cuts across the heavy coiffure of one, an eager woman who strains to the left. Behind

9. *The Seine at Bercy*, 1876–8 (V.242)

the chignon that falls over her brow we see a dark eye, and profiled against the sky are her nose, lips, and chin, the last defined by a dark almost horizontal line. She might inhabit a bordello scene by Toulouse-Lautrec—which was yet to be painted. Between her and the barge's tower is the more petite head of another woman, who appears to belong to the same milieu. Her head is tilted back, her plump whitened face set off by a heavily mascaraed eye; a ribbon floats over her hair (fig. 1). Any doubt concerning the women's profession is dispelled by the *grue* (crane) in the center of the painting; they are *grues* (prostitutes). They float because they are *femmes légères*. The painting was copied from one by Guillaumin,[8] but Cézanne's clouds tell us something about life around the docks of Bercy that is absent from the Guillaumin.

Houses and Trees near Bellevue, 1885–7 (pl. 10), shows a large sloping

9

10. *Houses and Trees near Bellevue, 1885–7 (V.450)*

field in the foreground. Occupying a third of the canvas, this field rises to a gently curving profile topped by a small knoll, a circular form that resembles a large ottoman—or an excellent representation of a very large breast somewhat flattened because of its horizontality. Apart from the fact of an actual knoll that could have evoked a nipple, it happens that there is a single term in French which designates both the topographical and the anatomical form: *mamelon*. Ineluctably, it calls up *mon melon* (my melon), and indeed a melon appears in two still-lifes by Cézanne. The family troubles aroused by his liaison with Hortense would have led him to meditate on the Provençal folksay: "*On ne peut reconnaître bien / Bon melon ni femme de bien*" (It isn't easy to pick out a good melon or a good wife).[9]

A stand of trees in a painting of ca. 1880 (pl. 11) contains several male figures—cryptomorphic, to be sure. At the right (fig. 2) is a large nude whose head is bent forward; left of center rises a figure shown frontally; immediately to the left and seen from the rear is a nude stretching upward. Once the three personages are discerned, the repeated trees suggest a whole human population. These trees are poplars; they give the painting its title. The French for "poplar" is *peuplier;* for "people," *peuple.* The

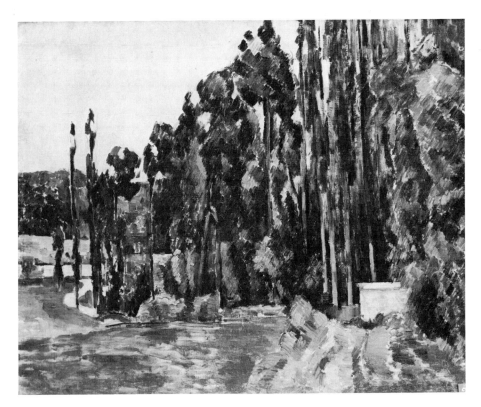

11. *Poplars,* ca. 1880 (V.335)

consonance of the two words (as of "poplar" and "popular") is due to their similar Latin roots. Thus, in Latin *pōpulus* means "poplar" and *pŏpulus* means "the people." Cézanne, an excellent Latin scholar, would have been aware of the philological situation. And he was not the only artist to anthropomorphize the trees: Van Gogh wrote to his brother, "A row of trimmed willows sometimes resembles a procession of almshouse men."[10]

A large part of the *tempérament* to which Cézanne often referred was, in his own case, a self-awareness bordering on paranoia, manifested not only in his relations with others, but also in an intense and constant reflection on his person and his art. If the many self-portraits are the obvious sign of this self-concern, there are other indications of the unremitting demands of and attention to the self.

One of the most remarkable is *The Stove in the Studio,* 1865–8 (pl. 12), which surprisingly for a painting of this genre shows a large canvas (*canevas*) with its face to the wall; we see its back. In front of it stands a black stove (*poêle,* with its echo of *Paul*). The erect stovepipe (*tuyau de cheminée*) is an affirmation of the sexual self; it points directly to the caldron (*chaud-*

11

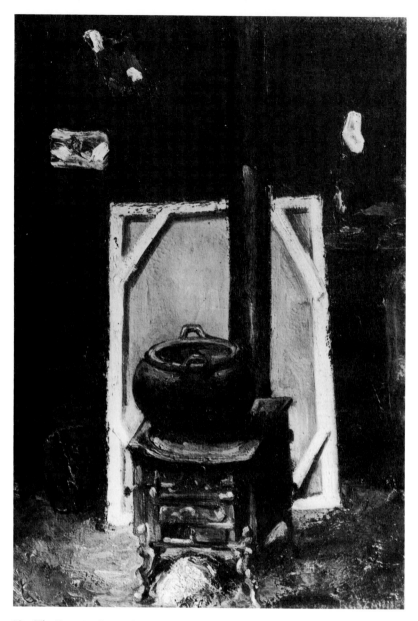

12. *The Stove in the Studio,* 1865–8 (V.64)

ron: "la nature de femme "),[11] which holds something red, the same red used for Cézanne's signature at the lower right; beneath the stove we see the signs of passion spent, a pile of ashes (*cendres*). On the wall, like rough hanging signs, are three other emblems: a small landscape (*paysage*), a *palette,* and a mask (*loup de Pierrot*) hung on its side—our artist can play the fool. In the lower left corner stands a large and very feminine vase (*cruche*). The relation of stove to canvas tells us that this painter comes

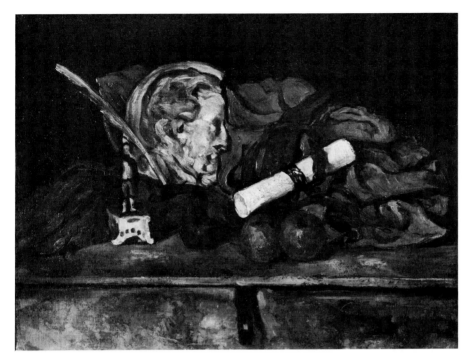

13. *Still-life with Relief,* 1870–2 (V.67)

before his painting. The canvas stretchers (*chassis*) actually frame the stove, the image of Paul. (In a letter of October 1866 to Zola, he writes, "I don't know if you think the same as I do—and anyway it doesn't make any difference—but I'm beginning to see that art for art's sake is a crude joke—that's between you and me.")[12] He has us looking at the back of a painting against which stands a symbolic self-portrait, instead of presenting us with the charm of a picture-within-a-picture. Rendered with an extensive use of black, a color of which he was master and with which he associated himself (as in *The Black Clock*), this painting is of an absolute originality.

And in addition to all else, the objects depicted have an unexpected function that is neither illustrative nor symbolic in the usual sense of this term. Of the ten French words which they call up, four begin with *p* and six with *c*—the artist's initials.

Coincidence? In a still-life of 1870–2 (pl. 13), we note, starting at the lower left and proceeding clockwise, a porcelain figurine (*porcelaine*), a pen (*plume*) in an ink bottle (*pot à encre*), a broken *plaque* in plaster (*plâtre*)

13

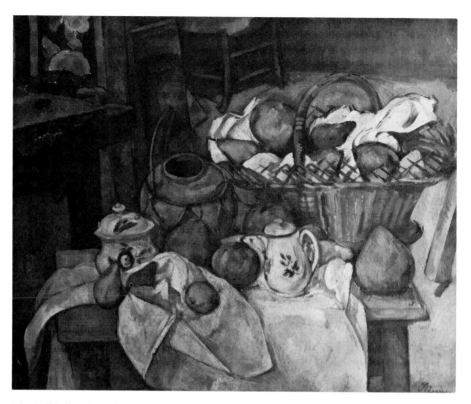

14. *Still-life with Basket,* ca. 1890 (V.594)

of Philippe Solari (sculptor and a friend of the painter), a folded overcoat (*pardessus plié),* a belt (*ceinture),* a diploma (*parchemin,* Venturi's term), two apples (*pommes),* and in the middle a small gourd (*calebasse).*

A final example whose fullness eliminates the possibility of chance: *Still-life with Basket,* ca. 1890 (pl. 14). Starting at the upper left we distinguish the border of a screen (*paravent),* the leather game bag (*carnier)* that several of Cézanne's visitors have mentioned, an ink bottle (*pot à encre),* a *palette,* the thong (*cordon)* of the game bag, a box (*caisse),* some pears (*poires),* a peach (*pèche),* apples (*pommes),* two pieces of pottery (*poteries),* a strawed jar (*pot paillé),* a basket (*panier),* three corners (*coins)* of the table, the prominent floor (*plancher),* the leg (*pied)* of a table(?) at the extreme right, a chair (*chaise),* two paintings (*peintures),* and behind the game bag, on the screen, a cryptomorphic but unmistakable bald skull (*crâne)* of a man. In sum, eighteen different objects whose names begin with *p* in eleven cases and with *c* in seven. In a number of French dictionaries I have consulted, words beginning with *p* and *c* together account for about 20

percent of the words defined. If this is also the percentage of nouns in the language, a randomly chosen list of eighteen nouns should have no more than four beginning with *p* and *c*.[13] But the objects in our painting were not random choices.

We note that the last three paintings show walls, tables, and tablecloths that have not entered into our accounting. I think that in Cézanne's imagination they were a kind of substratum *sine qua non,* a common denominator like the canvas itself on which he worked. And indeed at the beginning of his career Cézanne made a number of large paintings on the walls of his house. For his still-lifes he arranged objects on the table with the same care—and skill—that he brought to the painting. As for the tablecloth, it is very possible that he thought of it as a *toile.* I think it served as a constant metaphor for the *toile* on which he worked and—in view of its burden of symbolic, erotically charged objects—for that *toile* which, in common parlance, is the bedsheet.[14]

If an involvement with language leads to the painting of objects chosen because of the initial letters of their names, there are works in which actual letters, words, and punctuation marks appear. In the early canvas called *Sorrow (Mary Magdalen),* ca. 1867 (pl. 15), three large tears hang over the scene. These emblems of boundless grief are reinforced by a hidden message: the folds of the Magdalen's blouse create the clearly visible letters *ULU,* the beginning of *ululer,* to wail or lament loudly. Continuing to the right we may read the next fold as an *L* and the sleeve opening as an *O;* this would give *ululo* (Latin, "I lament"). *Trees in the Form of X,* ca. 1896 (pl. 16), probably painted on the edge of Aix, provides other word play. The French of this title, *Arbres en X* [iks], is a pun on "in Aix." The letters that spell *Aix* may be found in the heavy limbs at the right.

As a young man Cézanne's love of Virgil led him to translate one of

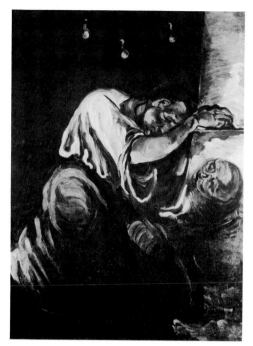

15. *Sorrow (Mary Magdalen)*,
ca. 1867 (V.86)

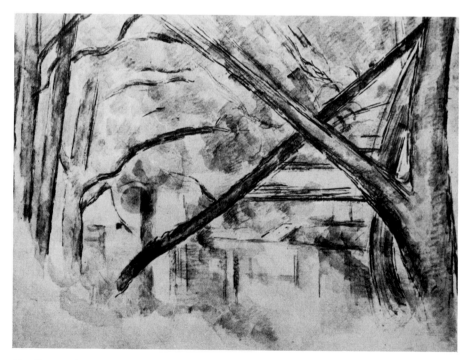

16. *Trees in the Form of X*, ca. 1896 (R.485)

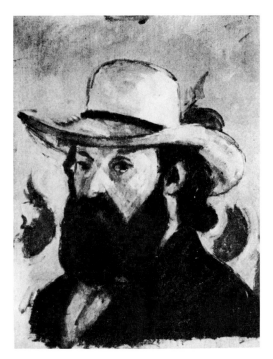

17. *Self-portrait in a Straw Hat,*
1873–6 (V.287)

the Eclogues, probably in verse. This love persisted, and years later he played on the poet's name in *Self-portrait in a Straw Hat,* 1873–6 (pl. 17). The graceful shape and sunny color of the hat make this Cézanne's only self-portrait to show him in a bucolic mood. If we call this mood *Virgilian,* we have for the first time a reason for the wildly dancing commas (*virgules*) on the wallpaper. This line of thought leads us to remark, on the face, the sharp *V* formed at the meeting of cheek and beard. This design is not to be found—certainly not with such sharpness—in the more than twenty other self-portraits in the oeuvre where it might have occurred. Still, there is a rather good *V* on the dexter cheek in the portrait of Anthony *Valabrègue,* ca. 1866 (pl. 18), as well as several others on his shirt collar, vest, and jacket. Is it the large presence of this motif in the portrait of Ambroise *Vollard,* 1899 (pl. 19), that caused Cézanne to say, after ninety sittings, that he was not dissatisfied with the shirtfront?

In the middle of the lower zone of *Houses in Provence,* ca. 1885 (pl. 20), a very good cryptomorphic self-portrait of Cézanne, looking to the right, rises from the lower edge of the painting (pl. 21), somewhat in the manner of a donor's portrait of an earlier period. Just to the right of this configu-

17

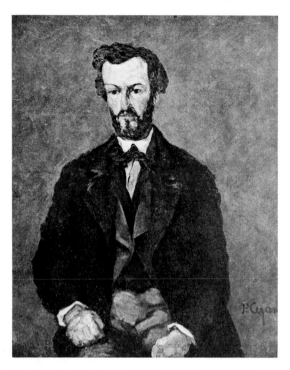

18. *Portrait of Anthony Valabrègue,* ca. 1866 (V.126)

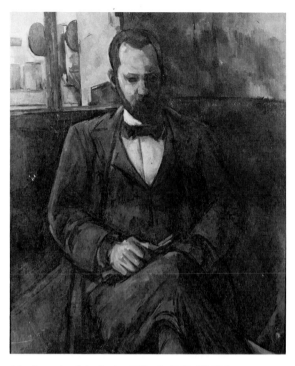

19. *Portrait of Ambroise Vollard,* 1899 (V.696)

ration and against a long wall is a bare vine whose branches are rendered in a curiously explicit manner; they spell out the word *Paysane*. The loops are missing on the *P* and *e,* but examination of the picture reveals that they have been painted out with gray. The hidden word would be a crossing of *Paysan* (peasant) and *âne* (donkey), the whole rhyming with *Cézanne*. As in the balloon of a comic strip, the word appears to be uttered by the artist in order to identify himself. On May 11, 1886, close to the date of the painting, Cézanne wrote to Victor Chocquet in an elegiac mood, "I had a few vines, but unexpected frosts came and cut the thread of hope."

The most extraordinary type of word/image play in Cézanne is the rebus, known in our day as a picture puzzle for children. Let us examine one that completely occupies the pictorial space. Who would expect to find a relation between the landscape in oil of 1873 (pl. 22) and the Desert Father shown in a watercolor of 1877 (pl. 23)? But an astonishing connection between these works is revealed when we learn that the oil painting was entitled *La Maison du Père Lacroix, Auvers* (*The House of Father Lacroix*

18

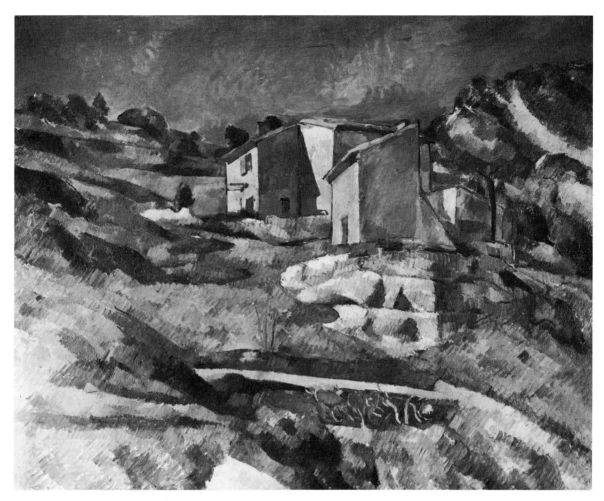

20. *Houses in Provence*, ca. 1885 (V.397)

21. Detail of *Houses in Provence*, pl. 20

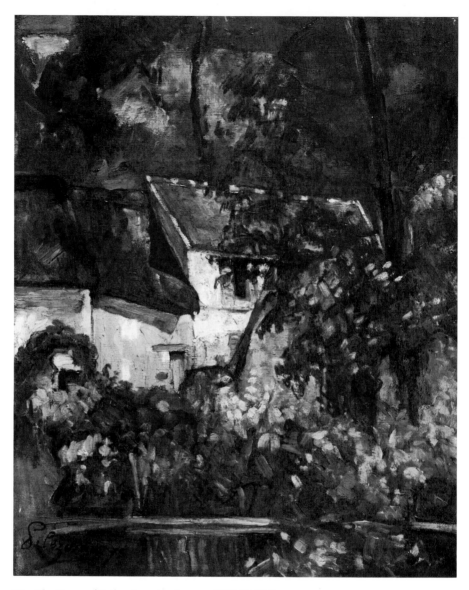

22. *The House of Father Lacroix, Auvers,* 1873 (V.138)

["cross"], *Auvers*), and is so named by Venturi. In the watercolor *The Hermit,* the building, the cross, and the man correspond to Saint Anthony and his surroundings as described in the opening of Flaubert's *La Tentation de Saint Antoine.*[15] We see a large cabin; to the right of it, Saint Anthony; and immediately to his right, a large cross. To the right of the cross, rising from the ground, is a tall serpentine form, not mentioned in Flaubert. We have, then, the dwelling (*la maison*) of Saint Anthony, a Desert Father (*Père du désert*), with the cross (*la croix*) and a large worm (*ver; and Auvers*

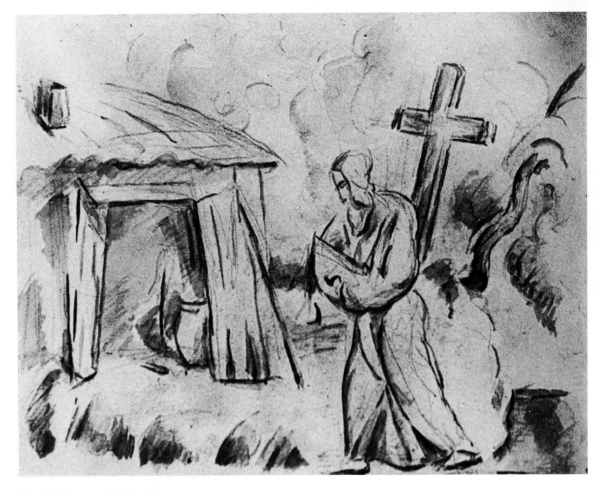

23. *The Hermit,* 1877 (R.66)

sounds like *au ver,* "with a worm"). Since nothing else intervenes in this series, it makes an excellent rebus of the title of the earlier work in oil.

Unlikely though it may seem at first glance, *Six Bathers,* ca. 1875 (pl. 24) adumbrates a rebus similar to the preceding one. On the far left, attached to a tree, is a tarpaulin (*tente,* with its connotation of a shelter and its reminder of *tentation*). On the far right a tall cypress and the branch of another tree together make an impressive cross (*croix*). And between the *tente* and the *croix* are two standing women who virtually mirror each

21

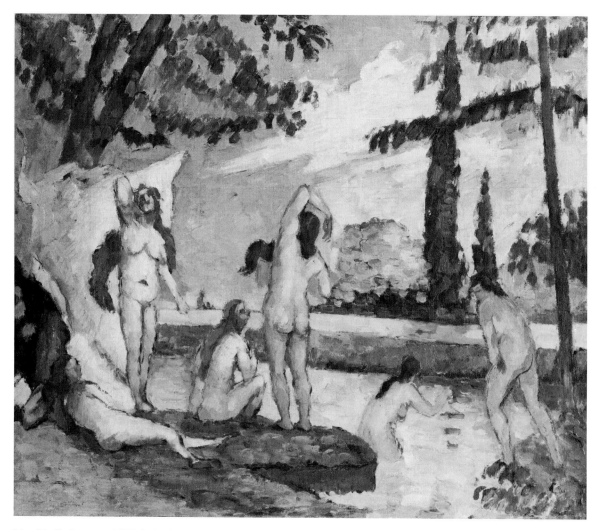

24. *Six Bathers,* ca. 1875 (V.265)

other; thus, a pair (*paire,* echoing *père*). We will come upon other rebuses or examples of word/image play pursued in a series that, like this one, lose their precision the further they are in time from the original. *La croix* (cross), the only element in the two paintings to maintain its initial form, and the only word to keep its form in the two rebuses, must be considered a potent feature of Cézanne's imagination. Apart from its religious connotation, it occurs in the name of his newspaper, *La Croix,*[16] and we know of his admiration for *Delacroix*.

It becomes apparent that *La Maison du Père Lacroix, Auvers* was in large measure undertaken because the very words in the name of the place had a personal resonance for Cézanne, calling to mind the house of his own father. Years after his father's death he still referred to the *hôtel* at the Jas

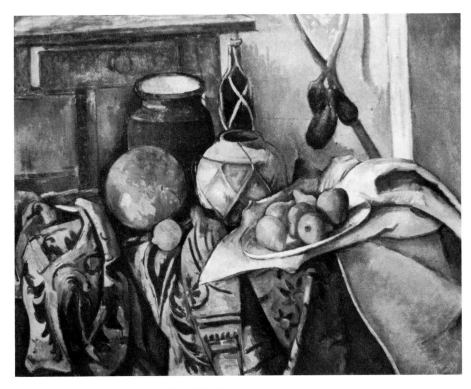

25. *Still-life with Eggplants,* 1890–4 (V.597)

de Bouffan as *"la maison de mon père."* And we will see that he twice sym-
bolized his father by a cross.

The rebuses examined so far are read from left to right in the usual
fashion and fully occupy the works they inhabit. The one that follows
occupies only a part of a painting and is read from top to bottom. Within
the upper edge of the white cloth on the table in *Still-life with Eggplants,*
1890–4 (pl. 25), it is possible to see a hand, surely a cryptomorph. There
is no difficulty in distinguishing four fingers, the wrist, and back of a left
hand; the thumb is out of view. This image is so clearly delineated that,
once it is seen, one can only wonder why it has escaped observation so
long. Indeed, since it partakes of the color of the white tablecloth, it looks
like a plaster cast of a hand (pl. 26).

23

26. Detail of *Still-life with Eggplants*, pl. 25

With this hand (*main*) in view and knowing that the objects suspended above it are eggplants (*aubergines*), the name *Guillaumin* sprang to my mind. That this should have happened is mysterious even to me, for while *aubergines* and *main* supplied the syllables *aumin*, I did not know what could give the sound of *gui*. My own French dictionaries only had the common definition for *gui*, "mistletoe," and I could find no word beginning with this sound that bore any relation to the painting. In a large dictionary the fourth definition of *gui* was *bôme* (a sailboat's boom). Since a *bôme* could be fashioned from the fork of a tree, I felt I was on the right track. Then I had the inspiration to consult a dictionary of Provençal; it listed *gui* and one definition: "*branche principale d'un arbre*," taken from Frédéric Mistral's great Provençal dictionary.

The three objects that supply the sounds for the name *Guillaumin* are in a line, with a small space between the *aubergines* and the *main*. I have tampered with these materials only to the extent of disregarding—for the moment—the last two syllables of *aubergines*. I don't think this compromises the case for a rebus here.

Armand Guillaumin was, like Cézanne, one of the painters who participated in the first Impressionist exhibition. The two men were very good friends for a time—the period of *The Seine at Bercy* (pl. 9)—and

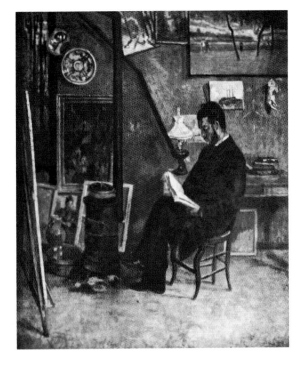

27. Armand Guillaumin,
Portrait of Dr. Martinez, 1878

often went painting together. Cézanne etched a portrait of Guillaumin and a copy of one of his paintings; it was even said at one time that Cézanne was influenced by him. In 1875 they both had studios at 15 Quai d'Anjou, and it was here that Cézanne did a self-portrait with a landscape of Guillaumin's behind his head (V.288). The same landscape appears in the upper right corner of Guillaumin's *Portrait of Dr. Martinez*, 1878 (pl. 27), and directly below it on the wall of Guillaumin's studio hangs a plaster hand. This, then, is the cryptomorphic hand in Cézanne's *Guillaumin* rebus. We note, besides, that *vieille branche* (old branch) is a warm term of address between old friends.[17] Finally, since *auberge* means "inn," and since *-ine* is a suffix denoting the diminutive, the word *aubergine* may be construed as an acceptable neologism having the sense of "small inn," and that is probably how the two artists regarded the building they shared.

Although something has been explained here, there is much that is opaque. What, for example, is the relation between the rebus and the rest of the painting? Is there a reference to Guillaumin in the suggestion of genitalia in the eggplants? In spite of these problems, we can see that Cézanne has not only accomplished the surprising feat of creating a rebus of the name of an old friend and accommodating it to a still-life; at the same time he has chosen objects relevant to his association with that

25

friend. The rebus demonstrates Cézanne's amazing faculty for intricate and explicit symbolization. He even leaves a hint that something special is taking place in the region of the rebus by lighting it sharply in a way that is unique in the oeuvre. If the simpler puns that I have indicated appear to be fortuitous or perhaps to be my own constructs, the meaningful intricacy of this rebus precludes the possibility of accident. Nor could I have "read into" the painting a language, Provençal, that I do not know. Alerted to the existence of Provençal in Cézanne's wordplay, we will encounter it again.

The graphic and verbal phenomena to which I draw attention must be considered unconscious products of Cézanne's artistic activity. In spite of their great number and importance, he never gave any sign that he was aware of them during a career forty-five years long, in the course of which he wrote many letters and talked to numerous people who left records of his conversations. We can only assume that he was frank in his discussions on art and did not have a secret procedure that included punning and cryptomorphic imagery. Nevertheless these psychological creations, extraordinary as they may be, are not incompatible with what we otherwise know of Cézanne's life and character.

He had an excellent education and was a good scholar who won a number of prizes. His early gifts were literary, and all his life he was able to quote from French and Latin poets. His memory apparently was remarkable: Joachim Gasquet tells us that his schoolmates recalled many years later that he never forgot anything he ever saw or heard.[18] Up to the age of twenty-four he wrote a great deal of poetry. While not of the first order—indeed mostly doggerel and meant to amuse—it is proficient, it demonstrates awareness of language and literature, and it mirrors a pas-

sionate nature. Cézanne never relinquished his interest in literature; he read constantly and widely, and his wife often read to him when he could not sleep.[19] When he went out to paint he took along a copy of Virgil. He knew the history and geology of the region in which he was born. Marie Gasquet, whose husband and father-in-law sat for portraits by Cézanne and who herself posed for an uncompleted portrait, said that his conversation was *"ahurissante d'érudition"* (overwhelming in its erudition).[20]

Cézanne's gift for writing highly colored verse was not simply abandoned as he turned to painting, but translated into the fervid images and erotic subjects of his early period. The large cryptomorphic image of a breast in *Houses and Trees near Bellevue* (pl. 10) could have had as its source a line from a poem included in a letter of January 5, 1863, sent from Paris, where he writes that he misses *"Ce temps où nous allions sur les prés de la Torse"* (The time we walked in the meadows by the river Torse; but *près de la torse* would also mean near the torso). His paintings make explicit reference to works by Flaubert, Cervantes, Zola, and Lucius Apuleius, not to mention the Bible and Greek mythology. Apart from the hidden verbal play that I find in the oeuvre, there are several spoken examples of Cézanne's wit: *"On ne devrait pas dire modeler, on devrait dire moduler"* (One should not say model, but modulate); *"Avec une pomme je veux étonner Paris"* (I want to astonish Paris with an apple); and *"Pour l'artiste, voir c'est concevoir"* (For the artist, to perceive is to conceive).[21]

It cannot be overemphasized that Cézanne lived all his life with two puns that play on the *âne* (donkey) in his name. That he was conscious of them is clear from the signature on a letter (dated January 17, 1859) to Zola: *"Paulus Cezasinus."* A latinization of his name would have yielded *Paulus Cezannus;* instead he made a pun in Latin on the *âne* in *Cézanne,* since *asinus* is the Latin for "donkey."

28. Rebus by Cézanne; letter of
May 3, 1858, to Emile Zola (C.17)

Although the rebus has become a children's game in recent years, in the latter half of the nineteenth century it was for the most part a very difficult puzzle intended for adults. It had not only an entertainment value but also an educational function. Children's stories were often published as long simple rebuses, and a Bible in rebus form appeared in the United States. It was the ancestor of the crossword puzzle. From the 1840s to the 1880s the back cover of the illustrated weekly *L'Illustration* carried a rebus and the solution to the previous week's rebus. Delacroix in 1833 signed his name with a 2, the note A marked on a treble staff, and a cross.

Surprising as it may be to suggest a significant relation between Cézanne and the rebus, the fact is that he drew one at the head of his letter of May 3, 1858, to Zola (pl. 28). Composed of two words and four images, its solution is: "*Il faut aimer les femmes*" (One should love women). A poem, "*Charade,*" in a letter of December 29, 1859, also to Zola, is a kind of literary rebus. It is made of five couplets whose first nine lines describe in order three things: *chat, riz, thé.* The last line tells us they add up to a "theological virtue." Solution: *charité.* Cézanne could have made a real rebus by drawing a cat, a bag of rice, and a box of tea, but it would have been too easy. He was showing off his skill as a versifying puzzler.

In the mid-1870s Cézanne paints the rooftops of Paris (*les toits de Paris*)

28

under a clear sky. When, a while later, he does a cityscape, billowing clouds above the *toits de Paris* form the head of a reclining woman, surely Hortense, *toi de Paris*—he had met her in Paris and forever associated her with the city. Words again indicate the sense of the painting-as-dream. They are the spur to Cézanne's fantasy; the stuff of the youthful poems, they later call up the pictures.

Ut pictura poesis. Writing and painting: both pursued in a fluid medium.

Cézanne, possessed by painting, was obsessed by language. We have been told for a long time that art is a universal language. But Cézanne's painting speaks French—unless it is speaking Latin or Provençal.

Father, Father

Despite the great volume of the Cézanne literature—devoted as it largely is to the biography of the artist, the identification of sources, the dating of painting, and the examination of structure—only rarely are single works studied for their content. How, in any case, to study the content of a still-life or landscape, by definition as "contentless" as the (supposedly) nonepisodic figure composition? The situation calls for interpretation, and practitioners of the art are few. It is of some interest, then, to examine the small number of instances where interpretation has been attempted or initiated.

An illuminating case is that of *Portrait of the Artist's Father,* 1866 (pl. 29), a magnificent canvas, six and a half feet tall, painted when Cézanne was twenty-seven years old. The work is executed with a palette knife, and if Cézanne's use of this tool has sometimes been called crude and violent, its handling in the *Portrait* shows a mastery, a subtlety of touch and variety of surface to satisfy the most exigent. The image is noble, calm; the color is somber but not dark—Cézanne has painted a subdued light. The setting is the family home on the property outside of Aix known as the Jas de Bouffan, acquired by Cézanne *père* in 1859. He sits in a high-backed chair that was probably his favorite, reading *L'Evénement.* It is unlikely that he would have had a copy of this journal, and indeed Cézanne *père* was at first shown reading *Le Siècle,* a republican newspaper.[1] The change to *L'Evénement* introduced a reference to Emile Zola, who had written his first bold articles on art for this journal but had left it by the time the *Portrait* was executed.

On the wall behind the chair and over the father's head hangs a still-life about twelve inches wide. A copy of an earlier work by the artist, it is three inches narrower than the original (pl. 30) and includes a bare strip along the bottom, as though to show more of the table on which the

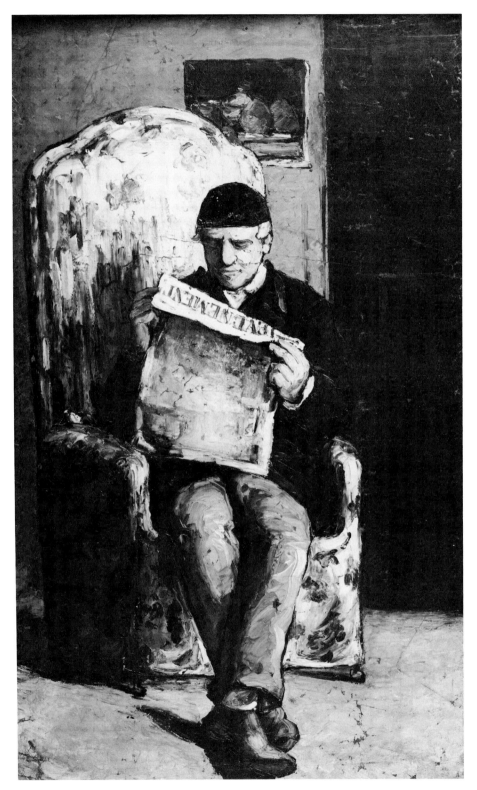

29. *Portrait of the Artist's Father*, 1866 (V.91)

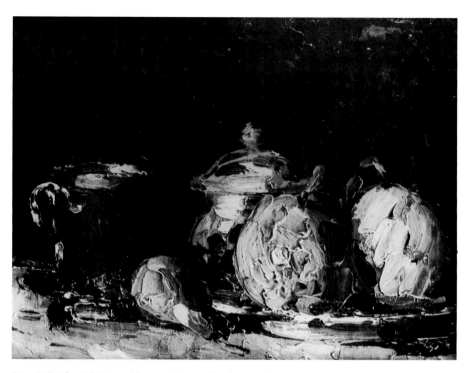

30. *Still-life with Pears, Mug, and Sugar Bowl,* ca. 1865 (V.62)

objects rest. In an article which investigates the pictures-within-the-pictures of Cézanne and finds that they are helpful in uncovering meaning in the host pictures, Theodore Reff discusses this still-life in the following manner: "The rectangular shape of the small canvas behind [Cézanne's father] reasserts the flatness and grid-like structure of the whole, just as its dark compact forms echo those of the figure directly below, locking it into the sequence of parallel and tilted planes formed by the newspaper, the chair and the wall."[2] These formulations are questionable: the painting, like all others, is flat as an object, but not as a representation; its "grid-like structure" is a critical fiction; the still-life "locks in" the figure by occult force, apparently, being at a distance from it.

In an effort to extract meaning from the still-life the claim is advanced that it "asserts" Cézanne's presence in his home. If anything was asserting his presence it would seem to be the imposing *Portrait* itself—the still-life occupies a mere thirtieth of its surface. In any case Cézanne's presence was already amply proclaimed by a screen, ca. 1859 (V.1–3), almost thirteen feet wide, made to decorate his father's study, and by an 1865 portrait of

31. *Portrait of the Artist's Father,* 1865 (V.25)

his father reading a newspaper (pl. 31), five and a half feet tall, itself flanked by four decorative panels, each over ten feet tall, in a large alcove of the main salon (pl. 32). On another wall he had copied Lancret's *Dance in the Country* (V.15) and elsewhere, also on a wall, had painted a *Bather by a Rock* (V.83), some nine feet high. In short, when Cézanne began the 1866 *Portrait* one could hardly move in the house at the Jas de Bouffan without coming upon his work.

However, if Cézanne's presence in the house is not at issue in the still-life, his status is. In placing the still-life over his father's head he declares his superiority to Cézanne *père*—and to Zola and delivers yet another and more abrasive judgment of the father. In the article cited above, the picture-within-the-picture is described as a "rectangular shape" that includes "dark compact forms." Upon examination, these forms turn out to be a mug, a sugar bowl, a small pear, and two large pears. Because the still-life appears in the *Portrait* at almost full size, the large central pear is easily discernible, being painted a bright green, and is, besides, the only object shown whole. In order for this pear to be the only whole object in

33

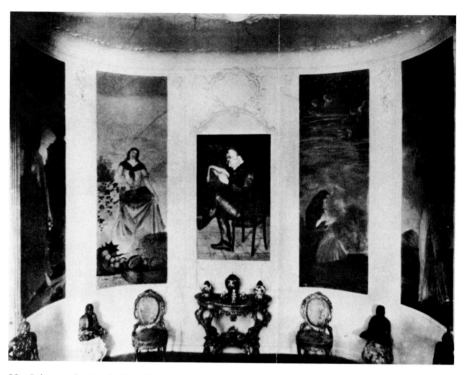

32. Salon at the Jas de Bouffan, photograph, 1905

the portrait's still-life—and thus able to bear the symbolic burden with which it is charged—Cézanne has made it *overlap* the pear on its right, with which it was *contiguous* in the original. Placed over the father's head like an attribute or personal symbol, the large pear is indicative of Cézanne's opinion of him, since *poire* (pear) in French slang means "fool" or "dupe." However derogatory the implication of the pear may be, it is less so than the explicit language of a letter Cézanne wrote to Pissarro on October 23, 1866, the same year in which the *Portrait* was painted: "*Me voici dans ma famille avec les plus sales êtres du monde, ceux qui composent ma famille, emmerdants pardessus tout*" (I am here at home, with the filthiest creatures in the world, my family, boring beyond belief). In addition, the Provençal for "pear" (*pero*) sounds very much like the French for "father" (*père*).

Cézanne had a famous precedent for depicting a fool as a pear. In 1838 Philipon had published in *Le Caricature* a four-part cartoon in which the king, Louis-Philippe, was gradually metamorphosed into a pear (pl. 33).

34

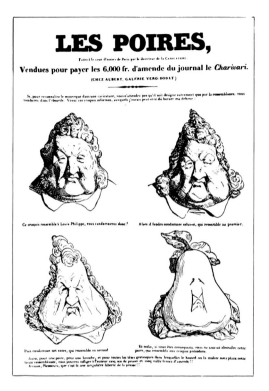

33. *Louis-Philippe Metamorphosed into a Pear*

The cartoon had immense fame, which has never ceased to reverberate in French journalism; a French political figure marked for ridicule is still caricatured as a *poire*. Cézanne's use of the pear was all the more apt since the given name of his father was Louis-Auguste.

It should be pointed out in passing that the *Still-life* of ca. 1865 is a symbolic family portrait, with Cézanne represented by the mug (*pot,* sounding much like *Paul*); his mother by the sugar bowl, sister Rose by the small pear, Louis-Auguste by the large pear, and sister Marie by the medium-sized one. The symbolic scheme of this early work will be maintained in later pictures showing the mug, sugar bowl, and large pear. Indeed, a pear will adumbrate a portrait of Cézanne's father.

Depicted as usual reading a newspaper, Louis-Auguste is the subject of a third portrait of 1875–6 (pl. 34), which includes wallpaper of baroque design. We read in the article cited earlier that the forms in the wallpaper "echo" those of the head of Cézanne *père,* and that without them "its effect would be much weaker." This may be true in the sense that any

35

34. *Portrait of the Artist's Father,* 1875–6 (V.227)

"effect" in Cézanne would be weaker if something were missing from a painting. In any case, the *Portrait* mentioned earlier (pl. 31) gets along very well without wallpaper.

Resisting the stylistics of nineteenth century wallpaper and regarding the present example as having a meaningful (as opposed to formal) function, I must claim that the large motif to the left of the father's cap delineates a monstrous, open-mouthed head which threatens that of Louis-Auguste. The fierce presence in the wallpaper thus displays an antagonism toward the father similar to that implied by the still-life in the *Portrait* of 1866 and by several other paintings.

One of these is the bleak scene *The Pool at Jas de Bouffan,* 1875–6 (pl. 35). In the bare branches and other elements to the right of the central tree we may pick out the portrait of a man looking to the left—Cézanne's

36

35. *The Pool at Jas de Bouffan,* 1875–6 (V.164)

father (fig. 3). It is astonishing that such an image could be secreted here, that an undulating branch could represent an eyebrow and eye. Louis-Auguste is shown above a prominent feature of his property, the pool (*bassin*). The French word, in its adjectival use, means "insipid, boring," epithets that conform to Cézanne's opinion of his father as implied in the manifest portrait of 1866.

While recognizing Louis-Auguste's chair in a picture of 1867–8 (pl. 36), we see that its occupant is a painter called Achille Emperaire—it says so in the inscription over his head. We can then guess that the painting was probably done in the winter because Emperaire is wearing a dressing gown and using a foot-warmer. We might wonder whether P. Cézanne, as the work is signed, had a high regard for Emperaire since the picture is over six feet tall. Size, as we saw in the case of the portrait of his father

(pl. 29), is not a sure index of respect, though it must be a sign of relative importance. Still, the *Emperaire* seems sympathetic; we see the sitter's face unshadowed and surmise that the painting is testimony to the admiration of one artist for another. Putting a subject's name on a painting had been a practice in the past, especially in the case of noble personages. (Tintoretto, one of Cézanne's admirations, inscribed his name over his head in the self-portrait in the Louvre.) In our case there is little doubt that Cézanne is treating his sitter in regal style, something the name *Emperaire* would have suggested: it is Provençal for "emperor." Cézanne has played along with this sense by orienting the chair to face front in hieratic fashion instead of placing it at the casual angle he had employed for the same chair in the 1866 portrait of Louis-Auguste.

In addition to the precedents for the inscription in high art there were humble examples of its use much closer to Cézanne—the *images d'Epinal,* the popular prints that flourished in France from the fifteenth to the end of the nineteenth century. These favored for their titles the same kind of lettering—Didot, or ultra-Bodoni, usually at the top of the sheet— and displayed a gamut of subjects that included "crimes that made you tremble, caricatures that made you laugh, naively archaic saints, Emperors, Kings, Generals, fires, floods, fairs, exhibitions . . ."[3] Their imagery was frequently embellished by a few bold, flat colors, and was usually accompanied by a text. These prints often have an arresting design and a naive charm; in the middle of the nineteenth century they were admired by writers and "fine" artists, and became the object of scholarly study. Meyer Schapiro has shown that several paintings by Gustave Courbet were influenced by them; indeed Courbet contributed a lithograph to a broadside whose format was like that of the popular images.[4] Since Courbet was one of the French masters—Delacroix was the other—whom Cé-

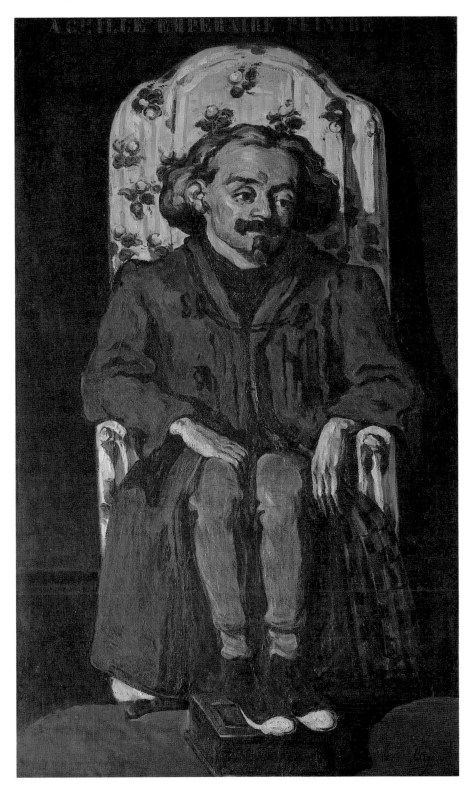

36. *Portrait of Achille Emperaire, 1867–8 (V.88)*

zanne most admired, it is not surprising that he should have been aware of the *images d'Epinal*. He seems, indeed, to have painted one in the background of a picture of his own at this time, *La Femme couchée,* which is lost.[5] And the Epinal prints had recently been associated with another artist, one whom he saw occasionally and whose work pressed on his consciousness—Manet. When the Goncourt brothers saw Manet's *Le Fifre* in 1867 they called him "*l'imagier à l'huile d'Epinal*" (the oil painter of *images d'Epinal*).[6] This may have been yet another instance when Cézanne took a cue from Manet, for he began the *Emperaire* in the same year.

Portrait of Achille Emperaire is neither executed nor colored like an *image d'Epinal,* but in its emblematic frontality, high-keyed color, and emphatic imagery, it is the painterly equivalent of the popular print. These qualities become evident when it is compared with the portrait of Cézanne's father (pl. 29), rather than with a popular print. In such a confrontation its flat design and artificial color are at once apparent and in clear contrast to the sophisticated spatiality and atmospheric color of the portrait of Louis-Auguste.

There was a popular subject of the *images d'Epinal* that would have suggested Cézanne's painterly version: Emperor Napoléon III. There does not seem to be a print showing him enthroned, but in plate 37 we see him on a horse, wearing his distinctive beard, which set a style and added a term to the lexicon of fashion, the *impériale.* Emperaire, of course, sports one too, and Cézanne has given it full prominence. There can hardly be a doubt: in view of the sitter's name, his beard, the imposing chair, its centrality and frontality, and the posterlike style of the rendition, complete with boldly lettered inscription, *Portrait of Achille Emperaire* is a hand-painted *image d'Epinal* of the Artist as Emperor.

In dethroning Napoléon III and replacing him by an unknown painter,

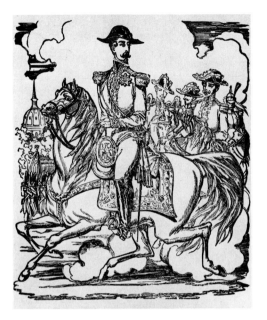

37. *Napoléon III*, image d'Epinal

Cézanne shows himself to be not only witty and wicked, but political as well. Just two years before, at the end of September 1865, his friend Val-abrègue had written to Zola: "I often see Paul in the afternoon . . . He has changed too . . . He explains theories, develops doctrines. And what used to be a huge crime—he allows you to talk to him about politics (theories, of course), and he goes on till he reviles the tyrant in terrible fashion."[7] The "tyrant" was Napoléon III; in the *Emperaire* Cézanne pokes fun at him while honoring his friend Achille, extracting a wry humor from the tension between mockery and homage. In the two large portraits of 1866 and 1867–8 Cézanne is far from being the ahistorical painter of legend: he refers to Louis-Philippe in ridiculing his father and to Napo-léon III in ennobling his friend.

So Emperaire of Aix sits on his chintz-covered throne, wrapped in a heavy robe decorated with frogs, his feet warmed by the *chaufferette,* which does double duty as the stool that keeps an emperor's feet from touching the ground. But the foot-warmer has yet a third function: to keep Emperaire's feet from dangling—for he was a dwarf. Thus, besides evincing Cézanne's high regard for a fellow artist, his large and regal por-trait attempts to compensate for one of fate's inequities. In this humane gesture we discern a seldom-glimpsed aspect of Cézanne's character.

The painting has another open secret, a motif in every sense central and always overlooked: the fingers of the right hand are nestled, at once discreetly and outrageously, in the sitter's crotch. The picture's absorption of this scandalous feature—by the sharp foreshortening of the thighs— required a skill and tact not usually associated with the young Cézanne. The pose, in any case, should alert us to scandals to come . . . The two long hands, whose pallor detaches them from the surrounding area, may be seen as cryptomorphic birds, the wrist providing the head and eye, the fingers long, elaborate tailfeathers; and once they are so perceived we move to a new interpretative level. When the hand between the thighs is seen as a bird rising from them, it becomes a symbolic phallus. Farmer glosses *oiseau* (bird), "the *penis*,"[8] a theme familiar in Mediterranean art. The allusion is altogether apposite in view of Emperaire's interest in erotic matters—and of the well-known sensual excesses of Napoléon III. Emperaire drew marvelously erotic women and supplemented his meager income as an artist by peddling pornographic postcards to the university students of Aix.[9] We may be sure that Cézanne, having himself an imagination that eroticized everything, was attracted to Emperaire not least by his lusty nature. The influence of Emperaire must lie behind Cézanne's exuberantly erotic paintings of the years 1870–5; both men would have relished the gallant prints of the day.

Did Emperaire collaborate in a private joke—posing with his hand on his privates? We don't know, but it is unlikely that he did. Once he saw the painting he could not have failed to note the placement of the hand, which is early evidence of a Cézannian obsession: the genital region. It will engross Cézanne first in male, then in female subjects, but rarely so pointedly as in the *Emperaire*. With his excellent visual memory, Cézanne could have done the painting without the model present. He had already

38. *Portrait of Achille Emperaire,*
ca. 1867 (C.230)

made splendid pencil drawings of the head (pl. 38), surely from life, and one of his friend seated. Working from memory would have fostered the artificiality of color and the stark, stylized treatment of form. It must be doubted, in the end, that Emperaire actually posed at the Jas de Bouffan. In view of the respect in which Cézanne held him, to have painted him seated in Louis-Auguste's chair reveals that at this time Cézanne regarded him as his spiritual father. The symbolic situation is therefore even fuller than it appeared to be earlier: in his allusions to two rulers of France, Cézanne makes use of Louis-Philippe's successor, Napoléon III, in order to designate the successor of his natural father.

What of the fact that the painting shows two hands, thus two birds? On this high occasion Achille wears a bright blue robe, a red foulard, and purplish trousers. He is dressed "to the teeth," "to the nines"—and, in an old French phrase, *aux oiseaux* (to the birds).[10]

Why at all, finally, this elaborate parody of the *image d'Epinal*? We may suppose in Cézanne a populism similar to Courbet's that led him to admire these prints—and other kinds of prints as well. In this case his appropriation of the *image d'Epinal* is accompanied by an erotic impulse that is central to the painting. As we have seen, it has a biographical source in Emperaire's character, but it is supported by a sexual note in the name

Epinal, suggestive of *pine* and *épine,* both allusions to "penis" in French popular speech.[11]

Cézanne's admiration for Emperaire—ten years his senior, married, the father of two—was enduring. In the early years of their friendship he allowed him to lodge in his quarters in Paris; and almost thirty years after the portrait he wrote to Gasquet, in what must be a reference to Emperaire, "I still have a good friend from those days—well, he has not been successful, despite his being devilishly more of a painter than all the daubers with medals and decorations who make you sick."[12]

The *Emperaire,* once owned by the painter Emile Schuffenecker, used to hang in the Jeu de Paume, in a corner. Was this a sign of the marginality of Cézanne's early work? But there is no hiding this scandalous, overwhelming painting, done at the flood tide of Cézanne's abilities—the biggest *image d'Epinal* of them all, a royal jest, a monumental *jeu d'esprit* that conjoins two kindred spirits—the marginal artists of Aix-en-Provence.

The flowered high-backed chair appears for the last time in *Overture to Tannhäuser,* 1868–9 (pl. 39), a witness to Cézanne's admiration for Wagner on the one hand, and on the other, it would seem, for Manet's portrait of his wife at the piano.[13] Cézanne has shown his mother at the right and probably sister Marie at the keyboard. They are not quite alone. The black chair on the left harbors a broad, approving, black-rimmed face of Cézanne: his hair in the topmost rung, his beard in the one below with a smile showing in the highlight, and between the rungs, the slits of the eyes (from the dado) and the nose (contributed by the vertical molding). We remember that he was symbolized earlier by a black stove (pl. 12).

The high-backed chair on the right is unoccupied. What would Cézanne *père* be doing at this family musicale? We do not know that he was

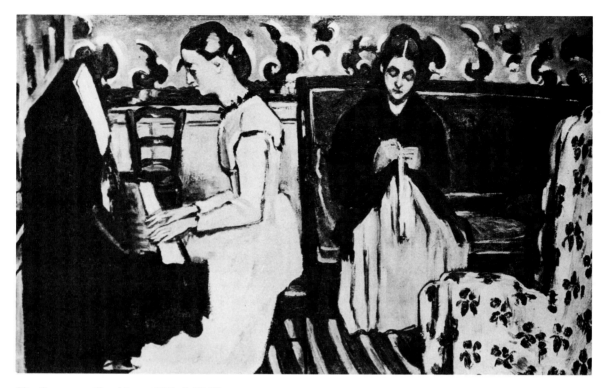

39. *Overture to Tannhäuser*, 1868–9 (V.90)

interested in art. Yet the portraits of Louis-Auguste are noble, and that of 1866 (pl. 29) is in fact majestic. Its close-fitting cap and the hand held in a gesture of benediction strongly hint at the presence of a pope (*papa,* Italian). Indeed, Antoine Guillemet, in a letter to Zola, says of the *Portrait: "le père à l'air d'un pape sur son trône"* (the father looking like a pope on his throne)—an opinion he probably got from Cézanne himself.[14] Gasquet reports that as the artist was showing him the portrait of 1865 (pl. 31), he exclaimed, *"Le papa!"*—surely a Franco-Italian pun.[15] Since he must have had a grudging respect for his father, how are we to account for the disdain embedded in the portraits? This attitude—and it will recur—was unconscious; the striving conscious artist could only ennoble the subjects that engaged him.

Cézanne's private view of his father is, in my reading of the paintings, harsher than it is generally thought to have been, and certainly harsher than that proposed by John Rewald.[16] Rewald's claim that Cézanne admired his father is based on the fact that he did three portraits and five drawings of him, and said, "My father was a man of genius; he left me an income of 25,000 francs." Is this a declaration of esteem or an example of

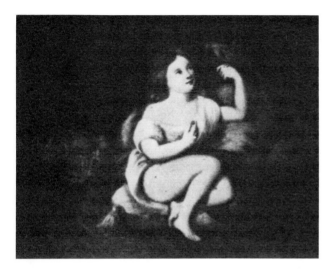

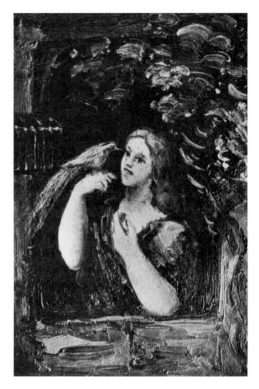

40. *Girl with a Parrot,* 1859–60 (V.8) 41. *Girl with a Parrot,* 1864–8 (V.99)

Provencal irony? And how dependable are the statistics of portraiture as a measure of esteem? Cézanne painted twenty-seven portraits of Hortense, whom Rewald thinks he disliked, and only one of his mother, whom he loved dearly.

After 1876 Cézanne's father never again sat for his portrait, as he seems to have done for the paintings reproduced above. But there are two drawings and a painting that will be shown to be of Cézanne *père* and that have not been recognized as such—because he is without the hat he wears in the works mentioned above—as well as cryptomorphic portraits that are also hatless, all done, we may be sure, from memory. In a number of works Louis-Auguste will be shown to be symbolized by a pear or by other means. If, as I think, Cézanne had the opposite of esteem for his father, this is not to say that he disregarded him. His father's large place in his imagination is indicated by the fact that he appears or is implied in more than ten works besides those Cézanne did from life.

46

The cryptomorphic birds of the *Emperaire* are the last images of birds that Cézanne was to paint for many years. But it is surely significant that one of his earliest pictures, *Girl with a Parrot,* 1859–60 (pl. 40), shows a seated

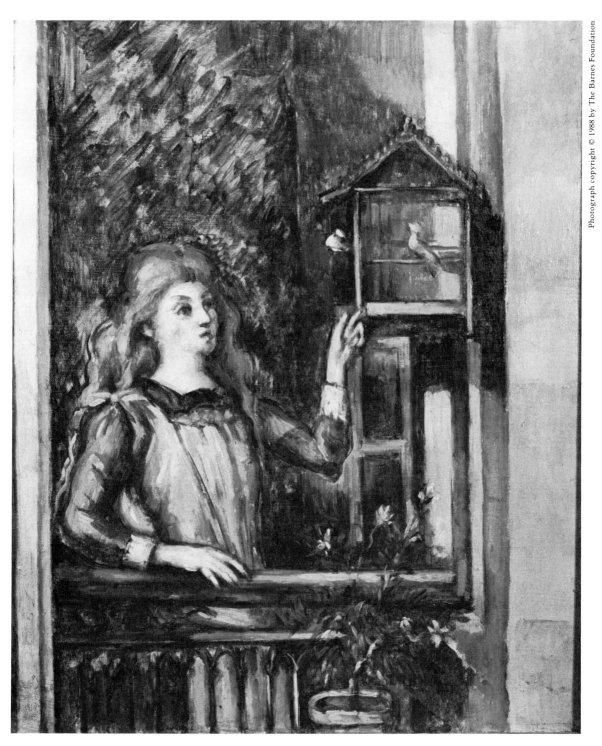

42. *Girl with a Parrot,* ca. 1867 (V.98)

child who looks up admiringly at a parrot resting on her hand; further-more, at the time of the *Emperaire,* probably just before painting it, he did a second and third *Girl with a Parrot,* (pls. 41, 42). The parrot (*perroquet*) would seem, like the bird, to have a phallic connotation. And in Farmer's erotic dictionary we find, at *perroquet:* "The *penis*" [Rabelais], and "*Elle m'a prêté sa cage / Pour loger mon perroquet*" (She loaned me her cage / To lodge my parrot in; Gautier-Gargouille).[17] The girl in these dreamlike in-ventions progressively diminishes in size as her nudity disappears under clothes. The parrot is high in the first picture; in the second it is lower, beside a cage, and the girl holds a cherry for it; and in the third it is caged, having achieved its symbolic destiny.[18]

Prompted by this series, we reexamine the *Emperaire* and see that its cryptomorphic birds have elaborate tails—the fingers—and therefore could be parrots. We imagine that Cézanne, rather than depicting a small bird with dull plumage, chose one with a notably erotic connotation, in French at any rate, and one whose name, moreover, begins with a *p,* like his own. The transposition of the parrot from paintings showing female admirers to a portrait of a male friend cannot but have homoerotic impli-cations. It will be a long time before birds again serve as subjects for Cézanne: in a painting of ca. 1888, a swan (*cygne*) is a large and curiously fragmented presence in the company of Leda (V.550); a peacock (*paon*) appears in a decoration of 1892–4 (pl. 59).

The Donkey in Cézanne *three*

If Cézanne himself, his family, and his friends are manifest in the many portraits he painted, they can be present as latent subjects in the other pictorial genres—landscape, still-life, and figure composition. In these they may be portrayed cryptomorphically or take on symbolic existence in faithfully rendered objects, as in the sugar bowl/mother identity. But these two devices do not exhaust the ways in which Cézanne can covertly show or imply identifiable human subjects. There is at least one case in which he introduces a visible and significant portrait, unrecognized because of the unexpected context. He also employs both actual and cryptomorphic letters to refer to Zola. And one of his frequent devices for signifying a human subject is the donkey (*âne*).

Cézanne's family name sounds like *seize ânes* (sixteen donkeys), and alternatively like *ces ânes* (these donkeys), simple puns that were recognized and used by the citizens of Aix.[1] As a child Cézanne misspelled his name in a way that may indicate a mental association with the donkey: *Cezane*.[2] The animal is present in an early work, *The Visitation*, 1860–2 (pl. 43), a small primitive picture crowded with arcane imagery and showing the Virgin Mary and an angel; below them is the inscription "*La mère des 7 douleurs*." The scene surely reflects a family situation, with the *mère* as *his* mother, the almost bald man as the father, and young Cézanne seated on a donkey.

I have already mentioned the Latin pun on his name, "Paulus Cezasinus," with which he signed a letter to Emile Zola when he was twenty. Cézanne's childhood friend was enough aware of the pun to have made it the point of a story in his first collection of tales, *Contes à Ninon* (1864). In "Les Voleurs et l'âne" two young men argue, during an outing in the country, over the affections of a girl who for the last hour has been off in the company of Léon, another member of the party. Léon, becoming

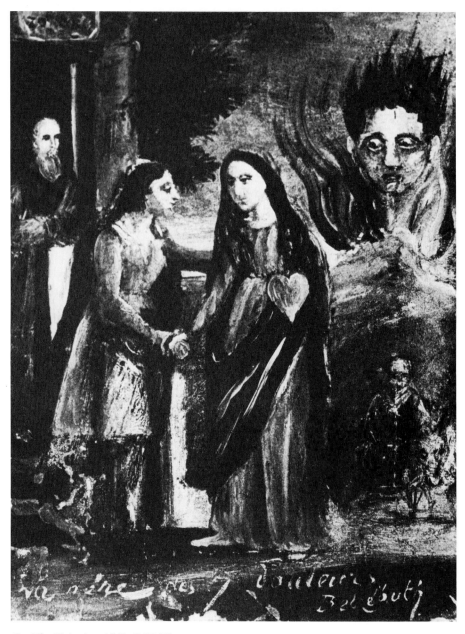

43. *The Visitation,* 1860–2 (V.15)

aware of the foolish debate, which the fifth member of the party has compared to La Fontaine's "Les Voleurs d'âne," shouts, "The comparison is *galant*. These gentlemen are thieves, and madame is a . . ." The girl kisses him, the kiss smothering "the ugly word." It would have been *âne*. Her name is *An*toinette.

If Cézanne's schoolmates often reminded him of the resemblance be-

tween his name and that of the beast of burden, his attention to the animal was given a more imaginative dimension by a book he studied in Latin at the Collège Bourbon: *The Metamorphoses* of Lucius Apuleius, popularly known as *The Golden Ass* (*L'Ane d'or*). This second century novel of perennial charm recounts the story of a man transformed into a donkey by magic and his many adventures before returning to human shape. The book, surely in its original language, was a favorite of Cézanne's, and Gasquet tells us that he would dip into it between the poses for *Old Woman with a Rosary* (V.702).[3] We may suppose that he considered the tale—in which the hero arrives at self-realization after a long ordeal as a donkey—to be a parable of his own life, and that a donkey in his paintings, whether manifest or cryptomorphic, is symbolic of himself.

The Thieves, 1869–70 (pl. 44), seems to have been inspired by an episode in *The Metamorphoses* (chapter 25, book IV), without being an illustration of it. In placing a donkey in the middle of an open space surrounded by a swirl of activity both human and pictorial, Cézanne has created a metaphor of his own isolation, not only in the world of art, but in society at large. We see little more of the donkey than its rump; its head is visible on its right side. Though the animal's buttocks have been rendered with obvious relish and made the rivetting focus of the painting, the shocking nature of the image has been overlooked in the high-minded respect paid to the precursor of cubism. *The Thieves* was painted soon after the *Emperaire,* with the same loaded brush and in the same spirit of scandal. The donkey is a defiant, iconoclastic self-portrait of the artist. It mocks the observer, seeming to declare, "So Cézanne is an *âne!* Well, *baise mon cul!*" He was always capable of coarse language, and such an expression is imaginable in view of the obvious donkey's tail (*queue,* a homophone of *cul*).

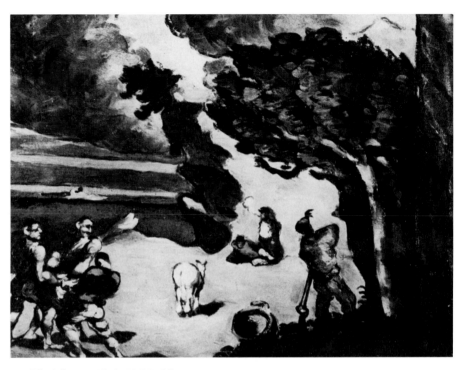

44. *The Thieves,* 1869–70 (V.108)

Apuleius' novel would seem to have had a great influence on Cézanne's imagination apart from its donkey component. The book is the *locus classicus* of the myth of Cupid and Psyche, the longest of the many tales in the book, and the stimulus of at least two drawings by Cézanne. It may well have caused him to pay special attention to *Psyche Abandoned,* a sculpture by Pajou in the Louvre on whose base is inscribed: "*Psyche Perdit L'Amour En Voulant Le Connaître.*" In our drawing (pl. 45) the hair that falls on the shoulder at the left makes an excellent cryptomorphic head of a dog or wolf biting that shoulder. Psyche is suffering from remorse (*remords*) and the animal bites (*mord*) her. Psyche is, besides, a surrogate for *Paul* Cézanne, and is identified as such by the shoulder (*épaule*) that is bitten. We shall come on other instances of Cézanne represented as a woman and identified by a shoulder made noteworthy by one means or another.

Though the fact lies hidden in our drawing, Cézanne was burdened for years by a sense of remorse. Gasquet recalled that Cézanne recited a quatrain from Verlaine one evening in the late 1890s:

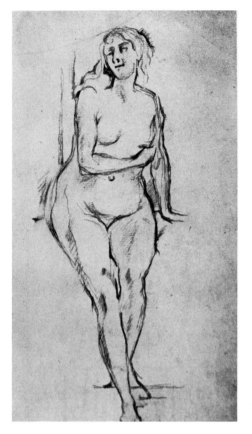

45. *Psyche,* ca. 1876 (not in Chappuis)

Car dans ce monde léthargique
Toujours en proie aux vieux remords
Le seul rire encore logique
Est celui des têtes de morts.[4]

(For in this lethargic world, always prey to old remorse, the only laugh that still is logical, is that of the death heads.)

The many skulls Cézanne painted always contained a reference to himself (*crâne—Cézanne*); their mention by Verlaine in the context of remorse struck a sympathetic chord. The hidden imagery and pun in the drawing of Psyche are neither gratuitous nor accidental. Cézanne's recognition of the emotion that invades Psyche was expressed in the drawing by a hidden image—thought and image being linked by language. We may well ask whether, apart from being attracted by the sculpture because of his familiarity with *The Metamorphoses,* he was drawn to it by his own predicament. Had he lost love in wanting to know it? The expression on his face in another drawing of Psyche (pl. 46) achieves a sense of remorse directly, without recourse to metaphor. And especially so since Psyche, appearing

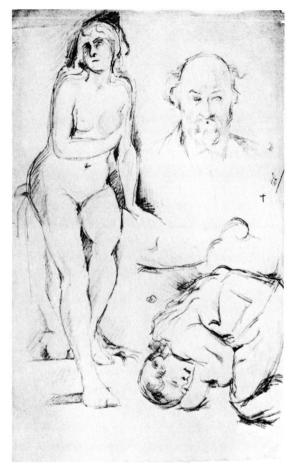

46. *Psyche,* on a page of
studies, ca. 1876 (C.363)

on the same page with himself and his son, becomes an image of Hortense.

The Metamorphoses, which Cézanne knew since his schooldays, did more than reinforce his sensitivity to the idea of the donkey and awaken him to Psyche. It was the early and abiding model of a metamorphism that was to be in his thought throughout his career. We will find Cézanne himself metamorphosed into a number of states other than those of a donkey and a woman. The pervasive ambiguity of his imagery, his systematic brushstroke after about 1875,[5] and his elision in the rendering of form, all facilitate metamorphosis; the process is perhaps most evident in his constant transformation of the art of others to his own ends.

The next occurrence of our symbolic animal is in a work traditionally

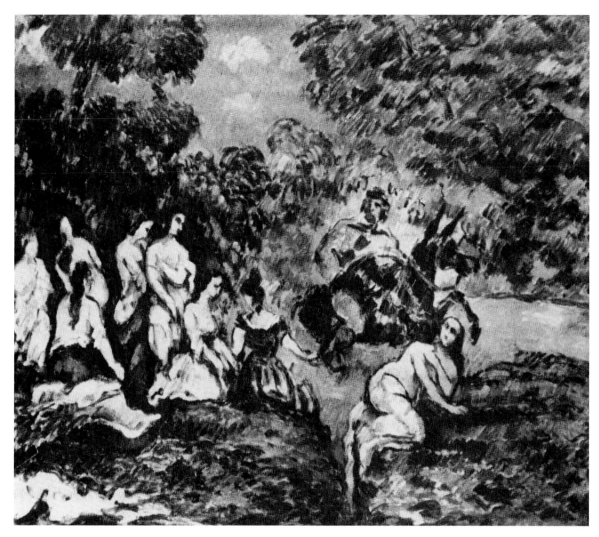

47. *Sancho in the Water,* 1873–7 (V.239)

called *Sancho dans l'eau* (*Sancho in the Water*), 1873–7 (pl. 47). It shows a rider on a donkey walking to the right in a stream. On the near shore of this stream, which goes across the picture, we see some women in various states of undress. A group is at the left; at the right a single woman reclines on the ground, nude but for a garment over her legs. She is close to a narrow creek (*anse*) which runs up from the lower edge of the painting into the stream and separates her from the others. Since the donkey is emblematic of Cézanne, it is of interest that its bent foreleg is so situated (when considered graphically) as to be directly over the head of the woman apart—the interest residing in the fact that Hortense is constantly symbolized in the oeuvre by one or both arms bent over the head. The *anse* is a second indication of Hort*ense;* these two elements will be asso-

55

ciated repeatedly. *Anse* as pronounced by Cézanne contains the sound of *âne* and thus an echo of both his own and his lover's names.

The title *Sancho dans l'eau* is of course an allusion to Sancho *Panza*. We shall find that the syllable *pan,* which includes the sound [an], is a key term in Cézanne's symbolic system, appearing in many other contexts, sometimes in association with a donkey, always with reference to himself. The women at the left, who number seven, are surely "the seven sorrows." One in the group points to the solitary woman at the right who must be "the mother of the seven sorrows" of plate 43, and symbolically Cézanne's mother. Her position on the right is one that the mother will often have; she will wear white again; and in three other works will have her back to Hortense or a symbol for her, as the *anse* is here. In placing the donkey's bent leg over her head, Cézanne seems to be attempting to assimilate her as Hortense, as his lover.

In *Harvest,* 1875–6 (pl. 48)—which calls to mind a work on the same subject by Poussin, an artist Cézanne never ceased to admire—a donkey stands at the extreme right. In the middle of the painting is a large cryptomorphic head of a woman facing slightly to the left. Its eyes, which look out at us, are the two dark clumps of trees on the horizon line; its nose materializes from the man with the scythe; its lips are the trousers of the figure lying prone; its chin is cut off by the lower edge of the painting; and a series of haystacks helps to define the cheek. The image is unstable and may best be seen by squinting; it is Daliesque in its assimilation of all kinds of pictorial matter. There is no reason not to think it is Hortense, who faces to the left, while the donkey, on the far right, faces the other way: the painting may register a period of discord between Hortense and Paul. The farmers are cutting hay (*foin*), which the rhyming *âne* awaits.

A fresh evidence of the consistency of Cézanne's symbolic system re-

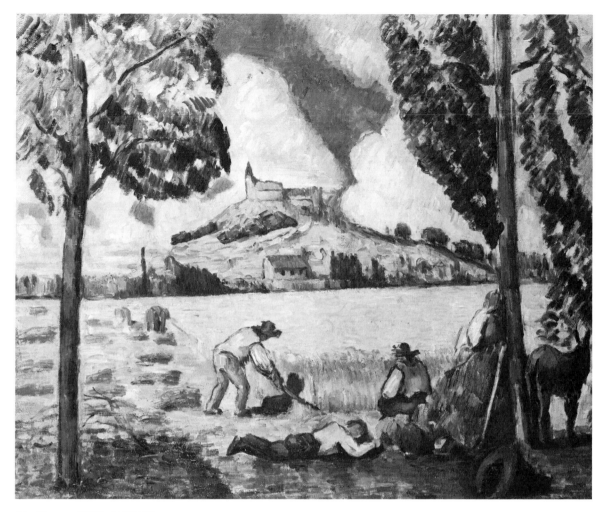

48. *Harvest,* 1875–6 (V.249)

sides in the fact that in *The Thieves, Sancho in the Water,* and *Harvest,* which have been examined in what I consider to be their chronological order,[6] the donkey appears first at left of center, then at right of center, and finally at the extreme right. This movement to the edge of the painting and the gradual reduction in size suggest the phasing out of the animal, and in fact it never again appears as a manifest image. From this point forward, as I believe, its existence is cryptomorphic; nor have I detected a cryptomorphic donkey in any work prior to *Harvest.*

The first "hidden" donkey may be discerned in *The Temptation of Saint Anthony,* 1874–5 (pl. 49). The large head faces to the right; its forelock and profile are supplied by the central tree; the black bird is its eye; its nose and mouth absorb the upper part of the child in front of the Temptress. The donkey appears to sniff her gown. With her arm bent over her

57

49. *The Temptation of Saint Anthony,* 1874–5 (V.240)

head, she is in the pose of Hortense, as we shall see. And since Saint Anthony (*Antoine* [an-twan]) as well as the donkey is symbolic of Cézanne, he can have it both ways: as saint he openly recoils from the naked woman, as donkey he approaches her lustfully and in secret.

A similar donkey head, facing the same direction, is imbedded in the hill behind the figure in *Man with a Jacket,* 1875–6 (pl. 112). The presence of the donkey tells us that this man is a disreputable persona of the artist.

Still-life with Bread, 1879–82 (pl. 50), contains a portion of a loaf of bread (*pan,* Provençal, with the *n* pronounced). This loaf is unique in being cut; in spite of the kitchen knife present in many still-lifes, every other loaf of bread, every cake and biscuit in the oeuvre is shown whole. The *pan* is an excellent effigy of a donkey head with the top of the cranium sliced off at the left. It has an ear in the pointed feature that rises near the slice; to the right of this is a very serviceable eye in a fold of the crust, and

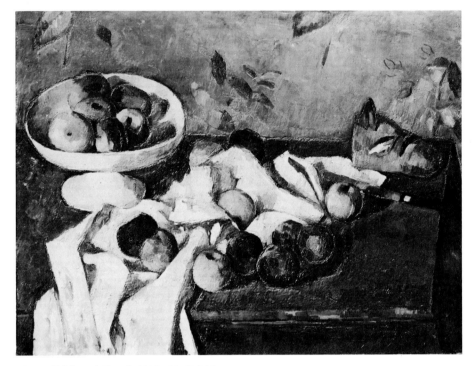

50. *Still-life with Bread*, 1879–82 (V.344)

so forward to the muzzle on the right. In this case, *âne* is in *pan* both graphically and phonetically. On the left of the loaf, the tablecloth is arranged in a vaginal fold; further to the left are apples (symbolic of Hortense, as we shall see). Since the *âne/pan* faces away from them, we may suspect another family drama as the hidden subject of the painting, although the phallic knife[7] is directed to the obvious feminine motif.

Immediately to the right of the head of Victor Chocquet in two portraits of this patron of Cézanne (pls. 51, 52) is a head of a donkey in the painted picture frame; the cryptomorphic image faces slightly to the right and is clearer in the second portrait. Chocquet's pose has been described by Rewald as "*à dos d'âne*" (on donkey back).[8] Since Chocquet commissioned the portraits and a still-life, which were painted in his home, it is possible that Cézanne conceived himself to be working like a donkey for his patron.[9]

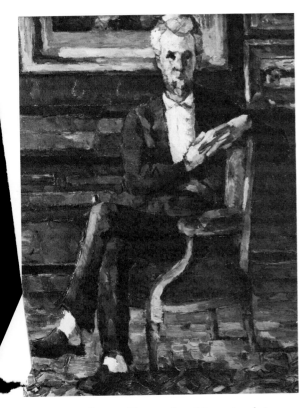

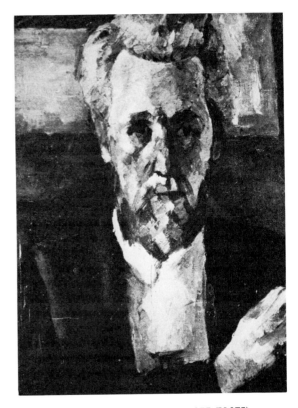

51. *Portrait of Victor Chocquet Seated in an Armchair,*
1877 (V.373)

52. *Portrait of Victor Chocquet,* ca. 1877 (V.375)

There is a cryptomorphic donkey, facing right, in the pale background on the left of *Woman with a Furpiece,* 1879–82 (pl. 53), sometimes thought to be a portrait of Cézanne's sister Marie.

The large presence of a donkey head in *Pines and Rocks,* ca. 1899 (pl. 54), hovers between the first and second of the three tall tree trunks that divide the pictorial space. The animal seems to be looking at something near the large rock at lower right. Directly above this rock and behind the two tree trunks that rise from it we may discern the hidden embrace of a man and woman; their faces interlock in the space between the trees (fig. 4). While the woman is in profile, she is also shown frontally, with an eye, two nostrils and mouth visible just above the rock. The man's profile, which fits into the woman's, continues upward to become a bald skull. To the right of the bridge of his nose is an almond shape, reserved by a pale edge, which is his eye; this clearly defined shape is not otherwise

53. *Woman with a Furpiece,* 1879–82 (V.376)

intelligible in the setting. The man is hunched over the woman, his left arm passing alongside the "eye" before embracing her; below the arm appears a breastlike shape. It does not seem to me that Cézanne is here picturing an episode of lovers encountered in the woods. I think rather that he shows himself in his donkey persona looking at an episode involving himself. This supposition is sustained by the fact that the donkey's muzzle and the woman's head overlap, and that the man in the embrace is bald, like Cézanne. I cannot resist the further conjecture that the passionate scene was not imagined, but that it recorded an actual event.

Cézanne made several copies after Delacroix and eventually owned two of the originals. One of these was *Hagar in the Wilderness;* he painted his version of it in 1899 (pl. 55). If he had copied an etching by Van Ostade because it pictured his *"idéal"* of family life (as Schapiro has shown),[10] in similar fashion his deep reasons for copying the Delacroix sprang from its

61

54. *Pines and Rocks,* ca. 1899 (V.774)

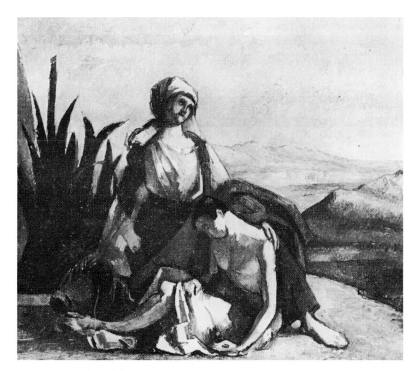

55. *Hagar in the Wilderness*, 1899 (V.708)

content rather than its formal qualities. The painting shows the discon-
solate mother and her son Ishmael in the desert, and Cézanne was surely
moved to copy it because, among other things, the biblical text that in-
spired it has the Lord say to Hagar (Genesis 16:12): "*Cet enfant sera comme
un âne sauvage; sa main se lèvera contre tous, et la main de tous contre lui, et il
placera sa tente en face de tous ses frères*" (This child will be like a wild don-
key; his hand will be raised against all and the hand of all against him; and
he will pitch his tent opposite those of his brothers). The whole passage
would have seemed to Cézanne to describe perfectly his opposition to the
painters of his time and his isolation from them, especially telling would
have been the characterization "*âne.*" We see too that Hagar's left hand is
on Ishmael's shoulder (*épaule*), a sign for *Paul;* her right arm falls over the
back of a small cryptomorphic donkey that faces him. She thus makes a
graphic, if "hidden," equation of Cézanne and donkey.

 A very clear and pretty head of a donkey foal floats in the elaborately
broken sky of the late *Landscape from Les Lauves,* ca. 1906 (pl. 56). The
image materializes in a patch of sky (*pan de ciel*) to the left of center, and
constitutes a third example of the *âne/pan* conflation. The young donkey
(*anon,* French; *aset,* Provençal), making an appearance late in the oeuvre,
refers, as I think, not to Cézanne but to his son. Its presence in the sky is

63

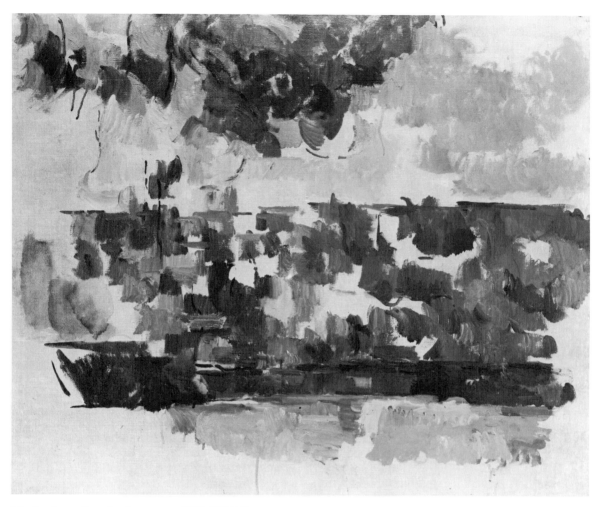

56. *Landscape from Les Lauves,* ca. 1906 (V.1610)

the result of the artist's long (unconscious) effort to elevate the humble animal, an undertaking that will culminate in its—and his own—transcendence in a sacred emblem of his son.

It is remarkable, finally, that all painted images of the donkey, both manifest and cryptomorphic, twelve in number, face to the right; yet in Cézanne's drawing of a donkey after Pisanello (C.491), and in two drawings from nature (C.531, C.532), the animal faces to the left. The astonishing regularity of his many inventions is surely not accidental and surely significant. Since the donkey is a troubling image, we may expect other matters on the right, and looking to the right, also to be troubling.

It has not been remarked that Cézanne's *Uncle Dominique* (pl. 2) was probably impelled by Manet's *La belle andalouse* (pl. 57). This work was done early in 1865 and was listed in the inventory of Manet's studio made

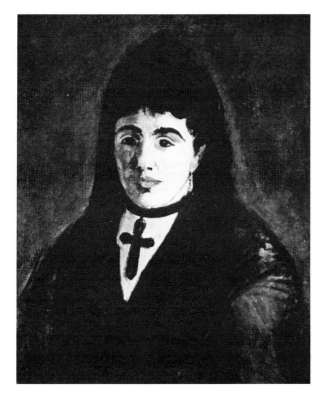

57. Edouard Manet, *La belle andalouse,* 1865

at his death in 1883. So it is likely that Cézanne saw it when he visited Manet in April 1866. He was in Aix from August to December. A "little later" than some time in October, Valabrègue writes to Zola about Cézanne's painting: "The uncle is more often the model. Every afternoon there appears a portrait of him . . ."[11] And indeed *Uncle Dominique* is one of nine portraits done at this time with the palette knife. The unusually large pendant cross on the woman's bosom in Manet's portrait would have caught Cézanne's attention, as well as the brilliant use of black, a color he himself favored. *La belle andalouse* must be added to the growing list of Manet's works that the paintings of Cézanne reflect and reflect upon. In his *Uncle Dominique* the cross is pinned to the painting by a pun. And *La belle andalouse* was probably pinned to his mind by another verbalism: the potent syllable [an] in the noun that names its subject. We may suppose

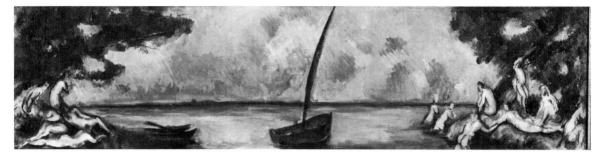

58. *Decorative Painting*, 1890–4 (V.583)

59. *Decorative Painting*, 1892–4 (V.584)

that the same sound in the title of Wagner's composition provided a secret stimulus to *Overture to Tannhäuser* (pl. 39).

Apart from its echo of *âne* the syllable [an] persists as a reference to Cézanne particularly in the sound [pan]. This is strikingly demonstrated by a pair of exceedingly broad decorative panels Cézanne undertook to paint for Chocquet. One, a watery scene, 1890–4 (pl. 58), shows a cove (*anse*) in the foreground opening into a wide body of water beyond; on the bank at each side is a group of female bathers. In the middle of this strange, still painting stands a boat, isolated, defiantly phallic, its sail furled: it is *en panne* (lying to). The other panel (pl. 59) presents a parklike space occupied by unusual objects and fanciful creatures. At center is a large bathtub on whose rim is perched a peacock (*paon* [pan]). Cézanne seems to have been engaged in the curious exercise of establishing a [pan] in two quite dissimilar *panneaux*.

66

On a drawing of about 1877 (pl. 60) after Barye's sculpture *Jaguar Advancing*, Cézanne has put on the animal a face that resembles his own. We may imagine a number of reasons why he did this, but the compelling one was, I think, verbal. Although Barye called the animal *jaguar*, it is more

60. *Jaguar Advancing,* after Barye, 1877–80 (C.482)

often called *panthère* in France. Cézanne probably thought of it this way and was attracted by the syllable *pan.*

Our *pan* can subtly invade situations that seem exempt from the erotic. In many portraits of Hortense and other fully clothed women, the skirt front (*pan de jupe*) is prominent, even elaborate. In thirteen portraits of Hortense her hands are shown on her lap (*pan*). There are, of course, other ways to pose a woman, and Cézanne uses them. But it must be significant that in half of his studies of Hortense he should emphasize a *pan,* with its inevitable reference to himself, here intimately related to an essentially sexual part of the body.

Manifestations of the enterprising syllable include, so far, Sancho Panza, *pan de ciel, pan* (Provençal), *en panne, paon, panthère,* and *pan de jupe.* It will soon appear four times in a single painting and will be shown to play an important part in a long series of later works. We can only ask why Cézanne is so attached to this syllable, apart from its containing the sound [an], why it finds its way into work after work, using up all the orthographic forms of the sound in French. The conclusion is inescapable that in a deep sense Cézanne, painter of the Provençal landscape, carrying easel and canvas up hill and down dale, identified himself with Pan, god

67

61. *Nymphs and Satyrs,* 1864–8 (V.94)

of the woods and fields, satyr—part man, part goat, personification of the instincts and natural forces. His identification with Pan would only have been strengthened by the fact that the Greek for "goat" is *aix*.[12] He painted satyrs in only one canvas, at the beginning of his career (pl. 61), but Pan seems to have been a constant preoccupation, appearing on all sides, suffusing all forms.

The Secret

Long considered one of the great works of Cézanne's early period, *The Railroad Cutting* is customarily the object of analysis that seeks to understand the picture's place in the (always formal) development of his art. Examination of the painting with the tools used in this book shows it to be a rich work of the imagination, in a way not usually expected of a landscape painting, and never of one by Cézanne.

The subject was situated a kilometer from the family estate, on the outskirts of Aix. Cézanne made a drawing and a small oil study of it before painting the large picture. The drawing, ca. 1870 (pl. 62), displays a variety of pencil and pen marks in a full range of touch and "color" that dazzlingly evoke the elements of the scene. Nowhere is Cézanne's *tempérament* more evident; in this small early work he is an expressionist *avant la lettre*. The two paintings (pls. 63, 64) share many features but also exhibit several differences—especially in the rendering of the cutting—that will enable us to understand the evolving, secret significance of the two works.

It is possible to discern in the early painting (pl. 63) a large reclining female figure; not the torso often sensed in an undulating landscape, but a series of figural elements arranged in a reasonably figural order. The house would be its head—an appearance reinforced by the placement of the windows and door which hint at eyes and a mouth. In front of the house are two mounds of earth which serve as the breasts. The hillock on the right looks like the bent knee of a left leg; the long string of forms in the foreground serves as an extended right leg. The depression between these legs would be the pubic region. (The drawing may be read in much the same way.) The French title of the painting is *La Tranchée* (ditch or trench). In the womanly configuration that I have described *la tranchée* may be understood as the female genitalia. We hardly require the con-

62. *The Railroad Cutting,* ca. 1870 (C.120)

63. *The Railroad Cutting,* ca. 1870 (V.42)

firmation of the *Vocabula Amatoria,* where *tranchée* is glossed as "the female pudendum; the 'trench.'"

In the later work (pl. 64) the house is more physiognomic than before, with the windows and door so rendered as to give it now a look of surprise. This version is dominated by a rounded hillock sliced through by a clean cut. We see the flat inner surface of one side of the cutting; the edges of both sides are bordered by a series of short posts whose staccato progression accentuates the curvature of the earth. A photograph of the site, taken in the 1930s, shows these posts to be short twisted saplings.[1] The "legs" of the first painting are not present, yet there is a residual sense of

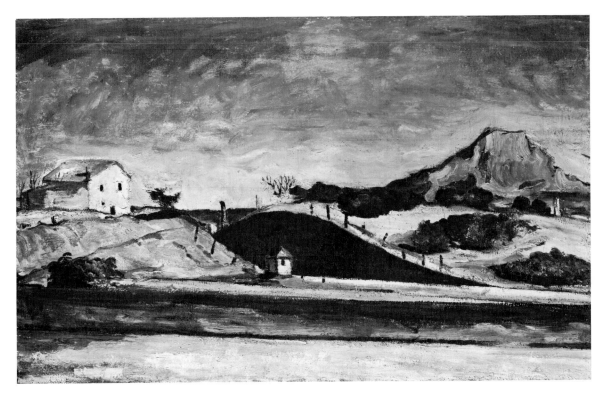

64. *The Railroad Cutting,* 1871 (V.50)

them in the prolonged curve of the cutting on the right, and below in the long, straight element that goes across the picture.

This feature, new to the later version, spans the scene and suggests continuation at both ends. In spite of its length and importance it is curiously ambiguous, but it finally resolves itself as a retaining wall, separating a narrow foreground from the cutting and the vista beyond. This would be the wall that went around the Cézanne estate; the cutting is thus depicted as though seen from within the estate, although it is a half-mile away. The French term for this enclosing wall is *enceinte,* a word that throws light on the significance of the painting since it has a second meaning: "pregnant." Now, Hortense Fiquet, the artist's companion, bore a child, Paul, on January 4, 1872; she would then have been pregnant in April 1871. She and Cézanne had met in Paris, probably late in 1869. They spent the latter half of 1870 and the early part of 1871 at L'Estaque, overlooking the Mediterranean, having gone there as the Franco-Prussian

71

War erupted. During their sojourn of almost a year Cézanne made occasional visits to Aix, some fifteen miles away.

While the *enceinte* delimits the Cézanne estate below, it serves as something like the sign of the scene above it. For the *tranchée* condenses the female genitals and the womb, in a painting that gives evidence of Hortense surprised by her pregnancy. In both the drawing and the first painting the *tranchée* is occupied by a small railroad hut and a number of vertical signposts and structures; in the later painting all the phallic furnishings are absent from the *tranchée*—only the railroad hut remains, now prominent and focal. Since this hut is a small version of the house that represents the head of Hortense, we may consider it to stand for the fetus in the womb. Such a reading would be confirmed by the swelling form that envelops it and is bloodred where it touches the hut.

Although the *tranchée* is now free of phallic elements, a phallus is present elsewhere in the painting. It is almost indistinguishable in a reproduction, but there is no difficulty in seeing it in the original, in the lower left corner. This configuration, which points to the left, is created by a thick ocher impasto, at the same time that it all but merges with the similarly colored ground on which it lies. Whereas in a reproduction it merely looks like a brushstroke if it can be discerned at all, on the canvas it is perceived in clear relief and has the dimensions of the male organ. In pointing to the left it is like the symbolic phalluses in plates 6 and 50, and like those in two other works (pls. 66 and 70) that follow *The Railroad Cutting* in a matter of months. In the present case it lies beyond the object toward which it is usually directed—a representation of Hortense—and furthermore is separated from that object by the *enceinte*. If the painting is a metaphorical image of Hortense's pregnancy, it also seems to give evidence of a Cézanne who is sexually deprived by that pregnancy.

Certain works of 1869–72—that is, from the end of what Kurt Badt called an "angry" phase to the beginning of an Impressionist phase under the guidance of Pissarro in Pontoise—have often been recognized as different in character from the paintings that bracket them, as transitional, and inexplicably so. I propose that a large part of the explanation is the changed nature of Cézanne's existence: in those years he met Hortense, lived with her, and had a child. The intensity of his feelings during this period resulted in a remarkable series of still-lifes which, as I will show, reflect the presence of Hortense and the child. Among the works of 1869–72 the second version of *La Tranchée* is by far the largest; Fritz Novotny, who noted its "bulky weight," thinks it "perhaps the most significant work of Cézanne's early period."[2] Significant, in my view, in showing that when Cézanne was "expressionist" he was not simply embarking on a stylistic venture but expressing strong emotion aroused by the condition of his life.

In making the picture's first version the painter would have been stationed on the ground, facing the cutting. Since the later version shows a retaining wall, the *enceinte,* and since this is about seven feet high, he painted as though looking over it and down at the cutting from a high point within the Jas de Bouffan—the top floor of the manorhouse, the third, where Cézanne had a studio. From it he could not see the cutting, which is to the south. We are looking in a northerly direction in the painting, and indeed only in facing north at the Jas or at the cutting could Mt. Sainte-Victoire, some fifteen kilometers distant, be on the right. Just discernible on the far right is the tower of Saint Sauveur Cathedral, in Aix. From the cutting or the Jas, west of the town, no view is possible in which the mountain could appear to the left of the cathedral, as in the painting; the mountain is much further to the right, to the east. Not only has Cé-

zanne pulled it into the painting, he has introduced in the middle of the work a body of water that looks like the blue Mediterranean, actually thirty kilometers to the south, behind him. In brief, he has rearranged the topography of the region, apparently in order to include reminders of a romantic year spent with Hortense. This digression on the orientation of the scene should make it evident that the light in the painting, as we can see especially clearly from the shadow cast by the railroad hut, comes from the right, thus from the east, and is therefore the early morning light.

The anatomical allusion in the word *tranchée,* which is central to an interpretation of the painting, may be disturbing to the accepted idea of Cézanne as a pure painter. But it should be recognized that this usage is imbedded in French popular speech. The case of *La Tranchée* is far from unique in the oeuvre, where we find countless instances of verbal play, often coarsely erotic. The association of *tranchée* with Hortense's pregnancy helped the painter create a work of rude graphic power, expansiveness, and vitality. It is reasonable to suppose that Cézanne, a man easily excited even by small matters, was fairly galvanized by the prospect of becoming a father—and, as we know, he later doted on his child. In this vigorous canvas a cloudless sky rises over the *tranchée.* Pale in its lower reaches and merging to a full blue above, it is a sky at dawn, at the break of day.

This painting can reasonably be dated to 1871, a date that would account for the features to which I call attention and that associates it with a series of still-lifes also related to Hortense and her child. Its size and its viewpoint, as we have seen, indicate that it was painted indoors, that is to say, in the house at the Jas de Bouffan. On June 19 Paul Alexis, who had looked for the lovers at L'Estaque, wrote to Zola, "The two birds have

65. *Allegory of the Republic,*
1871 (C.198)

flown away—a month ago!"[3] That would be about May 19, a time when
it is likely that the couple was aware of Hortense's pregnancy. The record
from here on is meager—a letter from Cézanne is lost—but his friends
didn't find him till July. Paul and Hortense must have moved about Prov-
ence for a few days, after which he went to the Jas and was working in his
studio by the end of May, having sequestered Hortense somewhere in the
neighborhood. In any case, she went to Paris before he did; he arrived
there by the end of the summer.

Work on *The Railroad Cutting* would then coincide with the suppres-
sion of the Paris Commune, where resistance ended on May 28. So moved
was Cézanne by the ending of France's ordeal that he at once made a
pencil sketch and a watercolor to herald the bright future. The drawing
(pl. 65) shows a nude woman with a flag in her left hand, her right hand
raised as she greets a radiant sun coming up behind a mountain very much
like Sainte-Victoire—fitting symbol of the victory of republican France.
For Cézanne, a republican and about to be a father, *The Railroad Cutting*
celebrates the dawning of a new day on the political as well as the personal
horizon.

The landscape was followed by *The Black Clock,* 1872 (pl. 66), a work of
extraordinary force that belies its modest size and unassuming subject.
Behind its realistic facade lurks an intense, muted drama depicted by
brushwork of surprising variety. Among the disparate elements of the
still-life, only the conch shell, with its outrageously red lips, is not com-
monplace—is, indeed, exotic.[4] Yet the clock, lacking hour and minute
hands, achieves a brooding presence, while the great expanse of white
cloth and its stark folds suggest a screen on which a cryptic message has
been projected. By their size and placement, the clock, conch, and table-

66. *The Black Clock,* 1872 (V.69)

cloth dominate the pictorial space, remaining unflinchingly enigmatic.

Cézanne thought highly of the work; he gave it to Zola, in whose house it was painted early in 1872, and wanted it included in the Impressionist exhibition that was planned for 1878 but never took place. In a career during which it has been in several distinguished collections, the picture has attracted universal admiration. A curious feature of this attention is the fact that although most viewers see the conch as flagrantly erotic—suggesting the vulva—rarely has anyone said so in public.[5] The general diffidence in this case would seem to arise less from reasons of modesty than from the fact that the intuition of erotic significance in a single element has not led to a revelation of the picture's significance.

Although appearing to be a work of great realism, *The Black Clock* includes several nonrealistic features that leap to the eye, as well as a number of others that do not. One of the former is the serpentine fold in the cloth to the left of the lemon: it seems to have been invented rather than observed. Another, below the lemon, is the compact cluster of cloth that comes forward rather than lying down on the mantelpiece as it should.

67. *The Black Clock,* reversed

Still another is the extraordinary configuration at lower left, a region that should show nothing but a large full drape of the tablecloth. If the painting presented no other formal or thematic oddity, this elaborate motif alone would lead us to suspect that *The Black Clock* is not a straightforward rendering of a group of objects.

On the starkly lighted tablecloth in the middle of the painting is an unexpected feature—a reversed *F*—created by a knifelike shadow and two thin folds progressing from its tip and its left side. The lower fold seems natural, that is, likely to occur this way in cloth; the wiggly portion of the upper one seems invented, forced, characteristically overdetermined. In making this large sign, Cézanne emblazons his work with the initial letter of *Fiquet,* the name of the woman with whom he is living, at the same time censoring, concealing, mitigating its presence. The accommodation of this (unconscious) device to the relatively naturalistic context is ingenious: we have only to reverse *The Black Clock* (pl. 67) to see that a large, central and correctly oriented *F* would immediately be apparent and would surely have been intolerable to Cézanne.

77

Pursuing our intuition that the painting, like so many others in this period, betrays his preoccupation with Hortense Fiquet, we discern her presence in the large conch. This arresting object, a creature from the sea, could have been for Cézanne a reminder of his recent ten-month stay with Hortense, much of it spent at L'Estaque. The shiny inner surface and red lips of the shell have made it a commonly accepted emblem of the female genitals (*conque:* "The female *pudendum;* 'the shell'"),[6] the French slang for which, *con,* occurs at the beginning of *conque.*

On the other side of the painting looms the black clock, in which it is possible to recognize the presence of Cézanne himself. The clock's physical solidity is like his own, as is its coloration. When compared with a photograph of Cézanne of the same period (pl. 68), its round white face surrounded by black is a very good approximation of the artist's face and bald skull framed in their black beard and heavy black fringe. If the clock is regarded as continuous with the short columnar shadow below it and the large dark area below that, the three forms together suggest a head, neck, and shoulders, with the head straining in the direction of the conch.[7]

The positioning of conch and clock establishes a left/right symmetry of size and importance befitting the picture's chief protagonists. Symmetry is maintained by a verbal/visual pun on the right that balances the wordplay on the left. The French for "clock" is *pendule.* Cézanne himself had the curious nickname "*Le Pendu*" (The Hanged Man) in an artists' circle that met in the home of the collector Dr. Gachet at Auvers in 1873,[8] and at that time signed an etching (V.1159) with a small hanged man. This date is a year later than what I take to be the date of the painting, and would seem to eliminate the possibility of the pun I find in *pendule.* But we don't know when Cézanne acquired the nickname. Why, in any case, was he called "*Le Pendu*"? In the absence of any other explanation, I pro-

68. Paul Cézanne, photograph, ca. 1871

pose the following one. In pawnshops of the period it was customary to hang pawned clothes on a rack, *le pendu,* suspended from the ceiling,[9] and it is likely that Cézanne, who was negligent in his dress and wore clothes daubed with paint, reminded his friends of the rack in the pawnshops. He probably got the nickname before he went to Pontoise (in 1872). Twice before Cézanne's dress had attracted notice: in a letter to Zola, of August 1866, Guillemet wrote, "his get-up itself causes a sensation on the Cours [Mirabeau]"; and later Monet would remark on a red belt he wore and displayed at the Café Guerbois.[10]

The object in front of the clock is an inkwell, similar to the one in Manet's *Portrait of Emile Zola,* 1868 (pl. 69). Since *The Black Clock* was painted in Zola's apartment,[11] the inkwell is Zola's and may be taken to be emblematic of him. In keeping with the symmetries already noted, this emblem for Zola on the right is balanced on the left by the cup, a feminine presence suggestive of Gabrielle, the novelist's wife. The Zolas, from the beginning of their liaison in 1864, reserved an evening each week at which the beverage was tea. A single sentence from J.-K. Huysmans serves to link Cézanne's cup to Gabrielle by both its appearance and use: "Mme.

69. Edouard Manet, *Portrait of Emile Zola,* 1868

Zola, tall, brunette, distinguished-looking, her eyes black with that astonishing deep black of the eyes of Velasquez' infantas, would prepare the tea."[12] To the right of the feminine elements is another pair of objects: a tall glass vase and a lemon. The phallic vase touches the lemon, which with its rotundity and pronounced nipple is a feminine motif. Indeed, a lemon, accompanied by a milk pail and a feeding bowl, seems to be a metaphor for Hortense in two other still-lifes.[13] Its association with Hortense is indicated by Cézanne's remark many years later to Vollard: "My wife likes only Switzerland and lemonade."[14]

The lemon is, besides, the head of a cryptomorphic bird whose body is constituted by the horizontal cluster of cloth in which it nestles. The shadow on the right side of the lemon is so placed as to serve as the eye of this bird. The bird's beak, just below and to the left of the lemon, holds a worm, well rendered by a serpentine fold in the tablecloth; a pointed shadow, to the right of the top of the *F,* serves as its claw. The image of a bird carrying food to its young is an extension of the nurturing symbolism of the lemon alone; at the same time, it incorporates part of the *F* that refers to *Fiquet.*

In *The Black Clock* the objects that stand for Hortense and Paul are situated on the left and right, respectively. This arrangement can be

shown to exist in at least eighteen other paintings, and so must be considered as one of the important features of Cézanne's (unconscious) symbolic system. But a reversal of this order in the middle of *The Black Clock* places the glass in Hortense's zone and the lemon in Paul's, creating a metaphor of sexual intimacy, of the merging of man and woman that results in a child. Such an understanding of this arrangement would seem to be sustained by a verbal/visual pun—the third in this painting—contained in the central configuration: a vase of glass (*verre*) and a cryptomorphic worm (*ver*), both French words having the same pronunciation. What, besides homophony, is the connection between *verre* and *ver*? The phallic *verre* transmits sperm; this is imagined as food for the embryo and is carried to it by the mother bird as a *ver,* which also resembles the tail of the spermatozoon. If this rationale seems oversubtle, it nevertheless links a primitive notion of the function of the semen with the cryptomorphic imagery of the painting.

Turning to the unusual forms at the lower left, we see that instead of the draped fall of cloth expected here, there is a rather complicated construct in the middle of which we note a dark shape. It can be seen as the female pubic mound viewed between the breasts, as though from the top of a figure. Since the three horizontal folds in the tablecloth are aligned and pointing directly toward it, they have an insistently phallic implication.

Let us recall that Cézanne and Zola had been childhood friends, sharing their dreams as they roamed the countryside, talking, reading, swimming. In the 1860s Cézanne saw Zola in Paris during his frequent sojourns in the city. The two men often wrote to each other; in fact, Cézanne's letters to Zola constitute the bulk of his extant correspondence. On May 31, 1870, Cézanne was a witness at the marriage of Gabrielle and Emile in

Paris; shortly thereafter he and Hortense left for L'Estaque. In the fall of 1871 Cézanne and the pregnant Hortense were back in Paris, as were the Zolas, and it was surely then that *The Black Clock* was begun; in all likelihood it was completed early in 1872, after the birth of Paul *fils* on January 4.

The proximity of clock and inkwell reflects Cézanne's friendship with Zola; we note the black of the clock and the black of Zola's ink. This was a color to which Cézanne was partial and which he handled with remarkable power. In his earliest painting, a large screen, the most interesting elements are the trees, painted, surprisingly, in black; and it is possible that Zola worked with Cézanne on this screen.[15] Black, as an English word, figures in their boyhood as the name of a dog owned by a mutual friend, Numa Coste; the dog appears three times in the oeuvre.

The inkwell in *The Black Clock* has a position similar to the inkwell in Manet's *Portrait of Emile Zola* (pl. 69): it is on the right in both works, and although one canvas is broad and the other tall, both inkwells stand almost exactly on the median line of their respective paintings. In the *Portrait* the inkwell serves as a link between Zola and his essay on Manet— but the connection is, if clever, essentially spurious since the inkwell was actually Manet's. In *The Black Clock,* however, the contiguity of clock (Cézanne) and Zola's own inkwell affirms Cézanne's real friendship with the writer.

Although the color black holds many references to Zola, it also relates Cézanne to Manet. The older artist was celebrated for his handling of this color, and Cézanne's frequent use of it strikes a note of challenge or competition. Black is of course the constant chromatic sign of Cézanne himself in his paintings.

The cup and inkwell are situated in front of the conch and clock, and

fittingly so since Gabrielle and Emile, with their social and literary activities, were much more in the public eye than the painter and his companion. But the great size of the clock and conch—and their depiction above the other two—reflect Cézanne's high evaluation of himself and Hortense, in spite of Zola's considerable reputation and Gabrielle's popularity. Cézanne had a new reason for pride: he was about to be a father and Hortense was fruitful—this after sharing their lives for about two years. The Zolas, on the other hand, who had been together for more than seven years, had no children—and would never have any, although many years later Zola would have two by another woman.

The distance between conch and clock is surely a sign of tension between Hortense and Paul, which was to exist throughout their association, along with periods of love and affection. The clock faces the conch as if to say, *Ars longa, vita brevis*—is there time for love? Yet the graphic linking of clock and inkwell indicates a close and persistent bond between Cézanne and Zola, one that probably had homosexual overtones for both. In the framework of the painting, the friendship of our four actors hinges on the circumstance of Hortense's pregnancy, which is set forth in the middle of the work. Its focal position marks *The Black Clock* as a celebration of Hortense's motherhood.

In view of Cézanne's personal intensity, and a poetic faculty—indeed, fervor—that has been overlooked in the general attention to his formal gifts, he must have awaited the arrival of his child during the fall of 1871 in a state of feverish excitement. If the mother bird that bulges out of *The Black Clock* is a metaphor for Hortense's appearance at this time, the whole densely packed painting is Cézanne's *couvade*, an image of the fullness of his soul, at bursting point in sympathy with his companion's condition. When the infant, a son, arrived it would prove to be for him an

everlasting source of joy. His pleasure in the child and later his confidence in the man were accompanied by an undying gratefulness to Hortense.

If the issues of art, love, and friendship, of male pride and motherhood, are reflected in the upper zone of *The Black Clock,* the lower zone presents the naked theme of sex as fundamental to all the others. This region is largely occupied by the tablecloth, a metaphor for the bedsheet. On this broad expanse three horizontal strokes depict three shadows, phallic in form and function. It is their pulse that makes *The Black Clock* run.

Because the painting includes a clock and a mirror, it has been explained as a "modern vanitas."[16] Yet the mirror, in doubling the clock, enlarges a sign for the artist and suggests nothing so much as simple vanity, Cézanne's good opinion of himself. As for the clock without hands, it seems to imply not the destructiveness of time, but time standing still, permanence, timelessness. These are apt metaphors for Cézanne's art, and they would have been routed by the indication of a specific hour. Such indication would also have hurt the sense of a human face in the clock's face. We may imagine that depiction of the hour and minute hands in certain positions would have produced facial appearances of a caricatural nature—grinning at 9:10, scowling at 8:20—and in most others would have effectively destroyed any facial connotation.

The clock's face may be seen as the face of a baby whose arms are suggested by the pointed fold of cloth below it at the left and by the inkwell to the right, and whose garment is the long rectangle of tablecloth below them (fig. 5). This baby naturally has Cézanne's face, since it has the clock's face. It confers immortality on Cézanne; it too puts him beyond time.[17] In contrast to this stylized image is the realistic (cryptomorphic) depiction of a sleeping child: its head is the lemon (it is Hor-

tense's child too) protruding from a fold of cloth on the right as from a blanket.[18]

Cézanne has subtly manipulated the objects of his attention in different ways. The face of the clock, for example, is quite round, as it could only be if seen frontally. But a flat frontal view could not have suggested the mass of a head. So he pulls the side into view and even increases its depth by the reflection in the mirror, creating a more voluminous object while preserving undistorted the frontal face. This tinkering with front and side is less noticeable in a black object than it would have been in one of a lighter color. The centering of the pink vase over the face of the clock is in keeping with a tendency of Cézanne to align objects on an axis. But the vase has been placed so far to the left that the left side of its footing must have overhung the edge of the clock. We are not aware of a precarious situation because the footing is not in our line of vision. The vase and its reflection create between them an oval of feminine significance placed on a symbol of Cézanne's head, as if to show what is on his mind. The feminine significance of the conch is evident because the artist has taken pains to prop the shell—top-heavy in this position—on the sharp edge of its outer lip.

The small portion of the mirror frame, visible in the upper zone of the painting on the extreme right, looks like the head of a monster or dragon gnawing at the back of the clock. Since this metaphor for Cézanne's head is contained in Zola's mirror, the depiction of an attack on the head by the frame, from the rear and in the dark, would constitute Cézanne's accusation (always unconscious) of treachery on Zola's part. Cézanne would have had reason for (conscious) rancor, since Zola had created a thoroughly unsavory character—clumsy painter, betrayer and murderer of his friend—based on Cézanne in his first "realistic" novel, *Thérèse Raquin*

70. *Still-life with Coffee Pot,* 1871–2 (V.70)

(1867). This tendentious portrayal was not observed at the time, but it would not have been lost on Cézanne. The novel and its successor, *Madeleine Férat* (1868), both project Zola's fantasies of the loss of his wife to his friend.

To return to the image of a monster that attacks (literally, eats its way into) the emblem for Cézanne: is this toothy creature a shark? In Zola's novel, Thérèse Raquin assists in drowning her husband. *Raquin* sounds like *requin* (shark). A marine creature is suggested by the filmy, transparent rendering of this image, the only such passage in a painting otherwise frankly pigmented. The mirror is a metaphor for the water in the novel. Both mirror and novel give a murky reflection of Cézanne, who was right in reading *Thérèse Raquin* as an attack upon himself.

Related to *The Black Clock* thematically and chronologically, *Still-life with Coffee Pot,* 1871–2 (pl. 70), is painted in a low color key and is richly pigmented in a way that has reminded many critics of Manet. But for all its sobriety and honorable lineage, the painting, like *The Black Clock,* ex-

hibits a number of peculiarities of representation that go unquestioned, if not unnoticed. For example, a diamond-shaped portion of the tablecloth in the center of the picture would, in nature, be half on top of the table and half hanging in front of it. Yet Cézanne's rendering results in a diamond-shaped area that seems to lie on a single and vertical plane. Within this area, the horizontal fold to the left of the knife appears to be an invention rather than the depiction of an observed fold. What I have called a table is an object of indeterminate character. If it were a table, a leg would be visible at the right; if it were a sideboard, it would show the knob of a drawer, and its front would be close to the lower part of the cloth. Instead there is behind the cloth a vague depth, a theater for a play of shadows whose cause is not immediately apparent. In the painting's upper zone the coffee pot is warped quite out of symmetry.

If, as we examine the painting, we recall the data of Cézanne's biography, we are struck by the fact that the fruit in the middle of the space between the knife and the coffee pot is a fig. *Figue* (fig) sounds like a play on Hortense's family name (Fiquet). The presence of a fig in the painting may seem too fortuitous to carry such a burden of significance. It should be borne in mind, however, that this fig is not an accidental presence on a real table, but an element within an invention; that a fig appears in perhaps one other painting in the oeuvre; and that it was put into this one by a man deeply involved with a young woman named Fiquet—a man, moreover, sensitive to language and the play of words, and a master of the culture of imagery. There are other references to Hortense's name in the painting: her initials occur in the handwritten or lowercase *h* formed by the folds of cloth directly above the eggs, and in the reversed capital *F* created by the knife and the two dark folds that touch its blade. This is, of course, a motif central to *The Black Clock*. The occurrence of the same

unusual and sharply defined designs in the middle of consecutive canvases depicting different subjects cannot be accidental. We will encounter another well-disguised *F* that relates to Hortense in a work of much later date.

The jar and the coffee pot, which stand near each other in the broad canvas, are feminine and masculine presences, with the pot being deformed as its spout strains toward the open jar. In front of the pot are two eggs so painted as to suggest testicles. Since the still-life is lighted from the front and left, the long shadow under the right side of the table (let us call it that) must be cast by the corner of the cloth which drops to the left of it. The triangle of cloth in which the reversed *F* is nestled does not seem to lie on the table or to recede, as does the rest of the cloth on either side of it. Cézanne was surely able to render this recession more "faithfully." If he had done so, the free corner of the cloth would more obviously have appeared to fall along the edge of the table. If we insist on this suppressed edge, we see that it would have been the base of an inverted equilateral triangle. In the present context, which we have seen to be erotically charged, this shape has the force of a pubic triangle that gives rise, in every sense, to the ithyphallic shadow—which points, as usual, to the left.[19] Even this partial examination cannot fail to suggest that *Still-life with Coffee Pot* betrays, even as it attempts to conceal, Cézanne's passion for the young woman with whom he was living.

A final observation: the elements in the still-life that are related to Fiquet and Cézanne are not merely distributed on the left and right, respectively: they are carefully partitioned into adjacent fields, with one important exception. A straight line touching the tip of the coffee pot's spout and the tip of the phallic shadow will have Paul's elements on the right (pot, eggs, shadow), and those of Hortense on the left (jar, *h,* fig, reversed

71. *Still-life with Jar and Bottle,* 1871–2 (V.71)

F, triangle). This dividing line just touches the end of the knife (*couteau,* penis), which may be understood as attached to the male zone and penetrating the female.

In a work that followed closely on the previous one, *Still-life with Jar and Bottle,* 1871–2 (pl. 71), two large vessels, their shadows, and an assortment of smaller objects take part in another symbolic situation which, like *Still-life with Coffee Pot,* has a left/right organization. While its rationale in the earlier picture was a female/male opposition, in the new work it seems to be a public/private contrast. The feminine jar, again on the left, is covered by a lid. The phallic bottle, standing properly beside it, is corked. In front of them is a very pretty, very symmetrical arrangement of apples flanked by two onions. And the tablecloth falls smoothly in front of the whole group—which resembles nothing so much as a family

posing for a photographer. The onions (*cebo,* Provençal, echoing "*c'est beau, c'est beau*") register the photographer's exclamation.

Beside the order that reigns on the left side of the table, the right side can only appear to be in disarray. The shadow cast on the wall by the bottle is sharp—sharp enough to look like the shadow of an uncorked bottle, whereas that cast by the jar approaches formlessness or dissolution. These conditions are unaccountable by any cause having to do with the depicted jar and bottle, the wall, the lighting, or the style in which the canvas is painted. But they intimate the mutual alienation of jar and bottle, and thus of the two people they signify. The lower zone of the painting, like that of the two preceding ones, holds a flagrantly sexual feature directly below the bottle's shadow: two swelling forms and a dark crease that compose a large image of a vulva.

The Black Clock is Cézanne's most impressive early still-life, the central panel of a triptych whose wings are the still-lifes that followed. It is so in great degree because of a roiling inner life that invaded his high-minded enterprise and imposed its urgency. Cézanne's most intimate feelings, his joys, fears and fantasies, memory and desire, are inextricably entwined with the pictorial concerns of subject, composition and facture. We may say they become these concerns.

In the period of the previous still-lifes Cézanne painted a small canvas sometimes called *Green Apples,* 1872 (pl. 72). It shows two unmistakable apples, some leaves, and some round fruit whose identity cannot easily be determined. The touch here is light, more flickering than in the earlier still-lifes; the structure is relaxed, lacking the clear organization of the others. The apple on the left rests on its base and we look down on its cavity; it is rendered with a directness that raises no problem in compre-

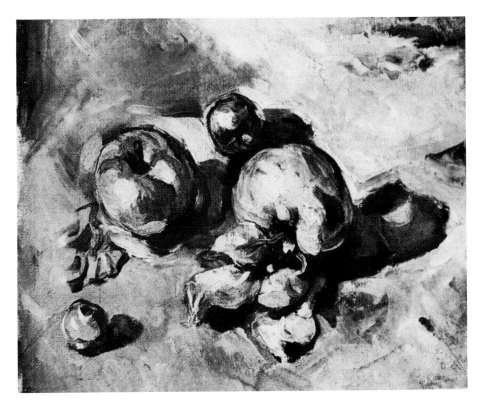

72. *Green Apples,* 1872 (V.66)

hension. The apple on the right, however, is fashioned by elaborate means, and its lower edge merges with and is covered by the leaves and their shadows. As we study this congeries of forms and touches, it becomes apparent that it harbors a hidden image, the head of a very young child—a baby. The head lies on its right side, seemingly asleep, with the back of the cranium formed by the upper right edge of the fruit, while the face, on the lower side, nestles among the leaves. A pale pointed feature near the leaves serves as the tip of the nose; above this is the depth between eyeball and cheek; a dark stroke at the rear of the cheek suggests the left ear; on the extreme right, an adjacent shadow makes a neck and shoulder. The table, whose edges are not visible, is a metaphor for sleep as an endless field in which the baby/apple seems to float.

When the picture was painted Cézanne's child was less than a year old, and there can be no doubt that the painting is a meditation on the infant as green, unripe fruit. The sleeping child is seen as though in a cradle or bed, hence the aerial view of the still-life.

91

73. *Woman Nursing a Child,*
1872 (V.233)

The two preceding works also contain apples. *Still-life with Coffee Pot* (pl. 70) has, on the far left, a single apple, surely the sign of Paul *fils,* shown apart from the objects that represent his parents. The numerous population of *Still-life with Jar and Bottle* (pl. 71) includes four apples already mentioned: a single one in front of an unusual pile of three, which represent little Paul and Hortense. The rationale of this apple symbolism (many is to one as mother is to child) is on the model of the house symbolism of *The Railroad Cutting* (large is to small as mother is to child). A group of apples will be a persistent metaphor for Hortense, they literally *are* Hortense in one remarkable case, as we shall see. In the context of French language, it is not surprising that apples should symbolize a woman: the breasts are vulgarly referred to as *pommes* (apples); a well-rounded adult or a pudgy child is described as *bien pommelé.* Hortense was, by all evidence, a buxom woman.

Woman Nursing a Child, 1872 (pl. 73), only nine inches square, was surely done from memory. And properly so; with the wisdom of hindsight it is difficult to conceive of the Cézanne oeuvre as including a large, objective study of subject, one more suited to the interests of Renoir or Cassatt. But the little painting, with its idealized drawing, tells us of Cézanne's enchantment with the mother and infant at his side. This persona of Hortense is on the left side of the painting. But a representation or

74. *Mme. Cézanne Leaning on a Table*, 1873–7 (V.278)

symbol of her has so often been in this place in works we have examined that it must be considered her canonical position. She is there, often on the left of a symbol for Cézanne, in plates 46, 48, 50, 63, 64, 66, 70, and 71, and in many other paintings, several of which will be discussed presently.

In a formal study of Hortense made some time later, *Mme. Cézanne Leaning on a Table*, 1873–7 (pl. 74), a bed frame is visible behind the sitter—a suggestive note in an otherwise proper picture. A cryptomorphic head of a child, surely little Paul, occupies her left breast, the same one at which the infant nurses in the preceding painting; it looks down and slightly to the left, the upper plane of the bosom serving as the top of the child's head. The breast with which we have been concerned in both paintings is the one over the heart.

When Hortense and Paul began living together, he decided to keep the fact from his father, probably fearing a reduction of his allowance if Louis-Auguste saw the liaison as a caprice. Once the couple had a child, the need for secrecy increased even as Cézanne's expenses increased. Caught in a double bind, with matters growing progressively worse, Cézanne turned to Zola for help. His mother, too, probably contributed small sums from her savings. She had become aware of the menage early, was delighted to have a grandson, and kept his existence a secret from her husband. These

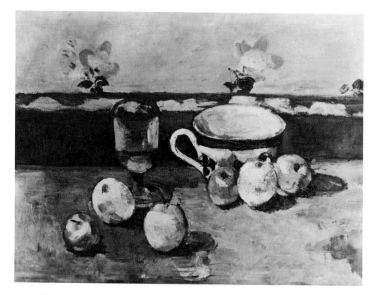

75. *Glass, Cup, and Apples,* ca. 1873 (V.186)

issues form a hidden subject in a number of still-lifes, ideal vehicles for the symbolic display of family situations.

An early reflection of the new problem occurs in *Glass, Cup, and Apples,* ca. 1873 (pl. 75). The still-life elements are divided into two groups; we see that they number eight, whereas the two families to which Cézanne belonged numbered only seven. The large cup on the right was probably Louis-Auguste's and stands for him; the large yellow apple in front of it would represent his wife, and the two smaller red ones, the daughters Rose and Marie. We may take the glass on the left to stand for Cézanne, like the one in *The Black Clock.* The small apple on the left, like one in the same position in *Still-life with Coffee Pot* (pl. 70), would be Paul *fils.* Then the *two* yellow apples near it would refer to Hortense—and indeed two apples in the same diagonal alignment and the same significance appear in a work soon to be examined. Characteristically, the Cézanne/glass is taller than the father/cup—in fact, is the tallest object in the painting. The symbolic symmetries are remarkable: the two mothers are shown as yellow apples, the three children (who are "children" because they have no children) are the red apples. Cézanne's little family is on the left, while Louis-Auguste's is on the right; but this placement seems matrilineal, since the left, as we have seen, is Hortense's region, and the right Cézanne's mother's. It is in keeping with the biographical facts that the

76. *Apples and Dessert,* 1873 (V.196)

group on the left is more dispersed than that on the right. Since the father/ cup faces right and seems to have its front blocked by three apples, the little Paul/apple on the left is the object furthest from it, and blocked from "view" additionally by the two Hortense/apples between them. The same problem—of hiding his family from his father—seems to have occupied Cézanne even earlier, in *Still-life with Coffee Pot,* where the section of tablecloth on which the reversed *F* lies looks like a head of Louis-Auguste in a nightcap, facing the upper right corner. The top bar of the reversed *F* makes its eyes and brows; the lower bar, an upturned mouth; on the right of the knife, a partial pear serves as the nose. In looking to the upper right, it can see neither the jar nor the apple.

Apples and Dessert, ca. 1874 (pl. 76), contains, on the left, a compotier that holds a mound of apples, four more dispersed at its footing, and at the right a dish of cakes, all resting on a decorated cupboard. We have no trouble recognizing the mound of apples, but the cakes are new to our symbolic repertoire. Upon scrutiny, the tallest bears a surprising resemblance to Cézanne *père,* being endowed with facial features and an ear, and wearing a small dark hat. The glance of the father/cake is directed up toward the compotier where it discovers nothing significant. For if we draw a straight line from the "eyes" to the rim of the compotier and beyond, it is clear that the line of sight just misses the apples, passing

9 5

77. *The Plate of Apples,* ca. 1876 (V.207)

above them. Hortense and young Paul are effectively hidden from Louis-Auguste, who is foiled once again by the geometry of isolation. In this painting *gateau* (cake) echoes *gateux* (idiotic, senile) an epithet directed at the father and typically derogatory.

Paul *fils* is hidden again from his grandfather's view in *The Pool at Jas de Bouffan* (pl. 35). We have seen that it contains a cryptomorphic portrait of Louis-Auguste (fig. 3), but it contains another of young Paul (fig. 6), which, since it is behind that of his grandfather, cannot be seen by him.

Probably the most dramatic example of the hiding of Paul from Louis-Auguste is *The Plate of Apples,* ca. 1876 (pl. 77). Here a crumpled table-cloth, a plate filled with apples, a sugar bowl, and a single apple are placed before a figured screen. Since the actual screen was painted by Cézanne,

78. Detail of the back of the screen *The Environs of Aix-en-Provence,* 1859–60 (V.1-3)

79. *Cézanne père in a Chair,* 1871–4 (C.266)

it is examined by Reff as a "painting within a painting."[20] He tells us that its forms and colors "echo" those of the arrangement of objects in front of it; also, that the "axis" of the design on the screen "coincides" with the peak of the "crumpled cloth and the pyramid of apples" below. In the new work Cézanne is seen to "strengthen the cameo-like female head" of the screen (pl. 78), but no significance is attached to this head, which is after all centrally situated above the still-life arrangement.

As we examine the head we must think that it has been strengthened (if that is the right word) to such a degree that it is no longer female, but male. It is bald and can be identified as the head of Cézanne *père,* who otherwise wore a cap when his son drew or painted him from life. He is without a cap in a drawing of 1871–4 (pl. 79), where he resembles the

man on the screen; again in what Reff calls the "physiognomic cloud" on the right of a bather (pl. 146); and above a drawing of a bather (pl. 147).

In our still-life, then, the head of Cézanne *père* is, when considered illusionistically, behind the peak of the cloth that effectively shields from his view the pyramid of "vivid" apples, symbolic as usual of Hortense. Mme. Cézanne *mère* is represented, appropriately enough, by a sugar bowl; this is placed among the apples while remaining, because of its height, in the line of sight of Louis-Auguste on the screen. If his head could turn, it would not be able to see either the group of apples or the single apple (representing Paul *fils*) on the right, shielded from view by the sugar bowl. In contrast to the red apples on the plate, the isolated Paul/apple is predominantly green, with some red showing at the right: now that Paul is four years old, it is no longer totally green, as in *Green Apples* (pl. 72), painted in 1872 in the months following his birth. The upper edge of the protective mound of cloth figures a cryptomorphic head in profile, facing up, but with its eye glancing down toward the apples— probably an image of a friend in Gardanne who sequestered Cézanne's wife and child. *The Environs of Aix-en-Provence,* as the screen is called, is where all this transpired.

Two years later Louis-Auguste discovered Cézanne's secret. The paintings stopped their meditation on young Paul's relation to his grandfather.

Double Trouble

Three paintings of Cézanne's early period are often mentioned as belonging to a group of scenes of violence and erotic abandon, but they have never been examined closely. *The Autopsy,* 1867–9 (pl. 80), is indeed difficult of access because of its ambiguities; *The Murder,* 1868–70 (pl. 81), and *Woman Strangled,* 1870–2 (pl. 82), are bewildering in their expression of fury, their excess of emotion going beyond the needs of illustration or anecdote. Even if the sources of their imagery were to be found, we would still have to account for Cézanne's interest in them. What we seek is the source of his own violence.

In the claustral setting of *The Autopsy* the color of the dead body is gray, the man's trousers are blue, the woman's blouse is red. The cadaver is in the same pose as that of a nude young man in an *académie* by Cézanne; in adapting the drawing, he has especially changed the character of the face, making it more mature and removing the mustache. Is the woman at the right merely an assistant? The male attendant has been seen to resemble Cézanne, but this observation has never before led to an understanding of the macabre work. To reveal its significance, we will have recourse to an unusual measure.

If we eliminate the male attendant except for his whole right arm, the arm is magically revealed to be doubling as an immense phallus that rises ambiguously from the cadaver's groin (fig. 7). The female attendant is now seen to be looking at the enormous organ; the corpse itself suddenly seems to regard it with some astonishment. The placement of the male attendant's right hand effects a joining of phallus and groin, but only by sleight of hand.

Beyond our surprise that such matter can be imbedded in a painting is the fact that the arm-as-phallus is a motif in art and popular custom and is the subject of psychological inquiry. It is most widely known in the

80. *The Autopsy*, 1867–9 (V.105)

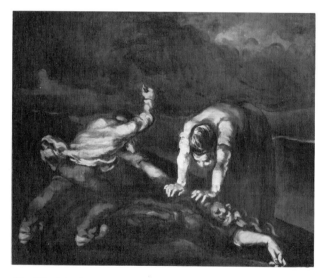

81. *The Murder*, 1868–70 (V.121)

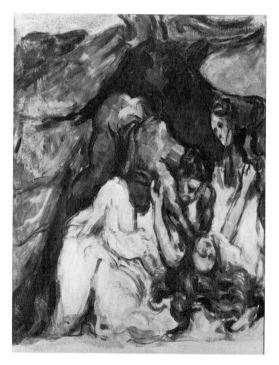

82. *Woman Strangled*, 1870–2 (V.123)

83. Joseph-Marie Vien, *The Sale of Cupids,* Salon of 1763

vulgar gesture of raising the lower arm while striking the bend of the arm with the opposite hand (the gesture made by the central cupid in Vien's *The Sale of Cupids,* Salon of 1763, pl. 83). *Bras* (arm) is a euphemism for "penis" in French erotic discourse.[1] To elucidate the significance of the upraised arm, Reff has linked Freud's concept of "upward displacement" and a lithograph by Tony Johannot depicting a reveller running in the street with a papier mâché phallus that covers his upraised arm.[2] In all these cases the arm-phallus equation is achieved by proximity or allusion. In *The Autopsy,* however, we have a unique instance of identity of arm and phallus in a graphic demonstration that is absolute.

With whose phallus does Cézanne identify his right arm? The only reasonable answer is: his father's. We have already encountered two other cases of an association between the genitals and a father-figure in the portraits of Emperaire and Pissarro (pls. 36 and 5, respectively). *The Autopsy* is surely a classic version of the Oedipal situation: Cézanne kills his father (by art) to be alone with his mother. Even as he does the Old Man in, he gets his sexual potency from him. If there is any doubt concerning the identity of the cadaver, it is dispelled by the basin (*bassin*) at left, beyond easy reach of the two attendants but close to the corpse. For *bassin* had another meaning in popular speech, "a boring man,"[3] and is thus a covert, typically disparaging allusion to Cézanne *père*. The Oedipal situation is reflected in the color of the mother's blouse: red, the color of love and ardor. It appears at this point because Hortense is not in the scene, and indeed the painting is given to the period before she and Cézanne met. After her advent the mother is never again associated with this color.

There is good reason to think that the female attendant represents Mme. Cézanne *mère:* she is not a young woman and she is on the right. In being on the right she is like the female accomplice in *The Murder* and the onlooker in *Woman Strangled,* whom she resembles and who may also represent the mother. Her position on the right—and on the right of Hortense when the latter is shown—is surely in contradistinction to the place assigned to Hortense—the left, as we have seen.

Can we firmly establish her identity and that of the young woman being done to death in the scenes of violence? The schematic design of the actors in *The Murder* secretes a clue to the presence of Hortense and Anne: the pale arms and face of the woman on the right make an *A* (with a round top) pressing down and collapsing an *H,* composed of the man and the victim (fig. 8). A motive for this violence is suggested by a Titian draw-

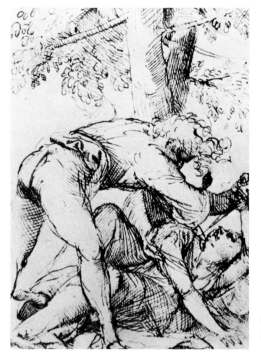

84. Titian, *Woman Attacked by Her Jealous Husband*

ing, *Woman Attacked by Her Jealous Husband* (pl. 84), at the Ecole des Beaux-Arts—where Cézanne probably saw it. It exhibits the same fury we see in *Woman Strangled* and like *The Murder* shows a victim on the ground and a dagger-wielding attacker. In seeking a cause for jealousy in the Cézannes, we note that the dates given to them, 1869–72, are those of the first years of the Fiquet-Cézanne liaison. Extraordinary as it may seem, the two paintings may be understood as expressions of a perverse jealousy in which Cézanne's anger is vented on Hortense for stealing his love, until then reserved for his mother. Yet on another symbolic level the paintings manifest something other than destructive fury. Since in French erotic argot a *poignard* (dagger) has a phallic connotation, and *étrangler* (to strangle) and *tuer* (to kill) mean "to copulate,"[4] these paintings are images of Cézanne's passion for his lover despite the inescapable presence of his mother.

In both paintings the perpetuation of the tie to the mother is another aspect of the Oedipal fantasy played out in *The Autopsy;* all three imply the desire to eliminate competition for the mother's love. We know that Cézanne was his mother's favorite child, that she supported him in his desire to devote himself to painting, and that he in turn had a strong attachment to her. But not till the revelation of these paintings did we realize the peculiar force of his feelings. His extreme reaction to the dis-

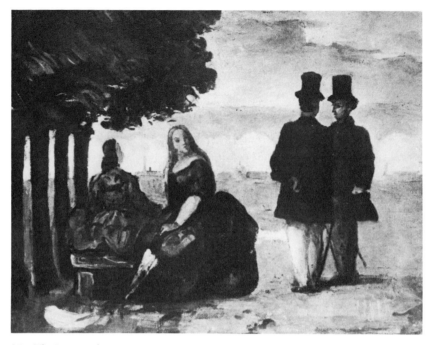

85. *The Promenade,* ca. 1870 (V.116)

turbance of his emotional economy occurs early in his relations with Hortense, its intensity will diminish with time, but the problem—of dividing his love between his wife and his mother—will persist as the submerged subject of at least a score of other paintings.

In *The Promenade,* ca. 1870 (pl. 85), four strollers are shown resting in the outskirts of Paris. Two modishly dressed ladies are seated under a row of trees at the left, while on the right, in the open, their smartly attired escorts engage in conversation. In the distance is the city; we glimpse the dome of the Panthéon in the space between the women and the men.

The painting was surely inspired by Manet's *View of the Centennial Exhibition of 1867* (pl. 86), which also shows the Panthéon in the distance and two men in a surprisingly similar relation on the right side of the canvas. Cézanne later drew the Panthéon three times;[5] the name, besides, contains the ever-attractive syllable *pan.* Cézanne's picture may also incorporate a literary source: Zola's first novel, *La Confession de Claude* (1865), in which a young couple look back on Paris from a distance and notice the Panthéon. Since the book has a number of autobiographical features, and since Cézanne spent much time in Paris during the years 1861–5 and prob-

86. Edouard Manet, *View of the Centennial Exposition of 1867*

ably explored the suburbs of the city, *The Promenade* may well synthesize a personal experience, a reading of Zola's novel (dedicated to Cézanne), and some graphic suggestions gleaned from Manet. But in creating an image of a social situation—whose complexity does not immediately strike the eye—Cézanne has gone far beyond what was given in experience.

The strollers, who presumably started out as two male/female couples, are presented as two women separated by a space from a configuration of two men. The latter pay no attention to the women; they are in close conversation, in fact they could hardly be closer. The women, although linked graphically, show no involvement with each other while sitting on opposite sides of the same bench; the one at the far left looks at the men; the other turns her head to the right without actually looking at them, but effectively turning away from her neighbor. What is the significance of this situation? And what are we to make of two notable constructs in the painting: at right, the compact, virtually independent design created by the men; and the regularly spaced tree trunks at left, which labor to particularize an imagined space, a *terrain vague* of the mind?

The men are of the same height and dressed in the same manner; both

wear top hats, carry canes, and have on coats of the same cut. Although we see one from the front and the other from the back, we have the impression that they differ only in the color of their trousers, which are black on one and gray on the other. Their similar appearance and physical proximity—emphasized in the overlapping of their figures—have permitted Cézanne to merge them into a discrete shape of surprising symmetry. This symmetry is especially striking in the upper part of the shape, where the tophatted heads and the space captured between them bring to mind recent illustrations of figure-ground phenomena; and it is the more evident when compared with the irregular design of Manet's two men, otherwise so similar to Cézanne's.

For their part, the two women strike roughly the same pose, one is seen from the front and one from the rear, and they overlap. If they resemble the men in these respects, they do so in no other: the woman on the right is clearly the larger of the two; her hair is blond and her dress blue, while the other is a brunette and wears purple. Thus, in spite of a rudimentary symmetry, the individuality of the women is apparent in contrast to the emphatic similarity of the men. One of our earlier questions can now be rephrased: What is the significance of this constellation of two women who are different and two men who are the same?

The painting was probably made in the latter part of the period 1868–70 indicated by Venturi, around 1870, after Cézanne had painted *The Murder* and *Woman Strangled,* and like them it attests to his persistent difficulty in dividing his feelings between his mother and the young woman with whom he has recently fallen in love. This young woman is symbolized in the painting by the lady seated close to the trees at the left—an association and orientation that will be repeated many times in the treatment of the Hortense imago. The woman in blue on her right has a position and color

that identify the mother. The two escorts, seen front and back, are two views of the same man, who surely stands for Cézanne. The doubled image of himself looks like a cutout whose other side would resemble the one we see. Its symmetry suggests that it can turn on its axis, as does the less regular female configuration. The turning male shape would always reveal Cézanne; the women, even if interchangeable, are unique. The symmetrical doubled man looks like a whirligig, a *pantin*. It is seen against a *panorama* of Paris, popularly called *Pantin* at the time, and identified, as we have observed, by the *Panthéon* in the middle of the scene. The identity of the doubled man as the single Cézanne is made possible symbolically by the fact of there being only one face visible.

In *The Promenade* the mother's relation to Hortense has changed: after being an accomplice in her stabbing, then a witness to her strangling, she has become her cool social companion. And Cézanne is no longer in the murderous mood of the earlier paintings where he wrought furious destruction on Hortense. He now suffers more subtly: estranged from both lover and mother, he turns round and round. He is in a whirl.

The striking pattern of the tree trunks on the left of the painting seems to be a graphic metaphor for the curious situation imbedded in the party of strollers: the four tree trunks enclose three spaces somewhat as the four people embody three souls.

A small study, *The Well Driller,* 1873–5 (pl. 87), looks like a sketch, the image being surrounded by raw canvas; it depicts a man bent over a rig, which he presses into the ground. If this well driller would not seem to have any connection with *Woman Strangled* (pl. 82), the men in the paintings are nonetheless in similar poses, and indeed a drawing of the period (pl. 88) perfectly mediates between these paintings. Further, if the stran-

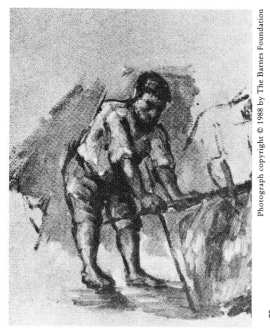

87. *The Well Driller*, 1873-5 (V.1520)

gler has a sexual relation to his victim (Hortense), there is likewise a sexual connotation in the theme of the well driller. The well (*puits*) in French slang of the late nineteenth century was a term for the female genitals, as in *puits d'amour*.[6] By itself the usage would be a tenuous link between *The Well Driller* and Hortense, were it not that *puits* is one of the several symbols for her. The two paintings, then, have in common a pose and an erotic allusion to Hortense.

Cézanne's propensity to establish verbal connections between paintings whose manifest themes are unrelated graphically is one we have already encountered. Let us examine another series in which a pair of related works are linked by language to two others whose subjects are quite different: *The Murder, Woman Strangled, The Well Driller,* and *Woman with a Furpiece* (pl. 53).

The mood which informs the first two is fury, and I propose to title them accordingly, taking a liberty with what are in any case simply conventional titles. When we give the other two paintings the French titles appropriate to their subjects, we have:

Fury (two works)	*La Fureur*
The Well Driller	*Le Foreur*
The Furpiece	*La Fourrure*

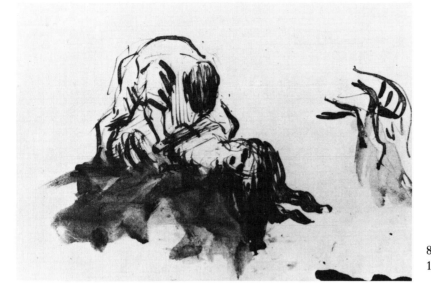

88. *Woman Murdered,*
1869–72 (C.254)

We observe a number of consistencies besides the astonishing similarity of the sounds in the echo-series on the right. The two paintings I designate by *La Fureur* are separated by a short period of time; a longer period elapses till the creation of *Le Foreur;* and there is a still longer time till *La Fourrure* appears. The second title shows a slight change from the pronunciation of the first; the third, a more marked change from the second. The first title accompanies two scenes of violent action in which a dagger present in the earlier work is absent in the later; the second title, a man engaged in restrained activity; the third, an immobile woman. In this series, then, we witness the deterioration of a two-syllable word and a decline of physical activity—signs of the gradual exhaustion of an impulse. At the same time the force of the latent subject, Hortense, is diminished: first she is represented by a young woman, then she is present metaphorically, and finally she is inferred where the cryptomorphic donkey sniffs the fur-piece (*fourrure*)[7] as he would explore his food (*fourrage*). *La Fourrure* was copied from a print of a work by El Greco that was thought at the time to be by Veronese, an artist Cézanne admired. From the example of other copies by Cézanne, his submerged reasons for copying *La Fourrure* would easily seem to have been as compelling as his interest in a (misattributed) work by the Italian painter.

In the midst of his preoccupation with the mundane subjects of the

109

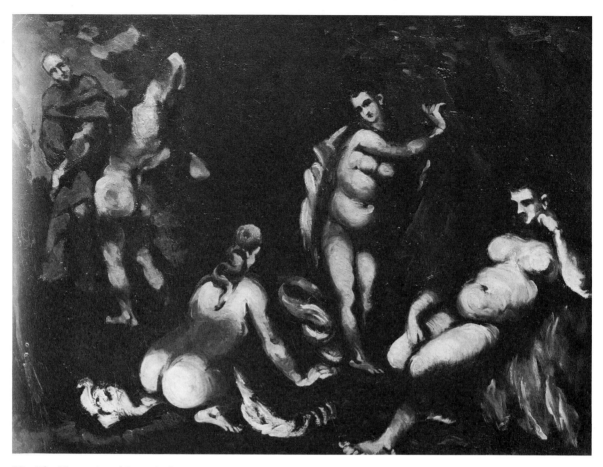

89. *The Temptation of Saint Anthony,* 1869 (V.103)

paintings just examined, Cézanne undertakes a more elevated theme, the Temptation of Saint Anthony (pl. 89). But even this biblical subject reflects his personal situation. Let us take the four women as metaphors for the women in his life and see to what degree this assumption is explanatory.

The saint is confronted by a woman on the far left; she is close to him in her exposed nudity and has an arm bent over her head in the gesture of the Temptress, which hereafter is a sign of Hortense. Cézanne had just met her (1869) and this is possibly the first work where the pose refers to her, but perhaps not the first in which he has used it. It appears in a drawing of 1868–71 (pl. 90), dates that bracket the meeting with Hortense. The drawing is reasonably taken to show the artist Frenhofer, the protagonist of Balzac's *Le Chef d'oeuvre inconnu,* a character with whom Cézanne identified himself.[8] The central figure in *Nymphs and Satyrs,* 1864–8 (pl. 61), holds an arm in the same position.

90. *The Painter,* 1868–71 (C.129)

91. Jean-Auguste-Dominique Ingres,
La Source, 1856

The Temptress pose was famous in Ingres' *Venus Anadyomene* (1808); the same figure, its bent arm holding a vase on the opposite shoulder, appears in his *La Source,* 1856 (pl. 91). *The Turkish Bath* (1862–3), also by Ingres, has a prominent odalisque reclining with both arms raised; this painting and *La Source* were both hung in the Louvre in 1868, the year before Cézanne and Hortense met. Chassériau's *Venus Anadyomene* (1838) was already in the Louvre, which was Cézanne's book and school. He would probably have known Courbet's *Sleeping Nude* (1862), and Cabanel's *Birth of Venus,* the latter shown at the Salon of 1863 and acquired by the Musée du Luxembourg; both display the upthrust arm on a recumbent figure. Brought to favor by Ingres,[9] the gesture caught Cézanne's fancy—for complex reasons, as we shall see. There can be no doubt that when he met Hortense he assimilated her to the pose of the Temptress, and not only in the *Temptation.* Cast in the role of a creature at once attractive and dangerous, she was made to conform to a late nineteenth

111

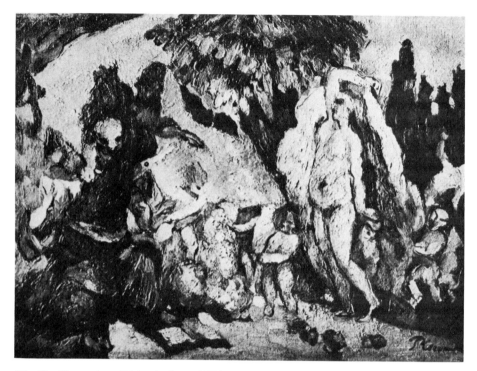

92. *The Temptation of Saint Anthony,* 1874–5 (V.240)

century obsession: the seductive woman who is a threat to the artist's career.

Saint Anthony (*Antoine*) is appropriate as a symbol of *Cézanne* because their names rhyme; in fact the key sound [an] occurs twice in *Antoine.* In our *Temptation* Hortense blocks the saint's view as he tries to look past her to the other three women. This group, which occupies most of the canvas, suggests the "other" women in Cézanne's life—his mother and two sisters. The standing figure might, because of her centrality in the group, seem to be the Temptress, but she does not hold her arm bent over her head like the actual Temptress at the left. She is nonetheless the focus of Cézanne's fantasy, the Ur-Temptress—his mother, so identified by being draped in blue, the color she wears in *The Promenade* (pl. 85), and by her position on the right of Temptress/Hortense. The crouching figure represents Rose, surely because she is *par terre* (on the ground), and a *parterre* (flower bed) is the proper place for a *Rose.* The large remaining figure is, by elimination, Marie, identified by her masculine face: masculinity is her indexical sign.

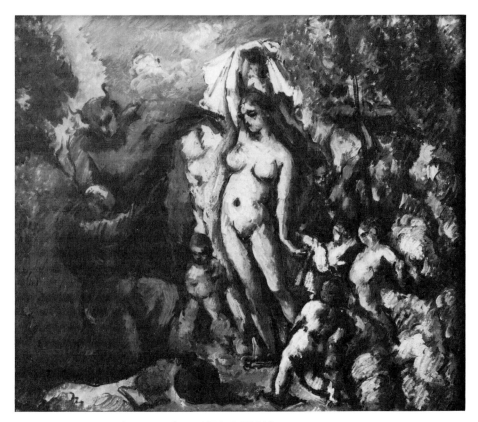

93. *The Temptation of Saint Anthony*, 1874–7 (V.241)

The second and third versions of the *Temptation,* dated 1874–7 by Venturi (pls. 92, 93), were certainly done after the publication of Flaubert's *La Tentation de Saint Antoine,* in April 1874. In both paintings the four women of the early *Temptation* are replaced by a single Temptress; Saint Anthony moves in from the edge of the canvas and is tormented by the Devil. The fact of a single, central, domineering Temptress with raised arm is symbolic of the ascendancy of Hortense, who at the time of these paintings had had a son—if not the swarm of little boys that surrounds the Temptress. (She is surrounded, according to Flaubert, by "*negrillons.*") Following the text in both paintings and in a drawing (pl. 94), the Devil's hand is on Saint Anthony's shoulder (*épaule*), identifying him as *Paul* Cézanne.

There is a fourth and final Temptation, which has always been called *Four Bathers,* ca. 1900 (pl. 95). Theodore Reff has independently recognized the similarity of this work to those on the Temptation theme.[10] But it can be shown that the picture *is* a Temptation. I first became engrossed with it when I noticed an almost life-size head of a woman nestled in the

94. *The Temptation of Saint Anthony*, 1873–5 (C.448)

bend of the right leg of the bather on the extreme right (pl. 96). In contrast to the rather rough handling of the rest of the painting, this cryptomorphic head seems to be executed in a style of elegant realism. Although it is in profile, looking to the left, it is identifiable as Cézanne's mother by its resemblance to the woman sewing in a domestic scene of 1868–9 (pl. 39). While studying this head it occurred to me that the fully displayed central figure and its fluttering drapery are not to be found in other *Bathers*, but rather are characteristic of works on the theme of the Temptation of Saint Anthony—although in this painting the saint himself is absent.

Once we examine the picture for a possible relation to Flaubert's *La Tentation de Saint Antoine,* we may see the seated figure on the left as a capital *G,* in the manner of a decorative letter; the two central figures together as constituting a capital *F;* and the remaining figure, with its partial arm, as a lower case *l.* This gives *G Fl; aubert* is supplied by the hidden portrait of Mme. Cézanne *mère,* whose maiden name was Aubert. In reading this rebus we have moved across the painting from left to right in orderly fashion and have omitted nothing.

This surprising rebus is evidence of Cézanne's regard for Flaubert.

95. *Four Bathers* ("Temptation"), ca. 1900 (V.726)

96. Detail of *Four Bathers,* pl. 95 97. Detail of *Four Bathers,* pl. 95

And it certifies the painting as a Temptation. Where, then, is Saint Anthony? It is the Temptress' function to face him, and since he is not in the picture, he must be outside it, directly in front of her. His exit from the paintings has been accomplished in a regular movement in both space and time—from upper left in the first Temptation, then down and to the right in the next two, then out to front and center in the last.

The space in front of the canvas is of course the real space in which the artist, Cézanne, stands. The partial figure, which would continue into this space if it were not cut by the picture frame, is the formal sign that the pictorial space participates in the actual space in front of it. That this place is occupied by both Cézanne and Saint Anthony confirms their identity and what has long been suspected: that the earlier versions of the Temptation reflected Cézanne's difficulties in reconciling the calling of art and the demands of the flesh. These demands were aroused not by a vague or generalized womanhood or by Flaubert's literary creation, but by a real woman, his companion Hortense, whose centrality and elevation are signs of her ascendancy in Cézanne's imagination now that his mother is no longer living.

She is indeed the Temptress: the capital *F* of which she partakes (like that in plates 66 and 70) is the initial letter of her family name, Fiquet; we note that her arms are raised, revealing the armpit. The face of her double, to which she is joined, cannot be seen: to show two faces of the same person is unsuitable in Cézanne's symbolic system, as we saw in *The Promenade* (pl. 85). Rose is once again seated *par terre*. The last bather stands for Marie: from her heavy extended arm falls a drape otherwise reserved for a male bather in paintings that predate this one (pls. 195, 199). Mme. Cezanne *mère,* as we have seen, is present cryptomorphically.

Looking back to *Six Bathers* (pl. 24), we recognize Hortense by her

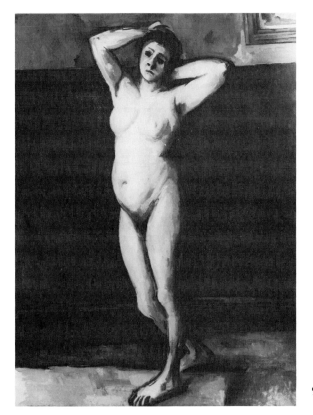

98. *Standing Nude,* 1899 (V.710)

raised arm; we do not see the face of her "reflection." Rose is seated on the ground; the bulky standing bather must be Marie, on the far right as in the first and fourth Temptations. The mother is in the water, in a place and pose in which we will find her again; as usual she is to the right of Hortense. Who could the reclining bather at the left be?

In the Bathers-Temptation (pl. 95) the implied continuity of the Temptress in real space, outside the canvas, reflects the biographical situation. Hortense was in Paris when Cézanne painted *Standing Nude* (pl. 98) of the same period. Its pose closely resembles that in the Temptation, and it is possible that Hortense was the model. Also at this time and in Paris, Cézanne did a large portrait of Ambroise Vollard (pl. 19), a young dealer who had mounted a one-man show of his work in 1895. An impressive Vollard looms cryptomorphically (pl. 97) at the upper right of the last Temptation (pl. 95); he is looking down at the Temptress. Was he an admirer of Hortense?

117

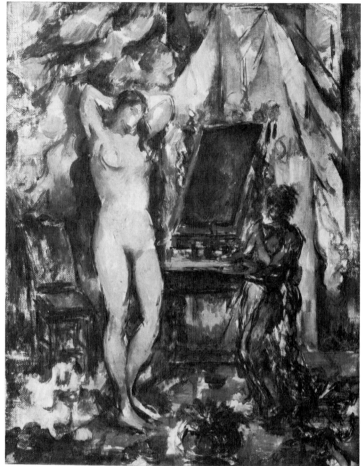

99. Adolphe William Bouguereau, *La Jeunesse et l'amour,* 1877

100. *The Toilet,* ca. 1878 (V.254)

The nude female figure with one or both arms raised over the head is a pervasive element of Cézanne's symbolic vocabulary, being one of the indexes of Hortense. The pose was attractive, at once erotically suggestive and socially acceptable. The raised arms leave the torso exposed and hint at its easy availability. They also reveal the armpits, an erotic focus of special significance for Cézanne. Its importance may be judged by comparing two of his nudes with the works by other artists on which they were based: *Standing Nude* (pl. 98) with Bouguereau's *La Jeunesse et l'amour* (pl. 99); and *The Toilet,* ca. 1878 (pl. 100), with *Le Lever* by Delacroix (pl. 101). In each case Cézanne has raised one or both arms of the figure in the earlier work so as to expose the armpit. (In his *The Toilet* he has a black-

101. Eugène Delacroix, *Le Lever*

amoor holding the mirror, yet another instance of a symbol for himself shown as black.) His version of Bouguereau's nude, the position of whose legs and feet he retains, is the more touching when we recall his sardonic phrase "Bouguereau's Salon," a reflection of his inability to gain acceptance by the official Salon. As remarkable as his manipulation of the nudes of his predecessors is the fact that the armpit is visible in more than twenty oil paintings by Cézanne, a number not nearly approached by his friend Renoir, a devotee of the female nude.

 Nor is it surprising that his interest in this region should have a verbal dimension. The word *aisselle* ([ess-el] armpit) seems to raise the question, *Est-ce elle?* (Is it she?) The question, though hidden, will be answered in a

102. *Small Houses at Auvers,* 1873–4 (V.156)

later painting. In the *Temptations* of 1874–7 (pls. 92, 93), the *aisselle* of the Temptress is echoed by the *essaim* (swarm) of children at her feet.

After working for almost a year with Pissarro at Pontoise, in 1873 Cézanne took his little family to nearby Auvers-sur-Oise, where Dr. Gachet, a collector of the Impressionists and himself an etcher, had a home. There followed a productive period during which Cézanne painted *Small Houses at Auvers,* 1873–4 (pl. 102). It shows a parade of young trees in the foreground, a row of small houses behind them, then fields going across the canvas and up to a high horizon that leaves room for a narrow strip of sky. The scene is that farmland typical of the Ile-de-France, rendered in the large clear design and ambiguous detail that we have observed before.

Especially ambiguous are the parallel vertical bands of pink on the right. Only vaguely suggestive of rows of plantings, these striations seem

to float above the field rather than describe something in them. Just below these regularly spaced brushstrokes is a clump of greenish-white shrubbery that extends to the left, where it turns upward, almost touching the corner of the white house. When the pink striations are seen together with the shrubbery, they make the back of a large right hand that seems to reach up over the field. This field has three large divisions: a broad expanse sloping up from the right to the left side; a triangular wedge which enters from the right; and a narrow curving section between the wedge and the sky. These three areas adumbrate the pelvic region of a recumbent woman: the lowest being the left thigh; the uppermost, the top of the right thigh; and between them, the pubic triangle. At the sharp angle of the pubic region are two elliptical green shapes, one on the other, whose presence in this landscape is difficult to justify from a geological, botanical, or horticultural point of view. But they make anatomical sense when seen as the labia of the genitals. The cryptomorphic hand on the right seems to be reaching toward this configuration on its left, the canonical place of Hortense. The phallic tree athwart the expanse of blue sky—most of which is on the right—is a sign of Cézanne's continuing fixation on his mother, which is ineradicable and is manifested, as usual, in proximity to an image of Hortense.

The configuration I call "labia" is present in three similar landscapes, all titled *The Bay of Marseilles Seen from L'Estaque*. In one, of 1878–9 (pl. 103), a chimney goes across the right side of what looks like a pair of lips in the foreground; in another, of 1883–5 (pl. 104), the top of the chimney touches the lower edge of a labialike configuration; in the third, of 1886– 9 (pl. 105), the top of the chimney seems to penetrate the configuration which, as in the other cases, is on the left side of the painting and so refers to Hortense. In all three paintings a great mass of blue sea enters from the

103. *The Bay of Marseilles from L'Estaque, 1878–9 (V.428)*

right. There is no escaping the association of *mer* (sea) and *mère* (mother). It is not, strictly speaking, Cézanne's invention (or mine): *Mère Méditerranée* is in current use.[11] And *la mer bleue* (the blue sea) sounds like *la mère bleue* and supplies us with the source of the color that is the constant attribute of Cézanne's mother. The three large works called *The Bay of Marseilles Seen from L'Estaque* surely have as their deep subject Cézanne's greatest personal problem: an erotic attachment to Hortense, which is never free of an overwhelming awareness of his mother.

In roughly the period of these works, Cézanne would shift his point of view at L'Estaque slightly to the west (that is, to the right) and paint a different aspect of the Bay of Marseilles in three related compositions. In the foreground of the first, of 1883–6 (pl. 106), is a group of houses seen from above, with the sea in the middle distance and a narrow expanse of

104. *The Bay of Marseilles from L'Estaque*, 1883–5 (V.429)

105. *The Bay of Marseilles from L'Estaque*, 1886–9 (V.493)

106. *View from L'Estaque*, 1883–6 (V.426)

107. *View from L'Estaque*, 1883–6 (V.427)

124

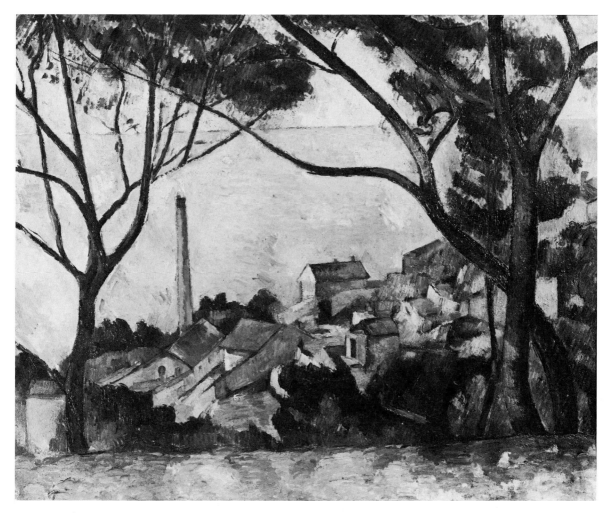

108. *View from L'Estaque,* 1883–6 (V.425)

sky above. This starkly simple division of the canvas is broken by a tall chimney, which rises from the foreground and penetrates the area of the sea. Phallic by definition, directed to emblems of Hortense in previous views of the bay, it now invades the emblem of the mother. A second painting, of 1883–6 (pl. 107), shows rooftops as in plate 106, but fewer of them since the easel seems to have been moved a few feet back from its earlier position. The stretch of sea beyond the houses is covered in large part by the interlacing branches of trees on the left and right. The phallic chimney has shrunk to the state of a tiny accent. In compensation, as it were, for the suppression of the erotic implications of the previous work,

125

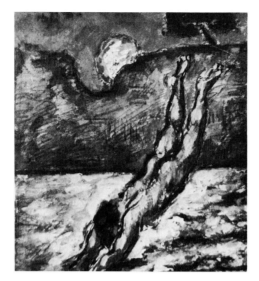

109. *Man Diving into the Sea,*
1867–70 (R.29)

the branches interwoven over the water on the left construct an *A,* or rather two of them—for Anne Aubert, the maiden name of Cézanne's mother.[12] In this fantasy she is unmarried, and therefore available.

The last work in this series (pl. 108) is similar to the previous one but shows some significant differences. The chimney has almost the relative size and prominence it had in plate 106, but its naked intrusion on the sea is now mitigated and absorbed by the overarching branches. The rooftops occupy a somewhat smaller area and the interlace that makes the *A*'s are more linear than in the second work, resulting in an expanse of sea which is larger and more visible. The *A*'s are now more legible because they are *less* leafy and the trees on the right *more* leafy than previously. In the final painting of the series the chimney has become doubly significant: it enters the region of the sea and points directly to the interlace. The crossing tree trunks at right, surely an erotic motif, are more firmly designed than in plate 107. The same erotic reference to the mother is repeated in the large *X* of plate 16, which also shows two large *A*'s.

In the third painting the elements that embody Cézanne's fantasies coalesce. It is clearly the most resolved of the series and, typically, resolution affects size: it is more than one and a half times as large as the combined areas of the others. The fullness of expression and size of the last landscape are indexes of the stature of his mother in Cézanne's thought. His attachment to her was profound; even when Hortense was in Aix or Gardanne,

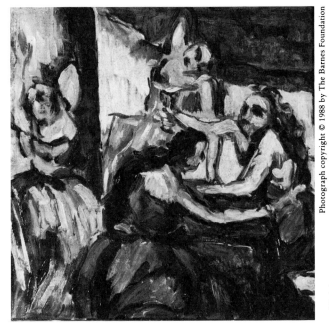

110. *Courtesans,* ca. 1871
(V.122)

he would spend a great deal of time with his mother at the Jas de Bouffan. The intensity of his feelings helps to explain the hallucinatory character of an early watercolor, 1867–70 (pl. 109), of a man diving into the sea—a plunge in which the self rushes into the welcoming waters with the propulsion of the soul's need. Cézanne said that his favorite sport was swimming; there is no question of his love for his mother. The watercolor shows the sense in which these two loves were united.

The appeal of Cézanne's mother was irresistible and his indulgence of it euphoric, as the watercolor suggests. His attachment to Hortense, with its physical basis, inevitably resulted in a very troubled inner life. There can be no doubt that Cézanne's simultaneous attraction to the two women was a long-lasting torment—what the French often call a *calvaire.*

His thematic escape from this torment occurs in a *Judgment of Paris* of ca. 1883 (pl. 124) and the series of female Bathers begun about 1880 and culminating in *Five Bathers,* 1885–6 (pl. 155). Although mistress and mother are symbolically present in these paintings, they create no tension in the artist since the theme is no longer erotic. The mother assumes the honorific position at the left; in compensation, Hortense, now centered, is raised above her.

127

The four women in *Courtesans,* ca. 1871 (pl. 110), show a 1-and-3 grouping like that of the first *Temptation* (pl. 89). We recognize the woman

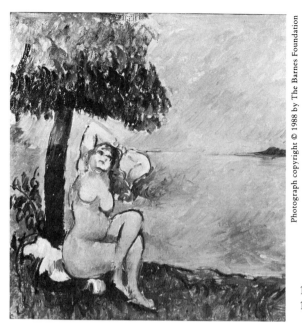

111. *Nude by the Seashore,*
1875–6 (V.256)

against the left wall panel (*pan de mur*) as Hortense because of her position in the painting and her bent arm. (Why is the other arm, with the open hand, stretched upward?) We may again understand the three on the right in this bordello (*bordel*) as the women in Cézanne's immediate family. The large woman in the foreground, dressed in blue, to the right of Hortense, would be the mother. The other two would be the sisters Marie and Rose. Which is which? I think the courtesan in the upper register is Rose and the one at the right, Marie: Rose was interested in men, she later married; Marie remained single. Marie is again at the extreme right, as in the first *Temptation* and *Six Bathers;* she has, besides, a customarily male feature in the outstretched arm, a phallic motif. Hortense and Rose, their arms raised suggestively, are the youngest of the four women. Cézanne has put two women rather than one in the Temptress pose in order to establish the nature of the milieu (just as Picasso, who may have seen this picture, did in *Les Demoiselles d'Avignon*).

Courtesans is related to two paintings by their small size—the largest is twelve and a half inches tall—and their dates of execution, 1871–6. Their conventional titles are *Nude by the Seashore* (pl. 111) and *Man with a Jacket* (pl. 112), but we will disregard these for the moment. Let us note the disreputable appearance of the man and recognize the island in the Mediterranean behind him as Ile Maire—Venturi mentions it twice,[13] and it can be seen on a map of Marseilles and its waters. We may now say that the

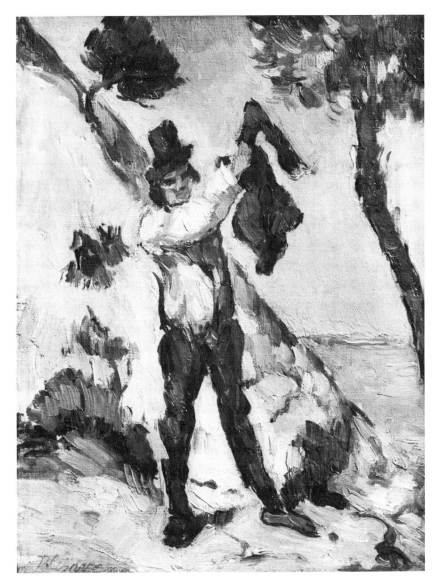

112. *Man with a Jacket*, 1875–6 (V.248)

paintings show, successively, four women in a bordello (*au bordel*), a nude by the seaside (*au bord de la mer*), and a man by the seaside (*au bord de la mer*, suggestive of *Au Bordel La Mer* or *La Mère*). *Maire* is Provençal for "mother," and the inclusion of the island in many paintings underscores the association of *la mer* with *la mère*. Cézanne's repeated references to women, especially Hortense and his mother, in the context of prostitution and the bordello, would seem to be explained by an insight of Freud's that boys have the fantasy, "by degrading her, to win the mother as an object for sensual desires."[14]

129

The Girl from Paris

In the period 1874–7 Cézanne painted a scene of Paris rooftops (*toits de Paris*) under a bald sky (pl. 113). A short time later he painted another such scene, under a cloud-filled sky (pl. 114). In the second work it is possible to see, in the central cloud formation, the reclining head of a woman who faces the viewer, the top of her head to the right. Her chin would be in the pale area to the right of the four prominent chimneys; the first dark patch to the right of this is her mouth, the next is her nose, and the third, slightly higher, is her right eye; her left merges with the shadow over the roofs; the curving edge of the clouds suggests flowing hair. There is no reason to think she is other than Hortense, *toi de Paris* (you of Paris). The *toits/toi* pun tells us that the work is an (unconscious) designation of Hortense as a Parisienne; it was of course in Paris that she and Cézanne had met. That the image in the clouds represents Hortense is underscored by another play of word and image: we have seen that she is symbolized by *pommes* (apples), and in the painting she is materialized in a *ciel pommelé* (dappled sky). The chimney pots for which Paris is famous dot the scene, several of them profiled against the throat of the floating head.

In the same period Cézanne made a pencil drawing (pl. 115) in which a gesticulating man reads to a half-reclining nude woman. Near her head he drew another head, larger and more carefully rendered, clearly resembling Hortense, who in turn identifies the reclining woman. She rests on a structure—not a couch—executed in dark tones of watercolor. This curious support is unintelligible till the page is rotated 180 degrees, at which point it is seen to consist of two rows of chimneys rising from the edge of a roof. If there is any doubt concerning the association of Hortense with the rooftops and chimney pots of Paris, it must be dispelled by this unexpected evidence.

The drawing is without doubt a study for *L'Eternel féminin*, 1875–7

113. *The Roofs of Paris*, 1874–7 (V.175)

114. *The Roofs of Paris*, ca. 1877 (V.1515)

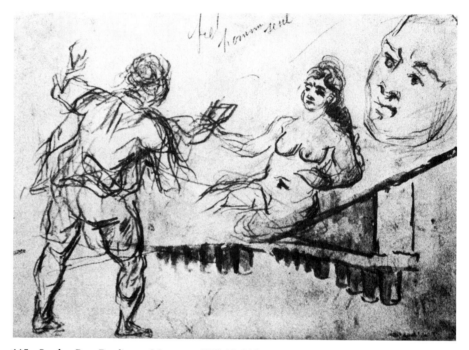

115. Study: *Poet Reading to Muse,* ca. 1875 (C.362)

(pl. 116). In this painting, contemporaneous with or slightly later than the second *Toits de Paris,* a nude woman seated under a canopy is idolized by a throng of men spread out at her feet—an artist, musicians, men bearing fruit and drink, a bishop in a red robe, and others, probably poets. The work is the culmination of a series of three inspired by Manet's *Olympia,* a nude portrait of a well-known Parisienne shown looking out at us, the picture's viewers.

In the center of Cézanne's painting, the right leg of the woman seems to disappear into the large and prominent miter worn by the bishop. In the drawing of the reclining woman, the upper part of her right leg ends at the chimney pots painted below her. The two right legs have rather different terminals—a bishop's miter and a chimney pot—yet the French

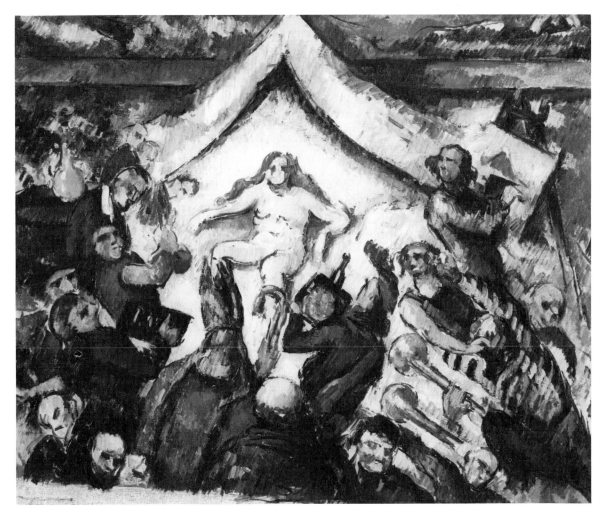

116. *L'Eternel féminin*, 1875–7 (V.247)

word for both is *mitre*. It would be difficult to adduce a more striking
example of the manner in which Cézanne's graphic invention is propelled
by verbal association. The configuration in which the leg seems to enter
the miter, or the miter to engulf the leg, is an ironic commentary on the
enslavement of the clergy by Woman, unconsciously triggered by a string
of associations linking a woman, rooftops, chimney pots, and a bishop's
miter. In the fantasy of *L'Eternel féminin,* the woman was Hortense, not
Woman in the abstract.

The first *Toits de Paris* (pl. 113) now appears untypically barren, "ob-
jective," opaque, hermetic—in spite of having been impelled by the
thought of Hortense. Not till she enters the picture cryptomorphically
and fills out the *toits/toi* conceit is the picture's deep purpose fulfilled.

L'Eternel féminin, for its part, is a parody of an Adoration of the Magi, minus the child. Stimulated by the *Olympia,* critical of it, drawing on Cézanne's mixed feelings toward both Manet and Hortense, it is rescued from didacticism by its boisterous imagery, brilliant color, and vigorous execution.

This is the painting in which, according to Reff, the "constructive stroke" of Cézanne was first employed. If this is so, the occasion was suffused with eroticism. It should be noted that Cézanne's stroke—distinct from Monet's cursive and Seurat's dot—was straight, thus phallic by definition. Such strokes, laid side by side and varying in color and length, engender ambiguity in every context and make possible the metamorphosis of all subjects while eroticizing them.

Hortense is often associated with the color red—in apples, in a dress in which Cézanne portrayed her. Red, the color of blood, of life and love, warms her face in *Mme. Cézanne in a Red Chair,* 1877 (pl. 117), doubly dazzling in its beauty of construction and the model's own beauty, rendered without the reserve so often felt elsewhere. In her aplomb we read the artist's confidence and the couple's mutual respect; the painting surely marks a signal moment in their personal relations.

Hortense is stylishly dressed, for she liked fine clothes.[1] They came, of course, from Paris and here are set off by the embracing chair—"the first and last red chair in all of painting," said Rilke.[2] This monumental shape projects from the wall, but only on the right side. Since the scene is lighted from the left, all the indications of depth are on the right: the shadows within the figure of Hortense, her shadow on the chair, the chair's on the wall. On the left we are in flatland—wall, chair, and blue arm seeming to lie on the same plane. This reduction to pattern makes it

117. *Mme. Cézanne in a Red Chair,* 1877 (V.292)

possible for one of the motifs in the wallpaper to stand on the arm of the chair. As we ponder this effect, we see that our motif is the largest of the several in the painting and that they get smaller as we follow them up and to the right. When we reverse this path they seem to become spatial, coming forward as they get larger, until the largest lands on the arm of the red chair. The sure sign of this progression in depth is the overlap of one design on another at the upper right; in addition, the picture has been so designed that all the motifs evident on the wallpaper can be connected by a continuous sweeping line—that is, they do not lie in two rows or become the apexes of a triangle as in other paintings (V.213, V.209). We have, then, five decorative elements that move forward, to the left, and then down, till one alights beside Hortense. Seen in this way, they look like little creatures or imps, the largest one certainly so. But surely all are the same imp, Paul *fils*. Since the painting was done in 1877, it would be a birthday picture: five imps for little Paul's five years.

The freedom of the decorative motif from its ground is not exceptional in Cézanne; it is in fact rather the rule that such elements, in spite of belonging to the wall, become unstuck and lead a life of their own. If the wall's flatness is often betrayed, the spatial indications are usually rudimentary, a sop to our expectations. We are served an illusion of the illusion of depth. Effective illusionism in Cézanne is often reserved for the unconscious dimension—as in the flight through space of the imp in the wallpaper. Cézanne's manipulation of the illusion of relief, the illusion of planarity, and the actual planarity of the picture surface creates a dubious, unstable spatiality which permits him to charge his pictures with a multitude of notations that have tasks other than the registration of the scene before him.

Mme. Cézanne in a Red Chair is dated 1877 by Venturi, correctly as I

think, because in that year Cézanne is known to have lived in a house papered with the design that appears in the painting. There are some nine other works showing the same design that are doubtfully dated around 1877—far too many for Cézanne's nervous intellect to have tolerated in a brief period. Besides, it has become clear that this wallpaper was a common one. The design is in any case simple, and in view of his visual memory and his great invention in motifs and subjects far more complex, Cézanne could have inserted it whenever and however he wished; indeed, it changes somewhat from painting to painting. Yet all the variations have the same significance since it is a cross.

That seems to go without saying, and in fact the only writer who has said so is Rilke,[3] art historical attention having been occupied with the motif's date of appearance, not its design. In the present case, the cross is also a child, a son (*fils*), who has the character of an imp (*esprit*). The one on the arm of the chair is surrounded by a golden color, as by a nimbus or halo. Five years before, the shape of the infant with the face of the black clock was already cruciform (fig. 5). The importance of the cross in Cézanne's symbolic system, and of its association with Paul, cannot be overstated.

Hidden in Hortense's right arm, which rests on the chair, is the long profiled head of a woman who faces to the left. Hortense's elbow is its nose, with a well-designed eye in the crook of the sleeve. In the loose sleeve below, two light patches serve as lips, with the end of the sleeve as the chin. About ten inches high, this head is a life-size image of Mme. Cézanne *mère*. She looks directly at the cross, which is little Paul, whom she loved; but she looks at it too because she was devout.

The fichu on the dress, extending from below the collar to the hands, secretes an excellent portrait of Cézanne *père,* looking to the right, tight-

137

118. *Still-life with Soup Tureen,* 1877 (V.494)

lipped, his face lined and bitter (fig. 9). He is *fichu* (as an adjective: bad, sorry, pitiful), the third derogatory reference to him in the paintings. Here, facing right, with his wife interposed, he cannot see the imp, Paul, on the left.

Hortense is the subject of a portrait that is possibly the most astonishing cryptomorph in the oeuvre; it occurs in *Still-life with Soup Tureen,* 1877 (pl. 118), painted in the same year as the preceding work and sharing its warm color, rich pigmentation, and preoccupation with the artist's family. It features a brightly decorated faience *soupière,* a black wine bottle, two apples, and a basketful of the same fruit, disposed on a figured red tablecloth. The arrangement is shown against a wall on which three unframed canvases are tacked. The one on the left is recognizable as Pissarro's *Road to Gisors, House of Père Galien in Pontoise,* 1873 (pl. 119); beside

119. Camille Pissarro, *Road to Gisors, House of Père Galien in Pontoise,* 1873

it is a scene of barnyard fowl of which Pissarro did several, although none corresponding to the version in Cézanne's painting has been found; the painting on the right shows too little to permit identification. There is little doubt that the *Still-life* shows a scene in Pissarro's home in Pontoise, where Cézanne and his wife and child were guests in 1877.

Of the paintings on the wall, Reff has stated that Cézanne "simplifies" the first one so that eventually it has characteristics of his own street scenes, and from the second painting "extracts so confusing an image of blurred and brightly colored shapes" that we cannot identify it; and he finds "formal and expressive correspondences" between these paintings and the objects on the table. Thus, "appropriately," the straw basket and the "rough, sprawling and irregular" apples are in front of the barnyard scene, while the tureen and bottle, "smooth, closed and symmetrical . . .

139

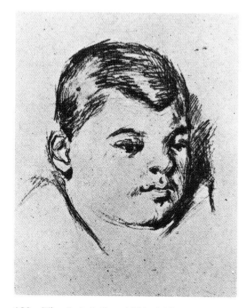

120. *The Artist's Son,* 1880–1 (C.820) 121. Paul Cézanne *fils,* photograph, ca. 1886

manufactured and sold in the city," are placed before the street scene. But it is plain to see that the bottle—whether viewed as pattern or illusionistically—is *not* in front of the street scene; it is in front of the barnyard painting. In fact, Cézanne has been so careful to have the street scene merely touch the bottle with its corner, that this fact itself must be significant, and we shall find it so. Furthermore, although bottles and baskets are generally symmetrical, their representations in the painting are not. Even if Reff's reading were a true description of the objects and their relations, we must wonder why such relations are "appropriate." The tur-

een, it seems, is placed "frontally" to correspond to the frontality of the house in the street scene. Even if this were so, we must ask, to what does the diagonally placed basket "correspond"? The tureen, finally, "may even suggest a physiognomy" that contributes to the "expressiveness and gravity" of the left side of the painting.[4]

There is every reason to identify the "physiognomy" in the tureen as that of Paul Cézanne *fils,* who was five years old at the time of the painting. A drawing of him of 1880–1 (pl. 120), a photograph of about 1886 (pl. 121), and Cézanne's portrait of 1885 (pl. 170) show the upturned nose that Cézanne often recorded[5] and that the handle of the tureen renders with caricatural accuracy. We note that the knob on the tureen's cover encroaches on Pissarro's street scene. The French term for this knob is *bouton,* also meaning "head of the penis" in French erotic vocabulary. And, to be sure, the knob of the tureen cover resembles the human organ. Proceeding upward from this penile form like a liquid jet is a slender tree trunk that ends in a spray of foliage. We must conclude that little Paul is *pissing* on the *Pissarro*—in French as in English. The same play of words is in effect in Cézanne's drawing of Pissarro (pl. 5). In "simplifying" the street scene Cézanne eliminated two of three slender trees in order, we may say, not to confuse the issue.

Having gone so far in our scrutiny of the tureen we may go further, into a personal terrain never before explored. It may fairly be said that in Cézanne's painting the tureen is a quite large object, suggesting therefore a large head. And in the drawing (pl. 120) and portrait (pl. 170) the head of the model is indeed large. Nor was Cézanne alone in having this impression of his son's appearance. In 1886 Zola, his friend of thirty-five years, published *L'Oeuvre,* a novel about the artistic life of Paris, which focuses on the decline of a talented but impotent artist. Zola based the

141

career and character of this painter largely on Cézanne, with other elements drawn from the lives and persons of Edouard Manet and Claude Monet. Zola's fictional artist, Claude Lantier, is the father of Jacques, who at the age of five has a "head grown excessively large"; Lantier, in a burst of temper, refers to him as "idiotic" and "an idiot." Seven years later the child is ill, his cranium now so large that he cannot support it. He dies, the growth of his head compared by the novelist to "the swelling of cretins."[6] The case of Jacques has never been examined, apparently having been accepted as a typically dolorous invention of Zola's. On the evidence of *Still-life with Soup Tureen,* the two portraits by Cézanne, and Zola's account of the child in *L'Oeuvre,* it is likely that Paul *fils* had a notably large head. Why Zola exaggerated it in a manner calculated to cause pain to Cézanne is another story.

The complex demonstration of the persona in the soup tureen does not have to be made for the black wine bottle, which is black-bearded Cézanne himself. Indeed, the spirelike upward extensions of the overlapping tureen and bottle show these to be a phallic pairing of father and son. There is a more subtle sign of the bottle's identity: Pissarro's street scene touches it on its shoulder (*épaule*), a term that is part of the French nomenclature of the bottle, as it is of ours. It is appropriate, in view of the teacher-disciple relation between the two men *at the time when the street scene was painted,* that that particular work should be touching Cézanne's symbolic shoulder.

We are led inexorably to consider the two apples on the table and the basket of apples as reference to Hortense. The apples in the basket are bounded at their upper limit by the handle (*anse*), a term already linked to Hortense in another of its meanings: "creek." But Hortense is not only symbolized by the apples in the basket; she is portrayed—figured forth—

by them. For the basket frames a beautiful cryptomorphic head of a young woman composed of the fruit and looking toward the tureen: she can only be Hortense. The pale apple directly below the *anse* serves as her brow; another pale one below contains her eyebrow, nose, and cheek, with the apple's cavity contriving to be a marvelously rendered eye. Hortense's right eye is in shadow; her right cheek occupies the angle formed by the handle and the body of the basket; the edge of the latter cuts off her lower lip and chin. Three red apples below the handle compose the hair. An effort is required to see the head (fig. 10); once seen, an effort may be required to dismiss it. The conjunction of the apples and Hortense in this cryptomorph pins down one of Cézanne's persistent symbols, underscored here by the two apples (*pommes*) outside the basket. In *Still-life with Soup Tureen* the fruit creates an image of the person it usually symbolizes—a rare case of the identity of signifier and signified (another was the arm/phallus). The extraordinary apparition in the basket is not readily evident because a realistic head and equally "real" apples occupy the self-same area. Such an achievement can only be seen as another—if unexpected—manifestation of Cézanne's genius.

We have to do, then, with a group portrait that even while imbedded in a symbolic structure is rendered with humor, pride, and a recognition of problems in the family situation. The face of Hortense in the basket looks reprovingly at the tureen, where the chastened mask of Paul *fils* is set in a tearful grimace. The bottle seems to reserve comment on Paul's misdeed but is clearly on his side. Paul's mischief is consistent with his known defacement of his father's painting, accomplished, it seems, with never a reprimand.

Cézanne has been remarkably even-handed with the members of the group, while varying their representational status. The tureen, though to

one side, is the center of attention; the apple-portrait occupies the geo-metrical center of the painting; the bottle, though spatially modest, dom-inates by its height. Paul, in the tureen, is a real presence; Hortense, a magical presence among the apples; Cézanne, a symbolic presence. I would claim that these shapes and positions, their attendant symbolic val-ues and the tension between them make possible what is after all a most unusual composition—heavily weighted on the left, almost "empty" on the right, and showing a gap between two groups of objects.

The warmth of Pissarro's friendship is symbolized by the red table-cloth in whose embrace the objects are shown. Cézanne has graciously permitted his hosts paintings to mount higher than the self-referential bottle. His tolerance of his naughty son does not compromise his respect for the older artist. Respect, we now see, is the reason why the bottle does not encroach on the street scene; it is little Paul's *bouton,* the knob on the tureen, that does that. If we turn to Pissarro's *Portrait of Paul Cézanne,* 1874 (pl. 122), showing Cézanne seated in front of the same picture, we see that Pissarro covered up much more of *his own* painting than Cézanne allowed himself to, at the same time that he is generous, like Cézanne, in his display of works by two other artists. It now seems odd that Cézanne should have copied one Pissarro painting with such slight alteration (*pace* Reff) that there is no doubt concerning its identity, and have copied an-other so that its subject matter is difficult to apprehend. From the per-spective of the tact with which the street scene has been presented, it would appear that the barnyard painting has been rendered all but un-intelligible so that the bottle *might* overlap it—without covering an actual Pissarro. For, as I think, the original of the barnyard scene will never be found; Cézanne has invented a Pissarro.

Even less comprehensible is the fragment of a painting on the extreme

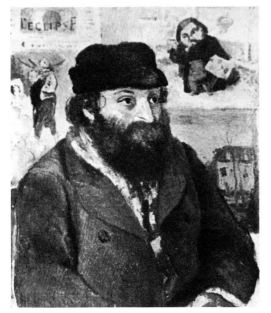

122. Camille Pissarro, *Portrait of Paul Cézanne*, 1874

right. It and the barnyard scene were introduced primarily, it would seem, to prevent the street scene from becoming focal, in spite of being clearly the most important. Secondarily, they are rich in ambiguities—something that could not be imposed on the street scene.

What are we to make of the cryptomorphic head (fig. 10), which faces the neck of the bottle with its mouth open? It ends in a sharp horizontal line made by the edge of the table. The hidden head of Hortense is *in a basket,* probably because she "lost her head" over little Paul's prank; the head of Paul, the tureen, is a discrete object. (There are hundreds of cryptomorphic heads in Cézanne's oeuvre; most of them merge with their surroundings in the region of the neck.) Finally, the fowl are missing *their* heads—and in the congeries of shapes we know this to be the case because of the one discernible head in an area otherwise ambiguous. Thus, much beheading (*decollation*) in the context of a simple meal (*collation*) of soup, fruit, and wine. Since *panier* (basket) is a vulgar term for "bed," the image of Hortense in the basket would also have an erotic connotation.[7]

Why a "headless" Pissarro? It is quite likely that Cézanne thought his friend had "lost his wits" (*perdu la tête*) to paint the barnyard pictures, since those that we know are certainly inferior to the street scene of 1873. Cézanne later said, "If Pissarro had continued painting as he did in 1870 he would have been the strongest of all."[8] Our still-life shows Cézanne touched by a picture from that period, when he first worked alongside

Pissarro. Since the barnyard paintings were done in 1877, the date of Cézanne's visit to Pontoise, the symbolic intrusion of Cézanne and Hortense upon a "headless" version of these pictures must count as a critical reaction to Pissarro's recent work.

The red tablecloth turns gray in the gap between bottle and basket; perhaps a shadow had fallen on the relations of Cézanne and Hortense. Yet *Still-life with Soup Tureen* is the complex record of a memorable occasion and an amusing episode in the friendly ambience of Pissarro. In the midst of the still-life, at the center of the psychological and illusionistic space, triangulated by fellow artist, wife, and son, is Cézanne himself in the guise of a dark bottle, gleaming by virtue of a white highlight (*lustre,* with its echo of *illustre,* "illustrious")—the only one in this company with a head on his shoulders.

In the course of a lengthy essay on the significance of the still-life in the oeuvre of Cézanne, Meyer Schapiro claims that a (lost) painting traditionally known as *The Judgment of Paris* (pl. 124) should be called *The Amorous Shepherd*. His argument may be summarized as follows. Cézanne could not have been unaware of the Greek myth according to which Paris awards an apple to one of three goddesses. In the painting in question, however, the shepherd is about to bestow an armful of apples on a young woman who is the least prominent of the three before him. Besides a superfluity of apples, there is an excess in the number of women, since the draped female at the right is not required by the myth. But there is a passage in Propertius that Cézanne could have read and that is a more likely source of the painting than the myth of Paris; in it the poet sings the love of a girl won by ten apples. At the symbolic level, the painting would have been suggested by elements in Cézanne's biography. A pas-

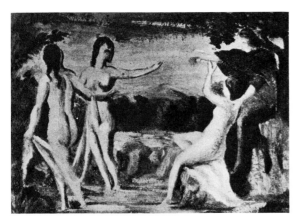

123. *The Judgment of Paris,*
1861 (V.16)

sage in Joachim Gasquet's memoir of Cézanne gives the artist's account of
an episode from his boyhood: at school he befriended Emile Zola, who
had been ostracized by their schoolmates, and in his turn was set upon by
the other students; the next day Zola brought him a gift of a basket of
apples. "Ah, Cézanne's apples, they start a long way back," said Cézanne
to Gasquet with a twinkle in his eye.[9] The painting, then, is a "transposi-
tion of that boyhood episode with Zola to his own dream of love." We
may conjecture that the "affective moment" of the painting, the occasion
that called it forth, was a reading of the Latin poets in the early 1880s that
suggested this "pastoral theme of Virgil and Propertius" and "revived an
unspoken hope that his own painting might bring him love."

These formulations present many difficulties. If our complex painting
shows Cézanne's "own dream of love," if there is "transposition" from the
mythological to the personal, we should know what becomes what in the
process. Schapiro proposes that the three women who do not receive
apples "can be regarded as accessories—like the landscape itself with its
indeterminate trees, sky and stream." But after much learning has estab-
lished a specific classical context for the painting, it is unsatisfactory that
three-fifths of its population and the landscape surrounding it be consid-
ered accessories. This landscape, moreover, is not carefully described.
Furthermore, it is extraordinary that a *Judgment of Paris* which Cézanne
painted some twenty years before is mentioned by Schapiro only in a
footnote at the end of this long essay.[10]

The first *Judgment of Paris,* 1861 (pl. 123), shows the requisite three
beauties and single apple. The goddesses have their feet in a shallow
stream, a feature not mentioned in the myth; missing are the sheep, the
attributes of Paris often present in paintings of this theme; Paris and one
of the goddesses are curiously intimate. In view of this early and idiosyn-

147

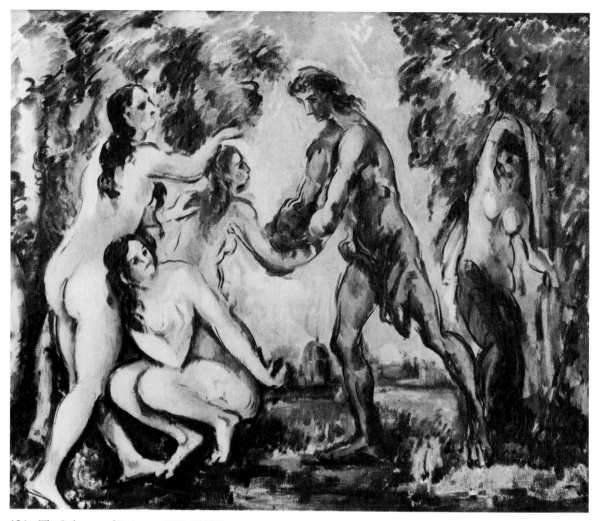

124. *The Judgment of Paris,* ca. 1883 (V.537)

cratic *Judgment of Paris,* it seems more reasonable to consider the later painting as another, fuller, more complex and no less idiosyncratic version, than to suppose a new theme based on a new text. The later painting has the shepherd facing the three women required by the myth of Paris; these, by their grouping and nudity, are clearly of an order different from that of the draped figure behind the shepherd; two of them have their feet in a shallow stream similar to the stream in the early painting. New in the later work are the abundance of apples, the fourth woman, and something in the landscape. These features and others not yet mentioned will, upon examination, confirm the painting as *The Judgment of Paris.*

On the horizon, visible beyond the lower legs of the shepherd, is a city. Prominent here is a building with a large dome and lantern: the Pan-

théon. It is symbolic of Paris and appears in paintings and drawings in the latter part of the 19th century whenever Paris is shown from a distance. Cézanne had included it in *The Promenade,* ca. 1870 (pl. 85), and had made a drawing of it (C.802) shortly before painting the *Judgment.* The proximity of the domed building and the shepherd's leg serves to emphasize a link between the city and the shepherd—their common name, Paris. The shepherd bestows apples on the young woman as a gift from Paris (in both senses); she accepts them as an invitation to go to Paris (in both senses). And that is why she is the least prominent person in the painting: already starting out for Paris on the horizon, she is the farthest from us, only partly visible beyond those who stay, her body facing the city even as she turns her head to the shepherd in accepting the apples. When we recall Cézanne's defense of Zola in the schoolyard, the grateful boy's gift of apples, and his urging Paul, six years later, to come to Paris (his birthplace; he had been taunted at school for being a "Parisian"),[11] it is not difficult to see the shepherd, the new Paris, as Zola.

If he is Zola, the young woman who accepts the apples and sets forth to Paris can only be the young Cézanne. Surprising as this change of sex may be, it is inescapable at the symbolic level. It is consonant, too, with the fact that the large woman at the left, whom Schapiro describes as "mature," has a hand on the young woman's shoulder (*épaule,* always with reference to *Paul*). We see now that Paris, in the *Judgment* of 1861, has his hand on the shoulder of the goddess beside him, with the same implication. In analyzing a painting made after the second *Judgment,* I will show that the mature woman represents Cézanne's mother, and will offer yet another reason to identify the young woman as Cézanne. In the meantime it will be convenient to refer to the former as Mme. Cézanne, and to name the young woman Paule. We see that our Mme. Cézanne's left hand, the

149

125. Detail of *The Judgment of Paris,* pl. 124

one on Paule's shoulder, which Schapiro characterizes as "friendly" and "protective," can also be read as urging Paule forward. As we know, Mme. Cézanne was sympathetic to her son's desire to become an artist, as Cézanne *père* was not.

Held in the raised right hand of our Mme. Cézanne and rising almost to the painting's upper edge is an excellent cryptomorphic head of the artist (pl. 125), which faces her. It shows Cézanne as he must have looked at the time of the painting, when he was about forty-four years old.

The draped woman on the right, with an arm resting on her head, strikes the pose that identifies her as Hortense, hence as the Parisienne. And doubly so since she is dressed like the Venus de Milo, one of the treasures of the Louvre. Here Cézanne merges the Venus and Hortense; he was surely thinking of her when he made drawings of the sculpture during the years 1872–5.[12] In this *Judgment,* Venus/Hortense and Paris/Zola are linked graphically by virtue of being Parisian. The latter does not offer an apple to Venus as required by the myth, but presents an armful to Paule, whom he prefers. In the *Judgment* of 1861 he makes the same choice, offering an apple to a goddess who is leaving, while his other hand touches the shoulder of one who stays. In the later *Judgment,* the Parisians on the right are contrasted with the Provençals on the left, an opposition of city and country emphasized by the contrast between clothed and nude figures.

If at the mythological level the crouching woman is the third contestant in the *Judgment,* in the present context she has other functions at the symbolic level. Her pose is forced and unusual, the position of her left arm especially so; and in her upturned hand she holds a red apple. In Dürer's engraving (pl. 126) Eve similarly holds an apple in the upturned left hand of an arm resting against her hip and rotated inward. Let us call

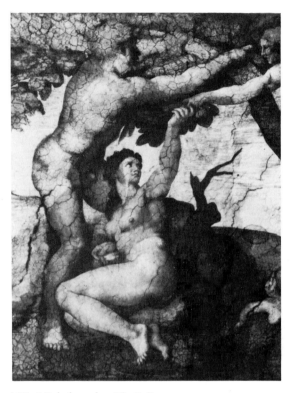

126. Albrecht Dürer, *Adam and Eve,* engraving, 1504 127. Michelangelo, *The Fall*

the woman with the apple Eve. Crouching beside the standing figure with arms outstretched, she resembles indeed another Eve, crouching beside the Adam who stands with arms raised in Michelangelo's panel (pl. 127).[13] By these references to two famous images of Adam and Eve, Cézanne's provincials suggest that Aix was Eden, the Paradise that Paule abandons for Paris. (In French there would be a play here on *Paris* and *Paradis*.)

In a further exercise of her role, Eve is an element in a significant rebus. Her right foot is linked graphically to the left foot of our Mme. Cézanne. If we read the latter's leg as an *L,* which it resembles, and join it to the name of the crouching woman, we have *LEve*. The figures of Paris and the Parisienne together make an excellent large *N. LEveN* suggests *L'Evénement,* the newspaper for which Zola wrote during his early days in Paris and which Cézanne's father is shown reading in the portrait of 1866 (pl. 29). And indeed at the feet of the Parisienne is a dark bush to which her left hand and the falling drapery direct us; nothing in the appearance of this bush prevents us from identifying it as *menthe* (mint, a

151

plant which flourishes in Provence) and completing our rebus. We now have another reason for Paule's lack of prominence: if her legs were visible to the right of Eve they would interfere with the rebus, which is read continuously without omitting anything on the way.

Our painting telescopes the past and present of Cézanne's relations with Aix and Paris in an image that dazzlingly conflates the Bible and Greek mythology, original simplicity and classical sophistication. Even as the young Cézanne benefits from the judgment of Paris the shepherd, he goes forth to seek the judgment of Paris the city. How favorable was his reception is shown by the image of Venus/Hortense on the right and by his own mature portrait in the painting's topmost zone. Here it is held aloft, directly above his youthful image, by his mother, who thus touches him both early and late. In the midst of the picture's intricate symbolism we should not overlook a distinctly phallic fold protruding from the shepherd's garment in the direction of Paule—an understandable feature at the mythological level and a residue of Cézanne's youthful homoerotic fantasies concerning Zola.

The painting may be dated ca. 1883. Its "affective moment" was surely generated by an important event (*événement*): Cézanne's first appearance in a Salon—the Salon of 1882, where he was admitted as a "student" of Guillemet, his friend and a member of the jury. The picture is a reprise, *vingt ans après,* of the 1861 *Judgment of Paris,* done at the time of his first trip to Paris. The two works bracket the years of Cézanne's trials in the City of Light, and illustrate, in the same ostensible subject, his progress—in art, in love, and in worldly success. When, years later, he made the famous remark, "I would like to astonish Paris with an apple," he was alluding both to the city and to Zola, the Paris of his heart. For the mem-

ory of Zola is never absent from any image of apples—which occupy the exact center of the second *Judgment*—whatever other significance they may have.

There is no doubt that problems arose between Paul and Hortense after their early ardor; it seems that they couldn't live together and they couldn't live apart. With the passing years, the girl from Paris became the woman *in* Paris, spending long periods there. But always, the thought and image of Hortense remind Cézanne of Paris—and Paris, of her. She occupies an immense region of his imagination, a realm where the boundaries between art and erotic impulse are indistinct. As the woman with the raised arm, she was at once assimilated to a tale by Balzac, a motif by Ingres, and eventually to an important work by Poussin. When Cézanne, newly a father, made a drawing of *Silenus Holding the Infant Mars* (pl. 173), it was as Hortense's lover that, at the same time, he made drawings of the Venus de Milo, and he continued to make them over the years—there are nine.[14] The constancy of his imaginative focus was such that he transformed all things and relations into signs for Hortense. She is indicated by apples, a basket handle, a jar, a fig, a lemon, a flower, a conch, a house; as a bather, a beauty, a bourgeoise, a prostitute, a mother; in a tree, in a cloud; by being on the left, and near a creek or tree; by the letters *H* and *F,* the color red—and the list will grow. Hortense is implicated, by allusion, metaphor, cryptomorphism, and manifest portraiture, in a fifth of the paintings Cézanne made after they met.

153

The Turk

In *The Judgment of Paris* Cézanne has stretched and bent a classical theme into a self-referential scene. Similarly, a series of paintings with a Turkish flavor become an exotic vehicle for his unceasing personal ruminations.

A work of ca. 1870 (pl. 128) has acquired the title *Une Moderne Olympia* because of its resemblance to a later and better known version of the theme bearing this title. But it is clear that the early picture was originally called *Le Pacha*.[1] The title is the clue to a Turkish fantasy that has long escaped notice, although it occupied Cézanne for several years.

The hirsute pasha of ca. 1870 is a projection, as some observers have noted, of the artist himself; he gazes up at a crouching nude woman in the lavish interior of a seraglio. *Le Pacha,* like its later version and *L'Eternel féminin,* 1875–7 (pl. 116), was inspired by Manet's *Olympia,* the scandal of the Salon of 1865, which forever stamped its author as the leader of the new school. This most French of painters would succumb to the Turkish mystique: ca. 1871 he employed his special skill on *La Sultane,*[2] evoking a lush figure standing in a loose, transparent gown.

French interest in Turkish matters had long found expression in art and letters, and it was given new impetus by the increased involvement of Western Europe in the foreign affairs of Turkey in the 1860s. In 1867 Abdul Aziz, the sultan of Turkey, visited the Paris Exposition to the accompaniment of much official and journalistic fanfare; many European dignitaries, including French artists and writers, paid a return visit to the sultan in 1869 on the occasion of the opening of the Suez Canal. The Turkish element in Cézanne and Manet appeared in the wake of these events. Even the protagonist of Lautréamont's *Les Chants de Maldoror* (1870), addresses the Eternal, all-powerful in the heavens, as "Sultan."

When Cézanne painted the second version of *Le Pacha* and called it *Une Moderne Olympia,* 1872–3 (pl. 129) he openly declared its relation to Ma-

128. *Le Pacha,* ca. 1870 (V.106)

129. *Une Moderne Olympia,* 1872–3 (V.225)

130. *The Stream* ("*L'Anse*"), ca. 1872 (not in Venturi)

net's work, with a claim to modernity based not only on its later date and bolder brushwork, but also, apparently, on its change of venue to a fancied Near East. Cézanne depicted himself more faithfully than he had earlier, acknowledging his bald skull, but remaining the pasha in his seraglio. It is altogether fitting that *Paul Cézanne* should be a *pacha* and arrive with his *chapeau,* his *canne* and *chien*—all have the right initial letters. If the cane is too far to the left to be what it suggests, an unexplained black brushstroke (*coup de pinceau*) to its right is placed more precisely. Some fruit and other objects survive the burning red of the table; among them is one that caused Ron Johnson to write that Cézanne "portrayed himself . . . with a skull on the table."[3] A skull there is, but not in the same way that the table, Cézanne, the odalisque, and the flowers are. The skull is a cryptomorphic image that impressed itself on one observer's attention, eclipsing the manifest carafe in which it is imbedded. Why, in any event would Cézanne put a skull in a seraglio? Nonetheless the skull (*crâne*) is a frequent subject for Cézanne and always, as here, refers to him. It repeats his bald pate and rhymes with his name, just as *crâne* and *Cézanne* rhyme in a poem that he sent to Zola in a letter of July 1859. But *crâne* has a second sense—*homme hardi et querelleur* (a bold, quarrelsome man)[4]—that

describes him correctly. To their mutual friend Baptistin Baille, Zola wrote, "To prove something to Cézanne would be like trying to make the towers of Notre Dame dance a quadrille."[5] Cézanne was quite aware of his stubbornness, hence his identification with the donkey (*âne*), the skull (*crâne*), and with all the associations of this word. For *crâne* appears in another context: Baudelaire, one of his favorite writers, mentions "la peinture *crâne*" (bold painting)[6]—the very style Cézanne assumed for *Une Moderne Olympia*.

Surely one of his oddest works is that known as *Le Ruisseau* (*The Stream*), ca. 1872 (pl. 130), probably executed between the two pictures mentioned above. A straight horizon line divides the scene almost in half, with a green field below it and, above, a blue sky fading to white where it meets the field. A current flowing between curiously serpentine banks rises from the picture's lower border to meet the horizon. On the right is a woman in a long white gown; we see her back as she regards the only other person in view, a man dressed in a loosely fitting pale yellow blouse and white trousers, and a red, tasseled fez. His outstretched arm is raised over the stream to the left in a gesture whose meaning is difficult to fathom. Is he pointing to something? Waving to someone? Staking a claim? Expressing a longing for something beyond the stream, beyond the scene? On the left is a large dense bush over which rises a slender tree, its sparse foliage occupying the corner of the painting.

Despite the painting's conventional name, the insistent zigzag of the banks suggests the meandering of slowly moving water, and I propose that Cézanne has depicted not a *ruisseau* but an *anse* (creek), and hereafter will use this term for the title. We have twice before met this word, both times in relation to Hortense. And indeed, in the foliage of the tree we discern a cryptomorphic head of a woman who faces to the left (fig. 11).

157

Her position on the left, her presence in a tree, and her proximity to an *anse* identify her as Hortense.

The man in the fez we may take to be a persona of Cézanne. At the narrative level of the painting, he is imaginably a visitor from Turkey— probably, in 1872, a *vizir,* a minister of state. Littré tells us that the term, besides indicating the foreign official, had a familiar or figurative usage: *un homme absolu, impérieux* (a despotic, imperious man). Cézanne, like the other bold painters of his generation, surely thought of himself as a *turc*— a young Turk. In fantasy he could be a *vizir,* a *pacha,* and assume a commanding character befitting those titles. The problem was still on his mind in 1899 when he described his personal situation to the collector Egisto Fabbri in a letter of May 31: "The fear of seeming to be less than what is expected of a person presumed to dominate any situation is doubtless the reason for my being obliged to live in seclusion." The dominating master artist has remained one of the conventions of the modern tradition.

Is the woman in white the same as the solitary woman in white of plate 47? She would seem to stand for Cézanne's mother in having one of his mother's important characteristics: looking toward the vizier, she cannot see what is in his field of vision—the image of Hortense. She looks at Hortense only in the scenes of violence (pls. 81, 82). But she has her back to Hortense on the left in the first *Temptation* (pl. 89), in *The Promenade* (pl. 85), and in *Courtesans* (pl. 110), because she is always facing away from her. Not until the Bathers-Temptation, ca. 1900 (pl. 95), does her (cryptomorphic) image face in Hortense's general direction, although its glance falls below her.

Within the symbolic structure of *L'Anse,* Cézanne faces Hortense with his right arm extended in her direction. Like the arm/phallus configuration of an earlier work (pl. 80), this upraised arm has an inescapably erotic

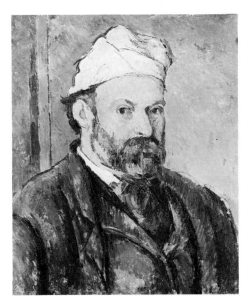

131. *Self-portrait in a Turban,* ca. 1876 (V.284)

significance. And the vizier, with his determined stance, seems now to be doing all the things suggested by the questions I asked earlier: he is pointing, gesturing, staking a claim, longing for Hortense. In addition, since he motions toward her, we may now suppose that she waves back to him from the *Courtesans* (pl. 110).

His left arm is down on his mother's side, indicating his resolution of the Oedipal conflict: he is determined, as we have just observed. And her gown is white, the color of innocence. But her canonical color, as we have seen several times, is blue, just as his is black—the opposite of white. Indeed, since she has no face, she must be someone already in the painting, and this can only be the vizier, the persona of Cézanne. It would seem, in short, that he paints himself as his mother clothed in the white of *his* innocence. We will come upon several works in which he clearly adopts a feminine role. Still in his Turkish phase, Cézanne does a *Self-portrait in a Turban,* ca. 1876 (pl. 131); here he faces right, his mother's side—and the turban is white, the sign of innocence. Painted in the same period and in the Turkish mode, as we shall see, is *Self-portrait with a Cap* (pl. 132); he faces left, the side of Hortense, and the cap is black.

In the one part of *L'Anse* that we have not examined, we find, not without difficulty, a large and remarkable cryptomorph that occupies the left side of the picture: a head of a woman turned three-quarters to the right to look at the man. It is composed for the most part of the bush that emanates, as it were, from the field. The patch of sky above it serves as the brow of the head; the thin foliage above that, as a fringe of hair. Through the top of the bush we see two small horizontal patches of sky

that serve as eyelids, with a dark spot below each in the position of the eyes. The large nose has a strongly marked nostril; the mouth is formed by a dark green shadow; another such shadow defines the cheek, and another, at the bottom of the picture, lies under the chin. Once seen, this head, which must be that of Mme. Cézanne *mère,* is a haunting human presence that dominates the curious artifice of the rest of the work. It is not easily grasped, chiefly because several smaller hidden faces in its lower half are in a state of metamorphosis, of endless formation and decomposition. Thus, longing and anguish beyond the *anse,* in the region occupied by leafy portraits of Hortense and mother—who, even as hidden images, face away from each other.

In a series of works that deal with Cézanne's attitudes toward his mistress and his mother, he changes his physical relation to them. He is on their left in *The Murder* (pl. 81); ambiguously so in *Woman Strangled* (pl. 82); on their right in *The Promenade* (pl. 85) and *L'Anse,* with the possibility in the latter case of being between them. The picture is an object lesson in the "crude" or "clumsy" work from the hand of a master: bleak, almost diagrammatic, it is the record of a struggle to solve a painful personal dilemma.

Among Cézanne's twenty-five self-portraits, he is shown in seven different kinds of headgear. The first of these seems to be *Self-portrait with a Cap,* ca. 1875 (pl. 132), done close to the time when he painted his father wearing a cap (pl. 34). In donning one himself and thus superseding his father, he is emboldened by his current Turkish persona, for the cap has a gleaming visor (*visière,* with its echo of *vizir*). He is, besides, impressively bearded and his baldness is not evident. His face, otherwise circled by beard and mane, would be a discrete mask if not for the large white high-

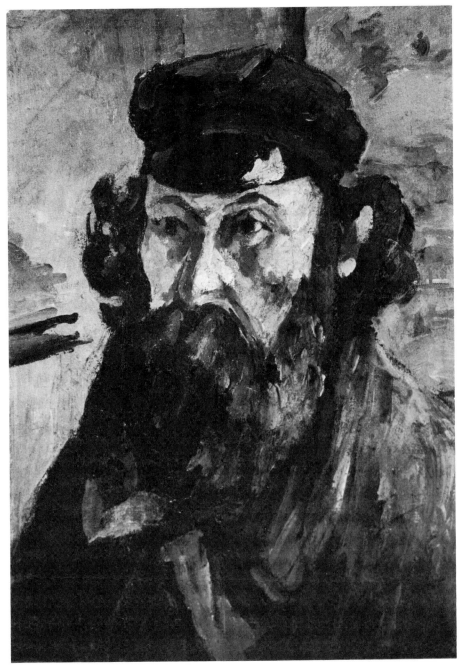

132. *Self-portrait with a Cap,* ca. 1875 (V.289)

light on the visor. This conspicuous motif almost merges with the relative pallor of the face, rescuing it from isolation in the dark surround. But the size, brightness and unusual shape of the highlight show it to be over-determined and suggest that it has a purpose beyond its denotative and formal functions. We recognize it, of course, as a *lustre,* which, with its

connotation *illustre* (illustrious), refers to Cézanne, as it did when it appeared on a black bottle (pl. 118). But this *lustre* has still other connotations.

Self-portrait with a Cap would not, at first glance, seem to be related to a small painting of the same date, *Nude by the Seashore* (pl. 111), in which a female bather is shown sitting under a tree, her legs crossed and her arms raised over her head. Every feature of the work—the figure, the tree, the background of sea and island, the space in which they exist—exhibits a fanciful invention. We detect, however, an ambiguity in the woman's relation to the ground: she seems to be seated on it, but since her legs are comfortably crossed below her body, there should be something that raises her above the ground, yet no such thing is visible. Surely the white towel—let us call it that—on which she sits could not raise her appreciably. A suspicion develops that the towel is significant and that is why the woman has been made to sit on it. It is an erratic, bounded shape of the same order of irregularity as the highlight on the visor in the *Self-portrait*. The two white shapes are linked in time, since the paintings in which they occur could both have been executed in 1875. Given the fact of their close temporal and formal relations, we must suppose that they are related at another level.

The French word *lustre,* besides "sheen," "luster," and "sparkle," means a "five-year period of time." The word exists in English as "lustrum," a term carried over unchanged from Latin. We may now imagine that Cézanne paints the *Self-portrait* in 1875; the large *lustre* on the visor is a reminder that a lustrum ago, in 1870, he and Hortense began an eight-month stay at L'Estaque, their first protracted period of living together. Seen from the perspective of five years, it was—to judge by *Nude by the Seashore*—a memorable, happy time; the towel shape similar to the *lustre*

puts a date on the nostalgic scene. The seated woman, who is customarily taken to be simply one of Cézanne's large cast of anonymous bathers—pretexts, always, to paint the nude—turns out to be Hortense, whom we recognize by the arm raised above the head and the tree behind her. Situated at the picture's left, her canonical position, she is the whole reason for the leftward orientation of Cézanne in the *Self-portrait.*

Stretching out from the nude to the right is the expanse of the sea (*mer*), making this another in the group of works in which Hortense and the artist's mother (*mère*) are symbolized on the left and right, respectively. This relationship is underscored by the fact that the island on the extreme right is the Ile *Maire.* The painting's subject—a nude by the seashore (*au bord de la mer*)—contains a punning reference to *bordel* (bordello) that we already know. The presence in *Nude by the Seashore* of a form similar to the *lustre* gains further relevance from the fact that the Latin word *lustrum,* of which Cézanne was cognizant, has, besides the meanings already noted, that of "a house of prostitution." *Bord de la mer* suggests such a house, for sailors, at the seaside. The cap with its obvious *lustre* in the *Self-portrait* is a sailor's cap.

There is, finally, a metric link between the irregular white shapes in the *Self-portrait* and the *Nude:* although appearing in paintings of sharply different dimensions—roughly 21½ and 9¼ inches high, respectively—these shapes are similar in size, being about 1¼ and 1½ inches in length, respectively.

In summary, these two paintings, unlike in subject, size, and style, have several unexpected features in common. They were both done around 1875; each contains a white, discrete abstract shape; these shapes are of the same order of magnitude and abstraction; and they embody different senses of the words *lustre* and *lustrum,* themselves related. The

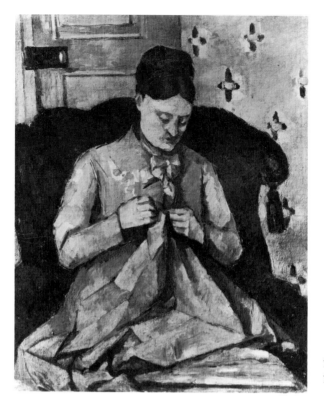

133. *Mme. Cézanne Sewing,* 1877 (V.291)

paintings demonstrate once again the remarkable fashion in which Cézanne's imagery was impelled, induced, or otherwise influenced by the pressure of verbal association.

This susceptibility to wordplay prolongs his Turkish phase in paintings of Hortense—it was, after all, a fantasy for two. To the left of his pasha, as the concubine in two *sérails* (seraglios), she crouches on pile of *coussins* (cushions). A few years later an obvious *serrure* (lock) appears in *Mme. Cézanne cousant* (*Mme. Cézanne Sewing*), 1877 (pl. 133). After a much longer period Cézanne paints *Mme. Cézanne dans la serre* (*Mme. Cézanne in the Conservatory*), 1890 (pl. 134). On the dress and above the bent right arm we discern in the mottled pigmentation a large cryptomorphic head turned slightly to the left; with its visible nostrils below the darkness of the eyes, it is recognizable as Paul *fils,* now eighteen years old. Hortense seems to press him to her bosom (*le serrer au sein*), with *au sein* now a more distant echo of *coussins* and *cousant.* Thus,

sérail	*coussins*	1870, 1872–3
serrure	*cousant*	1877
serrer	*au sein*	1890

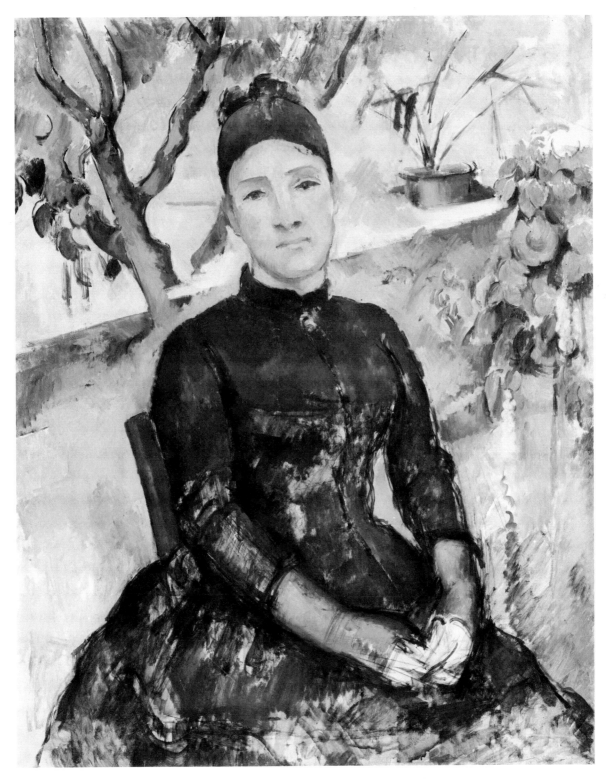

134. *Mme. Cézanne in the Conservatory*, 1890 (V.569)

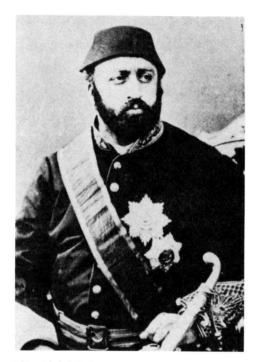

135. Abdul Aziz

An unusual pair of circumstances seems to have led Cézanne to depict himself in Turkish headgear in the *Self-portrait* of 1876 (pl. 131). In that year Abdul Aziz committed suicide or was assassinated. Cézanne's Near Eastern fantasies had dated from the visit of the Turkish ruler to France in 1867, and these fantasies were surely fueled by the fact that, to a remarkable degree, he looked like Abdul Aziz (pl. 135). The obituary occasion of the *Self-portrait* would account for the grim set of the visage.

Not Turkish—although Near Eastern—is another submerged theme of power and conquest: Cézanne's long identification with Alexander the Great. This is explicit in the astonishing cryptomorph that occupies a large part of his head in the *Self-portrait* of 1883–5 (pl. 136). If we cover Cézanne's right eye, a left-facing head comes into view. It wears a helmet

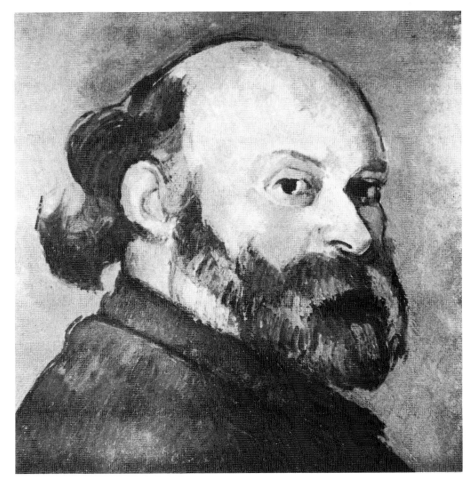

136. *Self-portrait,* 1883–5 (V.517)

formed by the artist's brow and cranium; this comes to a peak at the left. Below this point we drop along the (hidden) brow, come upon the shadowed region of the eye (seemingly a part of the sideburn), the delicate prominence of the nose, the subtly rendered lips, a strong underlined chin, and the throat which ends in the artist's mustache. This handsome head is surely that of Alexander the Great in a helmet (fig. 12). The *Self-portrait* seems to be the culmination, in a series of similar self-portraits, of an effort to fit the world conqueror's head onto his own.[7]

This effort had a later reverberation in *Man with a Pipe,* ca. 1892 (pl. 137), which shows the gardener at the Jas de Bouffan, a tall man whose name was Alexandre. Except for the clay pipe held in the side of his mouth, the painting is symmetrical, in fact it is quite the most symmet-

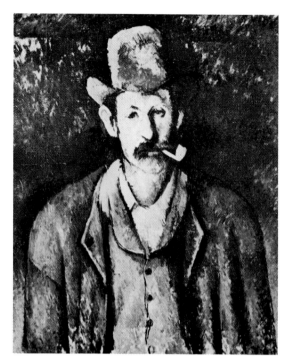

137. *Man with a Pipe,*
ca. 1892 (V.564)

rical in the oeuvre. It is also, at the sensuous level, a beautiful example of
painting, whose main graphic point would seem to be that it monumen-
talizes its subject. This monumentality is a function of the frontality of
the sitter and the noble drawing of the hat, the face, and the garments
that enclose the body, and it derives in great degree from the width of the
shoulders. These are so broad that the sleeves of the jacket approach both
sides of the canvas, with the result that the man's body seems to fill the
picture space. So we have big Alexandre (*Alexandre le grand*) with his
broad shoulders (*larges épaules*). Having in mind that Cézanne himself was
six feet tall and broad, we may imagine that he painted this imposing
image of the gardener because through it he identified himself with Al-
exander the Great. The assimilation of the conqueror to his fantasies of
personal power has a familiar verbal basis—Alex-*an*-dre. It also has a lit-
erary foundation. Cézanne surely knew Racine's *Alexandre le Grand:* on
the curious document "Mes Confidences,"[8] he wrote that his favorite au-
thor was Racine.

The Rack

We have already encountered *Man with a Jacket,* ca. 1875 (pl. 112), in two contexts. It contains an allusion to a bordello (*bordel*) in the fact that the man is at the seashore (*au bord de la mer*), and it alludes to Cézanne in the head of a donkey (*âne*) constituted by the hill behind the man.

Let us examine this strange work from another viewpoint. It shows a man in a state of disarray in the shelter of a hill or dune that comes down to the shore. His hat is precariously tilted on his head, his shirt falls out of his trousers, and he is struggling with a jacket while one foot is shod and the other bare, with a shoe lying nearby. Is he hurrying to get dressed—or undressed? Does he mean to get into the water—or has he just left it? He looks as though he has been caught in a compromising situation.

An upraised arm we found to have phallic significance. Is this also the case with a raised arm entering a jacket sleeve? Reff thinks it is (and I agree) for reasons that are Freudian, but other reasons may be adduced. He points out Cézanne's debt to Millet's *End of the Day,* 1860–5 (pl. 138),[1] for the man's pose, without noting the erotic implications of the latter. Millet's painting shows a young peasant in the failing light of evening, standing beside a mattock with which he has been working. He is about to go home, and we may imagine his cottage, his wife and children, and the evening meal. He thrusts his arm (*bras*) into the jacket's sleeve (*manche,* fem.) which is held aloft. The phrase *avoir le manche* (masc.; to have a handle) is slang for "to have an erection."[2] As though to leave no doubt about the matter, the handle (*le manche*) of the mattock rises beside him. If the memorable image of Millet's peasant was the prototype of Cézanne's figure—and there is every reason to think that it was—we may suppose that its erotic implications were not lost on him and are present in *Man with a Jacket* by virtue of the play on the double meaning of *manche.*

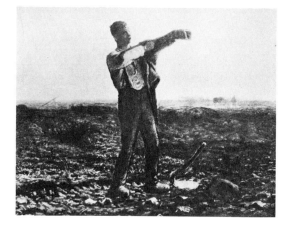

138. Jean-François Millet,
End of the Day, 1860–5

The notable hat (*chapeau*), shirt (*chemise*), shoe (*chaussure*), and foot (*pied*) further identify the man as standing for *Paul Cézanne*. His closeness to the sea (*la mer*, echoing *la mère*), puts him, symbolically, in a familiar, painful relation to his mother, whose presence is underlined by the island on the right, L'Ile *Maire*. After the apparently determined resolution of the lover/mother conflict in *L'Anse* (pl. 130), in which an arm pointed up to an image of Hortense in a tree on the left, and the other arm down toward his mother on the right, the arm on the right now points up to his wife, symbolized as the tree on the right, the same side as *la mer*, which he has just left or into which he is hastening to plunge. This is the disturbing fantasy in which Cézanne has found—and painted—himself. *Man with a Jacket* shows the disarray of its protagonist, but it also records the disarray of Cézanne's psychic forces.

Soon afterward he produced a group of paintings that chart his effort, ever renewed, to resolve his problem. In a long article published in 1962, Reff called five of these paintings *Bather with Outstretched Arms*, although strictly speaking the first shows a nude standing figure—which was once exhibited as *Nu debout*—whose arms are not "outstretched." I make this point, which may seem a small one, because I think the idea of a bather was a hindrance to the proper interpretation of this painting and eventually of the series. Reff came to the conclusion that the deep subject of this pictorial theme was "anxiety and guilt about masturbation."[3] My own conclusion is rather different, and my approach to the matter shows many differences from Reff's, only one of which I will mention. He arrives at his interpretation on the basis of a drawing which in his view looks like that of a man resisting the impulse to grasp his erect penis. Rather than regard a painting by Cézanne as having this kind of reality, I claim that it should be read symbolically.

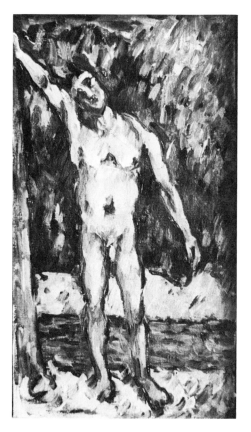

139. *Standing Nude,* 1875 (V.262)

In what seems to be the first work in the series, the *Standing Nude,* 1875 (pl. 139), we see a man whose upraised arm is leaning on a tree at the left, although his hand is not visible. His head lolls against this arm, while his other arm hangs down at the right. Given his anguished expression and an immense shoulder (*épaule*), which nothing in the picture can explain, we suppose that the nude is an image of a suffering *Paul* Cézanne.

In the same period Cézanne painted two single standing nudes, close to the first in size. These two works (pls. 140, 141) give every sign of belonging to an early projection of Cézanne's predicament as a calvary, based, it seems, on Mantegna's *Calvary* (pl. 142) in the Louvre. He has removed the loincloths and adjusted the legs of Mantegna's crucified thieves to be consistent with "bathers" standing on the ground. The arms of his central figure, *Standing Nude,* are not horizontal; such a pose would not be pertinent to a secular nude—it would, indeed, be an impertinence. Yet the hand outside the picture, from which the body seems to hang, holds the suggestion of crucifixion. This nude faces squarely to the front and his head lolls to the left in imitation, apparently, of Mantegna's Christ. *Nude with One Arm Raised* faces to the right; *Nude with Arms Raised*

171

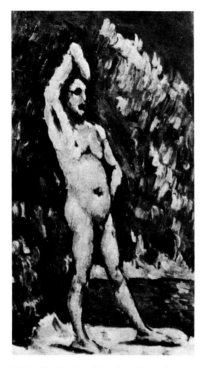 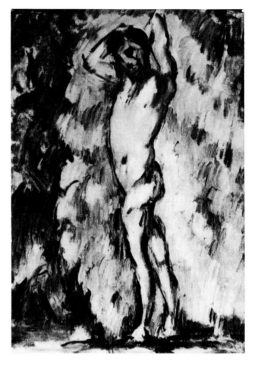

140. *Nude with One Arm Raised,*
ca. 1875 (V.261)

141. *Nude with Arms Raised,* ca. 1875 (V.263)

142. Andrea Mantegna, *Calvary,* ca. 1457

faces to the left; three of their four arms are in the same positions as those of the Italian work; and their height is surprisingly close to that of Mantegna's thieves.

Who are Cézanne's "thieves"? They are the bosom friends of his boyhood, Baptistin Baille on the left and Emile Zola on the right. The three were called the "inseparables"; they used to spend their weekends together, reading and reciting poetry, roaming the woods and swimming in the Arc River. Zola of course became the famous novelist; Baille, who was really interested in science, became a distinguished engineer. We identify Baille in the painting by his open mouth: he yawns (*bâille*) and stretches his arm in the familiar gesture that accompanies a yawn. The second thief is Zola, by elimination. But he has a limiting characteristic. We note that whereas the left leg of Mantegna's second thief partly covers the right, an effect generated by the artist's viewpoint rather than by muscular effort, the same leg on the Zola/thief is violently twisted over the other. This twist is not sheer invention or expressive form—although the rest of the painting justifies its intensity. The leg is wrenched into an unnatural shape in order to cover the crotch. Zola, as we shall see repeatedly, is the nude or member of the "inseparables" whose genitals will never be presented to our view.

Lionello Venturi, who could not have known the precise order in which the three nudes were painted, must have had an intuition that they constituted a calvary, for he published them in a way that suggests one (pl. 143). But despite its rude force Cézanne was not satisfied with his triptych, apparently since it did not fully display his agony—his own image being too remote from a crucified Christ and dependent on two other paintings. Yet the three, which are only around twelve inches tall, had served as a first approach to the subject. We know he is working, however

143. "Calvary," from Venturi

unconsciously, in terms of a crucifixion because at the same time he makes a drawing (pl. 144) of Christ in Rubens' eleven-foot-high *Crucifixion with the Virgin, St. John, and the Magdalen* in the Louvre. Christ on the cross is, after all, the most famous image of a nude—or almost nude—figure with outstretched arms in the history of art. Such a lone figure is Cézanne's ideal, but since taste forbids it, he continues to seek a solution by changing the position of the arms.

He proceeds to paint two solitary figures wearing trunks, who are now more properly "bathers," although they (and two later ones) do not face the water and seem to have no intention of entering it. Firmly planted on their feet, they face front, their arms more outstretched than those of *Standing Nude.* The extended arm, raised above the shoulder, on the left of the first *Bather,* ca. 1875 (pl. 145), crosses a tree at a right angle and is therefore attached to it graphically. The same arm on *Bather II,* ca. 1875 (pl. 146), hovers over some bushes. This phallic arm, then, points toward a tree on the left, symbol of Hortense: the tree of *Standing Nude* becomes much smaller in *Bather I* and declines to a bush in *Bather II.* The arm at the right of each bather hangs down, away from the body. Further to the right in *Bather I* is the sea, of which Venturi says, "*A droite, le bleu de la mer.*" A larger expanse of sea ("*mer bleue*"; Venturi) in *Bather II* is actually touched graphically by the bather's hand. Thus, the nonphallic arm points down to *la mer bleue,* which is on the right, has the mother's canonical color, and echoes her designation, *la mère.* This is Cézanne's latest solution of the lingering lover/mother problem that arose in such distressing form

144. *Christ on the Cross,* after
Rubens, ca. 1875 (C.311)

145. *Bather I,* ca. 1875 (V.259)

146. *Bather II,* ca. 1875 (V.271)

147. *Bather and Cézanne père,*
1883–6 (C.654)

148. *Bather III,* ca. 1883 (V.544)

in *Man with a Jacket.* It is an admission of his sexual relation to Hortense and a suppression of any such relation to his mother, whose attraction remains constant.

Among the many studies of bathers with outstretched arms is one (pl. 147) that shows the bather as usual with the arm on the right pointing down to the sea. Floating above him is a clothed man who is bald, obviously the father; his arm points *upward* to the same sea—an acknowledgment by Cézanne of his father's right to his mother, in the context of a blocking of his own impulses. In another study (C.380), which Reff calls an "amazingly frank image," is a clenched hand "frozen near the erected penis."[4] But Cézanne has not let his guard down and sketched a scene of masturbation. The bather's hand is placed between his member and the sea (*la mer*) on the right, *toward which it points,* in order to thwart the fantasy of incest with *la mère.* That the mother is at issue here is indicated by a careful drawing, immediately above the bather, of a seemingly unrelated object, a sugar bowl—which we have seen to be symbolic of Mme. Cézanne *mère* in two other instances (pls. 30 and 77).

Standing Nude, Bather I, and *Bather II,* measure 9¼, 9½, and 9 inches in height, respectively. Their similar dimensions and dates show them to be a set of works; their small size suggests an inconclusive research. It would be ten years before Cézanne would return to the theme of the solitary bather.

Two works complete the early series. *Bather III,* ca. 1883 (pl. 148), has twice the area of *Bather II. Bather IV,* ca. 1885 (pl. 149), is more than four

149. *Bather IV,* ca. 1885 (V.549)

times as large as I, II, and III combined. It is in every sense the culmination of the series: the arms have gone into alignment, a process begun in *Bather III;* the figure has achieved a compact design and is a monumental presence in the simplified setting with its great expanse of sky. Venturi again notes: *"Mer bleue";* in it we see the mother's presence, specified on the right by Ile Maire. In fact, the hand of *Bather III* on the right seems to cup a breast-shaped mountain on the island. But the trees and shrubbery of the first three works have disappeared, and with them, it would seem, the index of Hortense. It is impossible to think that she, or the problem she raises, has been dropped as an underlying concern of the painting, yet there is nothing in the upper left but undifferentiated sky (*ciel*). We note that for the first time the hand of the outstretched arm lies snugly in the corner of the painting: in the first work the arm ends below the corner, in I and II it points to the left side of the painting, and in III to the upper edge, at the right of the corner. *Coin* (corner; the "ingle nook")[5] is another term for the female genitals in French argot, and by synechdoche a reference to Hortense. (We recall that in *Small Houses at Auvers,* pl. 102, the back of a cryptomorphic right hand reaches toward the cryptomorphic genitals above and to the left. This act is repeated in *Bather IV* with the difference that the hand is manifest and the genitals are symbolic.)

With *coin* unexpectedly established as a focus of the painting, its Provençal equivalent, *caire,* comes into play. It rhymes with *maire* (mother), which, in the form of Ile Maire, entered the series only in the last two paintings. The bather's right arm, then, reaches to the *caire,* and his left to the *maire*. An old trouble—that of being pulled in opposite directions by his lover and his mother—is still the deep subject of the painting. But as the result of small changes in design, its new imagery is a restatement of the problem in terms that are more economical than they were earlier.

150. Paolo Veronese,
Calvary, ca. 1570

In arriving at a relative alignment of the arms, the painting achieves a subtle reference to a crucifixion. Cézanne's model is no longer the frontal, almost Byzantine *Calvary* of Mantegna, with its (for him) impossibly horizontal arms. The formula he was seeking lay, I think, in the Louvre's *Calvary* by Veronese, one of his admired Venetians (pl. 150). Its immense blue sky, which pushes the drama to the side and bottom of the painting, is repeated in Cézanne behind the bather, who sadly looks down at *la mer* (*la mère*), just as Christ looks down at his mother. The feet have been adjusted once again to those of a standing man; we see the backs of both hands, for to show the palms would be to turn a commentary on an icon into the icon itself. Most important, the newly aligned arms are not horizontal as in the Rubens drawing or the Mantegna, but canted as in the Veronese.

If a man with outstretched arms were viewed from the side and below, or by someone shorter, the near arm would appear to rise from the body and the far arm to slant down, to the vanishing point, in the language of perspective. In Veronese's *Calvary* the slant is accentuated because the cross is high and the figure is seen from far below; the left arm is, of course, not visible. It was a dazzling idea (all unconsciously) to have the bather, who is not tall and whose torso is all but frontal, absorb the pattern suggested on the surface of the *Calvary* and created by a gesture con-

179

ceived in depth. The strain or tension that accompanies this translation is experienced by the observer as esthetic effect, as an aspect of the picture's fascination.

While the arms make a diagonal pattern on Cézanne's picture plane, they are *not parallel* to it in the fictive space, just as they are not at a single angle to it. In "space" they are quite out of line: the arm on the left is thrust back from the torso, the other is thrust forward (fig. 13). The pose has been called "extraordinary," not likely to emerge "in the course of exercise, relaxation or play."[6] But once we take account of the arms' differing angles of thrust—observation of a kind that is forced on us by this artist and that makes looking at a Cézanne more than an exercise in delectation—we see a bodily attitude that, except for the feet, could be struck while swimming. The hand "coming out of the water" is open, the one "in the water" is cupped, and the head is inclined to the proper side. Cézanne has taken advantage of the convention of the bather as a "screen" in order to develop a personal theme, and then allowed him to return by an unexpected path. This bather is not simply a bather, he is a swimmer—as Cézanne himself was. At the same time it is possible to see the pose as that of a rope-walker (*danseur de corde,* containing the syllable *anse*), a reasonable description of his position between Hortense and his mother. His feet, planted apart in four paintings, approach in *Bather IV* the alignment of a rope-walker's. He seems to be taking a tentative step, but as bather, rope-walker, or suffering man, he is not going anywhere.

Extraordinary is the fact that secular activity and a personal crux have been fused with the religious sentiment of a crucifixion. The image has such autobiographical density, such continuous resonance, that we must be moved even if we are mystified. It is a sign of Cézanne's mature genius that this haunting work is graphically economical, a stark icon that mas-

terfully assimilates the most familiar image in Western art. With its single figure and spare landscape, it shows us Cézanne as he endures his predicament, anchored in space, swimming in time, stretched on the rack of irreconcilable loves.

This image of his fate has implications for someone who is never far from his thoughts. In the pencil studies for *Bather III* and *Bather IV,* a boy replaces the man of the early versions. He can only be Paul *fils,* who surely merges with his father to become the young man of *Bather IV:* we note the rather large head, a characteristic of son Paul.[7] He enters the symbolic field as the *Bather* series more closely approaches a crucifixion. The association of Cézanne's son with the cross and with Jesus has been a long time developing.

The theme of the solitary bather is prolonged in the last and much the largest version, *The Large Bather,* ca. 1885 (pl. 151). This is usually discussed with reference to the photograph on which the male figure was surely based. In 1976 Diane Lesko boldly undertook to reach an understanding of the painting by, among other means, a consideration of the cryptomorphic male heads that she discovered on either side of the bather's head.[8] The study was inconclusive partly because no persuasive reason was offered for the presence of the heads; nor can I explain them. Yet despite these difficulties, much can be understood of *The Large Bather* by seeing it in relation to *Bather IV.*

Criticism of the work has been trapped by the knowledge that a photograph is the source of the pose, but a pose is not a painting, and the use of a photograph is no less personal than the more frequent nineteenth century adaptation of a painting or sculpture. To take a different approach to the painting: I propose that it follows *Bather IV* closely and shows its bather with outstretched arms at a later moment when he has bent his

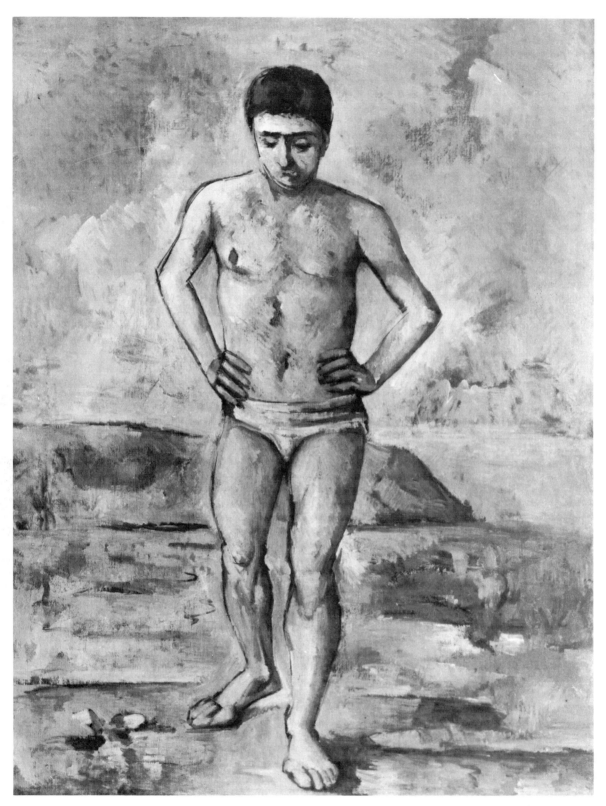

151. *The Large Bather*, ca. 1885 (V.548)

arms and put his hands on his hips. Lesko seems to consider the change in the same way since she says that the new pose appears to resolve the tensions of the earlier one; whether these tensions are formal and/or psychological we cannot tell. At the level of significance that I attribute to them, they declare Cézanne's rejection of his situation between his wife and mother: "A plague on both your houses!" His bather even steps away from that situation. The thesis of rejection is supported by a significant detail: Ile Maire, symbol of the mother, was initially included at the painting's right, beside the arm, then was painted out in obvious fashion. The bather inclines his head to avoid looking to left or right. His glance seems to pass along his body as if to affirm his own being and his freedom from the problem of the two women—the glance, that is, of his left eye. The other eye looks slightly to his right, the painting's left.

In a letter to Zola, dated August 20, 1885, possibly written as he was beginning the painting, Cézanne said, "I would have replied at once, but I have been distracted by some pebbles under foot which are like mountains to me." And the painting indeed shows pebbles to the left of the bather's feet. They are new to the *Bather* series, and very clearly are two.

If the bather cannot avoid wife and mother by glance or tread, no more can he escape them by leaving the cross. For with arms akimbo, he is in the attitude of a *pot à deux anses* (pot or vase with two handles)—of a man with a woman on each arm.[9] *Pot* echoes *Paul,* who has already been symbolized by this object; *anse,* related in many contexts to Hortense, here equates her and Mme. Cézanne *mère.* Thus, as he steps out of the crucifixion in which he was held by two women, he finds himself out walking between the same two women. There is no escape. *The Promenade* of ca. 1870 (pl. 85) continues in a new form.

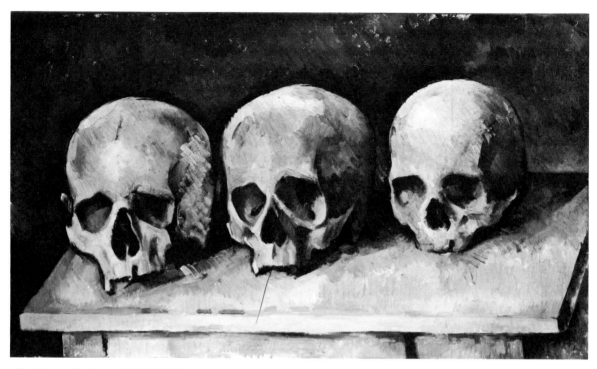

152. *Three Skulls,* ca. 1900 (V.1567)

If we consider the solitary *Bather IV* to be a calvary—Cézanne's Calvary—we must regard *Three Skulls,* ca. 1900 (pl. 152), with special attention. The Latin for "skull" is *calvario,* as Cézanne knew very well, and Calvary is the place of the skulls. We have seen that the skull (*crâne*) refers to Cézanne. What of *three* skulls?

In this macabre lineup, we note that the one in the middle has a slight bump at the top, while the other two craniums show nicely faired curves. Such details hardly affect what is called "composition"; they are of the kind that is overlooked in the summary formal examination to which Cézanne is usually subjected. Nor would they be likely to find a place in a more venturesome thematic consideration: the aging artist's concern with death. Yet Cézanne's rich, precise, muted (and unconscious) symbolism often depends, as we have seen, on small, specific features of his color, design, or drawing. The details in the present case have interest since Cézanne had a peak on his cranium like that of the central skull. It appears clearly in a sculpture of him by Philippe Solari (pl. 153), in a *Self-portrait* (pl. 160), and in the excellent cryptomorphic self-portrait in *Mont*

153. Philippe Solari, *Portrait of Cézanne,* ca. 1904

Sainte-Victoire (pl. 154), where the top of his head coincides with the peak of the mountain (fig. 14).[10] This painting is, significantly, the largest of seventeen late studies of the same subject.

If the central skull represents Cézanne, let us suppose that the other two stand for two other people. We then note that the skull in the middle, with its ruddy color, is darker than the others; it is also slightly larger than the one on the left and noticeably larger than the one on the right. In keeping with a generally accepted symbolism (a "natural" symbolism) we may take the contrasts mentioned above—angular/round, ruddy/pale, large/small—as indicative of a male/female opposition. Following our reading of *Bather IV,* we suppose that the skulls on the left and right stand, respectively, for Hortense and Mme. Cézanne *mère.* Such an identification would accord with the fact that the skull on the right, representing the older woman, is smaller and more delicate than the one on the left. The two are similar in having a small gap in the mandible, in contrast to that of the skull in the middle, which is unbroken, suggesting that it is made of stronger bone—another detail in support of a male/female contrast.

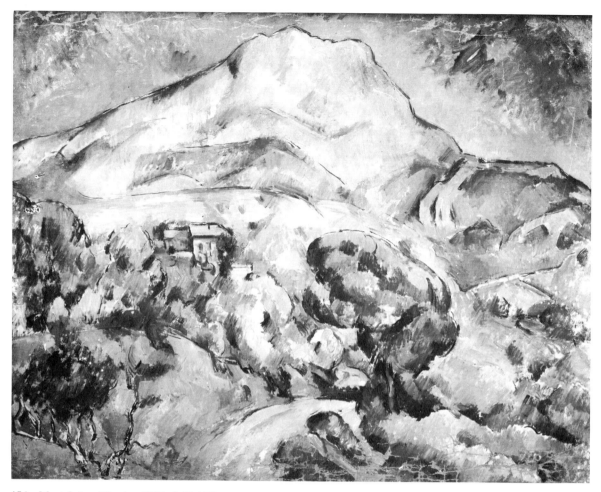

154. *Mont Sainte-Victoire,* 1896–8 (V.663)

While the skulls at left and right are paler than the middle one, the skull at right has a slight reddish cast (as against the greenish tone of the one at left), linking it genetically to the middle skull. A genetic relation is affirmed by the similar left cheekbones on these skulls, a feature absent altogether on the Hortense/skull, and by their small empty nasal cavities, in contrast to the larger cavity containing a bone that characterizes the first skull. The middle and right skulls are further linked by having shadows on the right side; the first skull is curiously pale there.

The arrangement in depth shows the youngest skull, that of Hortense, closest to the front; Paul's is slightly to the rear, and the one representing Mme. Cézanne, the oldest, to the rear of that. Graphically—that is, on the picture plane—the last skull is shown higher than the others, corresponding to her authority in the Cézanne family; and since the painting

was made about three years after her death, this elevated position may signify that she is "in heaven." In *Bather IV,* Paul looks resignedly to the right, the mother's side; he is enough a realist to face now to the left, the wife's side, when the mother is no longer living. In fact, the central skull is closer to the Hortense/skull than to the mother/skull.

It is of some interest, from a logical point of view, that all the distinctions to which I refer deal with oppositions between features that are singular. But there is one feature that is plural in all the skulls—the eye sockets. Each pair shows a pale one on the left and a dark one on the right; they are therefore not symbolically distinct. But the contrast of light and dark indicates that the skulls are illuminated from the left, with the result that the first eye socket in the row is light and the last dark. All of which is fitting, since Hortense was alive and in the light at the time of the painting, and Cézanne's mother was not.

Three Skulls depicts the last lineup, the ultimate state of Cézanne's *calvaire:* wife, mother, and self together in eternity.

Family Matters

Five Bathers, 1885–6 (pl. 155), painted not long after *Bather IV* (pl. 149), is, like it, the culmination of a series, a magisterial resolution of a formal and personal problem, although now in the context of a family group. At the extreme left is the mature woman who was in the same position in *The Judgment of Paris* (pl. 124) and whom I take to be symbolic of the artist's mother. Whereas in the earlier picture she takes a small step, in *Five Bathers* she seems to be striding. But once again, one of her hands, surely when considered graphically, is on the shoulder of the woman in the stream, whose legs, for the first time in the series, are drawn up to her body and parallel. *Five Bathers,* much the largest of the series of eight, gives the impression that Cézanne, in finding these personages, their placement and poses, achieved the fulfillment of an idea that had occupied him for ten years.

He seems to have arrived at the pose of the bather in the stream by reverting to a drawing of about 1874 (pl. 156), which shows, among other things, a man seated on the ground. Chappuis correctly sees Cézanne's father reading a newspaper (but cites Rewald: "it could as well be Dr. Gachet and his family").[1] The man on the ground, he continues, seems to be drinking from a bowl, while the woman behind him holds a basket. If such a reading is possible, it does not explain what causes the second woman on the bench to glance to her right. What I think happens here is that the man on the ground tilts his head back to receive a wreath held in the hands of the woman behind him; it is this scene which the second woman regards.

The source for the man seated on the ground is plainly a photograph of Cézanne (pl. 157) taken in 1873 on a day when he and Pissarro went out painting together in the neighborhood of Auvers. In the drawing the man's hat is on the ground to his right rather than to his left as in the

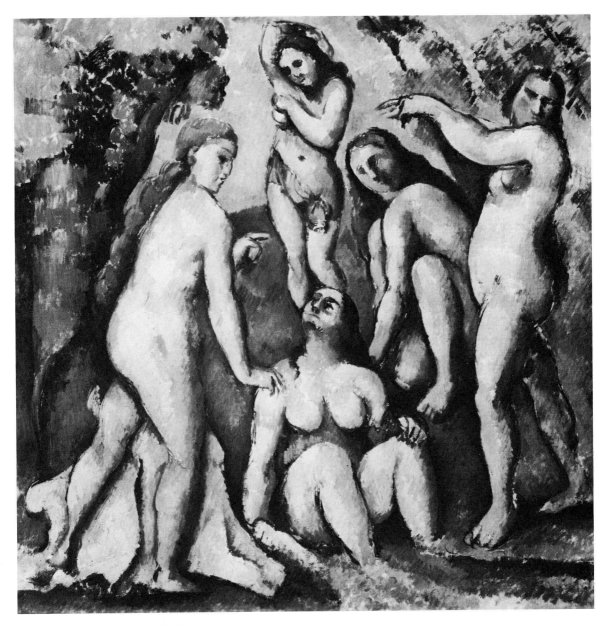

155. *Five Bathers,* 1885–6 (V.542)

photograph, and the left arm has been shifted. But the important change occurs in the lack of personal resemblance in the drawn head, and therefore the avoidance of a self-portrait crowned with a wreath. But there is no doubt in the artist's mind about who was being honored. In spite of the portrait of Dr. Gachet on the upper right border, the clear presence of Cézanne and his father within the drawing makes it reasonable to suppose that the other members of the garden party are Cézanne's sisters,

156. *Family in a Garden,* ca. 1874 (C.294)

Marie and Rose, seated on the ground; and on the bench, seated in the order we have come to expect, his wife and mother. There is little reason to think that such a family idyll ever took place; it is another of Cézanne's fantasies.

The woman in the stream not only strikes Cézanne's pose, she *is* or *represents* Cézanne in the guise of Paule, an identification confirmed by the

157. Cézanne seated on the ground, photograph, 1873

hand on her shoulder (*épaule*). And by the fact that her tilted head is graphically continuous with the woman standing behind her (whom we recognize as Hortense by the arm raised over her head), just as in the garden party Cézanne's tilted head is continuous with Hortense, seated behind him. We think of Paule as "in the stream," yet it is not certain that she sits in the water, and unaccountably one foot seems to have sunk into the bank of the stream; only her right foot is clearly in the water. This reminds us that in *The Judgment of Paris* (pl. 124) her feet are not shown to be in the stream. It appears that Cézanne associates femininity with the attribute of moistness, which he is loath to accept although he is willing to assume long hair and breasts.

As for the striding bather, let us examine the drapery beside her left leg. There a large bulbous shape makes a curve which may be read as the letter *C*. Below and continuous with it is a double curve which can be read as the letter *z*. Considering these to be elements in a rebus, we may pronounce the *C* as *Cé,* which is its French name, and add the sound of *z;* this gives us *Céz* and suggests *Cézanne*. To make this we need *anne,* but there is no object in the adjacent cloth, ankle, foot, or leg that is called *anne* or has a similar sound in French, nor is this syllable produced graphically in the painting. However, if we take the whole female figure as *anne* our rebus is solved since *Anne* was the first of the given names of Cézanne's mother.[2] (These identifications provide further reason to understand the mature woman and Paule in *The Judgment of Paris* as symbols or surrogates of Cézanne's mother and of himself.)

191

158. Marie Cézanne, photograph, ca. 1870

The standing figure behind Paule must represent Hortense: she shows her armpit and is in the same relation to Paule—behind and above—as she is to Paul in *Family in a Garden* (pl. 156). Central and elevated above the others, she prefigures her dominant position in the Temptation-Bathers (pl. 95). Rose is seated as usual *par terre*. The remaining figure, on the right, is Marie: not only does she have the extended phallic arm, her customary sign, but her head is a somewhat masculine portrait of Marie seemingly based on a photograph (pl. 158). An unusual example of the masculine element in a symbolic representation of Marie may be seen in *Four Bathers*, 1879–82 (pl. 159). Here the central standing figure must be Marie. She has the extended arm that often identifies her but that here is no less graceful or slender than those of the other bathers. And her face is delicate and feminine—uniquely so among the symbolic images of Marie. But in the pubic region there is an unmistakable configuration of male genitals impressed on her garment.[3]

In *Five Bathers* the pointing fingers of Marie and her mother are directed to Hortense. What can be the significance of this concerted gesture, which has no counterpart in the other five *Bathers*? The painting's date,

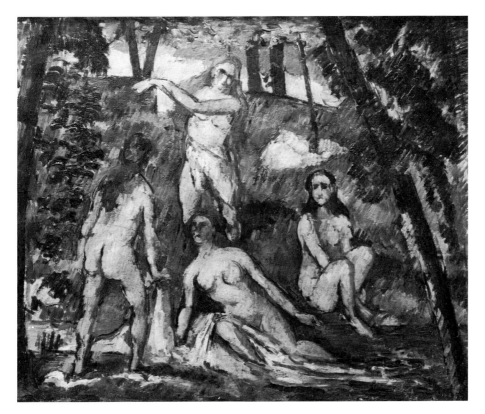

159. *Four Bathers,* 1879–82 (V.384)

1885–6, places it in the period when the family pressures on Cézanne were coming to a head. One can almost hear the two women saying, "*Elle, elle*—marry her!"[4] And marry her he did, in the spring of 1886. As the mother points to Hortense she looks down at Paule, whose shoulder she touches. Marie must point over the head of Rose; the younger sister stares straight ahead since she is not involved in Paule's problem.

In the *Self-portrait* of ca. 1880 (pl. 160), Cézanne has portrayed himself against a wallpaper that appears in several still-lifes and in the background of *Mme. Cézanne in a Red Chair* (pl. 117), and that once again participates in the picture's significance. In this case the background seems not so much behind the head as around it. That is, the graphic contiguity of background and head is more persuasive than the illusion of a space between them. This effect arises, I think, from the position and power of the three crosslike motifs that seem to go around the head in a manner the opposite of benign, since they suggest a vise or clamp.

The head itself upon examination reveals an unusual feature at the forehead: a break in its continuity that takes the form of an edge made by an alignment of brushstrokes going diagonally across the brow from the

160. *Self-portrait,* ca. 1880 (V.365)

upper left to a point just above the eye on the right.[5] Because of its steep angle this edge cannot be a wrinkle in the skin, nor is there any reason to think it a scar or a shadow. It can only strike us as a painterly device or effect that current opinion is inclined to designate as Cubist. But Cézanne was not a Cubist, and the edge is unique in this painting. It is surely the locus of an ambiguity, like others that arise from his systematic deposit of brushstrokes. Regarded as meaningful, it may be read as a shift, a break or cut in the brow where there is every reason to expect continuity and solidity. It then suggests that the top of Cézanne's head is cut or loose. *Perdre la tête* (literally, to lose the head) meant, according to Littré, and still means "to go crazy," "to go out of one's mind." All is not well. Cézanne may be wearing a mask of patience.

Two elements in this work relate it to *Still-life with Bread* (pl. 50), a painting of the same period: in both there is a *pan;* both show a slice through the cranium of Cézanne, whether actually or symbolically. There was trouble of a personal kind in the *Still-life;* some such trouble is surely indicated in the *Self-portrait.*

161. *Self-portrait with a Black Hat*, 1879–82 (V.366)

The division of the wall in the *Self-portrait* is similar to that in *Courte-sans* (pl. 110). We recall that in this picture the narrow left *pan de mur* framed Hortense, the wide one on the right being occupied by three women identified as Mme. Cézanne *mère* and her two daughters. Since the decorative feature of the wallpaper is cruciform, we may read the triad around Cézanne's head as representing three members of his family in their Christian aspect—probably father, mother, and Marie. Hortense's panel is blank: she was not devout. At this time the Cézannes were troubling the painter on two accounts: urging him to rejoin the Church and pressing him, as we have seen, to marry Hortense and put an end to what they considered a scandalous situation. *Self-portrait* shows him caught in their grip and driven to distraction, to the point of losing his mind.

Our lapsed Catholic seems to face the same problems in the contemporaneous self-portrait (pl. 161). Here he is soberly dressed in a black hat and jacket; his cheek and nose catch the light; he looks out at us with a sharp gaze. Otherwise, only a French window (*fenêtre à deux battants*), a window with two wings, and a piece of bare wall—and one of the most amazing cryptomorphs in the oeuvre. The painting, like so many others, raises formal questions, the most immediate for me being the treatment of the region of the lips. We see them from the right, as it were. Since this side is near and the other side further away, we would expect the bare part of the lip on the near side to be larger than the corresponding region on the far side—but the reverse is true. (This is precisely the case in Renoir's 1880 pastel of Cézanne, pl. 162, and Renoir's portrait is *not* a reflection. So Cézanne's rendition was probably influenced by the Renoir—which he copied; V. 372.) At one moment of my study of this region, the image flattened—that is, its illusionism lost its force—and gave up a small portrait of Cézanne in profile (pl. 163), where he may be seen facing to the

162. Auguste Renoir, *Portrait of Cézanne,* 1880

163. Detail of *Self-portrait with a Black Hat,* pl. 161

left. We note the sharp nose, a cheek, and eyesocket in gray, the top of the skull in earth red, and the back of the skull, catching the light from the right, in pale yellow ocher; between the gray and the ocher, the black of the hair; below the nose, a tiny pale stroke that serves as the edge of light on a black mustache; the beard merges with that of the large manifest portrait. This head is *constructed*—not the result of accidental brush-strokes. It measures about two inches across and, condensed though it may be, is a remarkable likeness.

In facing to the left, the head may be said to be looking at one half of the French window, where vertical and horizontal mullions may now be interpreted as three interlocking crosses. (An old name for the window is *porte-croisée,* a crossed door.) The personal problem here would then be religious and surely related to the same three members of the Cézanne family as those referred to in the previous painting. The family occupies one *battant* (from *battre,* to beat); the artist occupies the other; they are *combattants.*

If the small hidden portrait contemplates the three interlocking crosses that represent the unified force of his Catholic family, what are we to make of the manifest Cézanne who fixes us with his gaze?

197

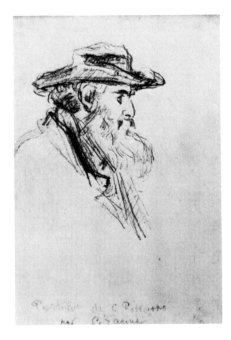

164. *Portrait of Camille Pissarro,* ca. 1873 (C.298)

On his head is a low-crowned, broad-brimmed hat typical of those worn by Jews of eastern Europe and probably by others Cézanne would have seen in southern France. Pissarro, a Jew, wears such a hat in Cézanne's drawing of him, ca. 1873 (pl. 164). And whereas in most of Cézanne's self-portraits and in Solari's sculpture (pl. 153) his nose is long and sloping, the light that catches his nose in the Berne painting shows it to be beaked—a "Jewish" nose—though only beaked by the light. Pissarro, again, has such a nose in Cézanne's drawing. The strong light that catches Cézanne's nose also strikes his cheek (*joue*—with its echo of "Jew"). It is possible to suppose such a multilingual pun, for surely Cézanne had some English. And is there not something "Eastern," hence "Semitic," in the upward slant of the corners of the eyes? Finally, in the wing of the window above the hat are two panes with a vertical mullion between them. As for the horizontal mullion, Cézanne has painted only the part on the left, *omitting* its extension on the right. Rising out of Cézanne's hat, the two lengths of mullion make an angular *J*—for *Juif.* It would seem that a bare-headed Cézanne contemplates the crosses, while another, his head covered in the Jewish fashion, regards us as a Jew.

Why would Cézanne fantasize himself as a Jew, or possibly as Pissarro?

Out of sympathy with his old friend, for one, and for another, with An-
thony Valabrègue, a Jewish friend of whom he painted three portraits.
Cézanne's nonconformism (originality) shows itself not only in his art,
but in his deportment at every level: his attitude toward the Salon officials,
his unorthodox liaison with Hortense, his speech, his dress. In the *Self-
portrait* he can, like another Paul, be both Christian and Jew. And as a Jew,
he would not be troubled by his family over religious matters.

The Blue Vase, ca. 1886 (pl. 165), is so immediately lyrical, calm, and clear
that it seems to strike the senses all at once, reserving nothing. Its few
objects breathe easily in an airy blue space in which nothing, it seems,
could be hidden. And indeed, commentators have dwelled on the gaiety,
the light, the orderliness of the composition. Meyer Schapiro has sug-
gested that the objects in the picture are disposed "like pieces on a chess
board."[6] The painting does gradually reveal a logic in the distribution of
its elements, so that we begin to sense a significance in the handsome
arrangement.

Imbedded in the interplay of orthogonal and angled features, of the
discrete objects and multifarious bouquet, is the horizontal alignment of
four occupants of the still-life. And a close look at the painting discovers
a ruled pencil line that guided the placement of the vase, the two apples,
and a third fruit whose identity is not clear. We cannot help noting a gap
in this lineup—a gap in a possible series of five objects. The sense of a gap
is carefully created: an empty space beside the vase or the third fruit, with
a resulting 1-and-3 or 3-and-1 grouping, would have created the impres-
sion of random distribution, not of a broken row. Here then is a series
with a gap in it, and the concomitant sense that something is missing.
The only candidate for the empty space is the ink bottle; it qualifies both

199

by size and proximity. Its ocherish color relates it to the other small objects in the lineup, a color unusual in a bottle of this kind which customarily holds the black Chinese ink used by artists. The bottle is related, besides, to the vase and the fruit in being, like them, represented whole, as the partially revealed wine bottle, dish, and screen are not.

Pursuing our intuition that Cézanne's still-lifes are charged with personal reference, we wonder if the five whole objects stand for the family in which he was raised. The vase, with its undulating lip suggestive of a ruffled collar, would stand for the mother; a vase, in any case, is a common feminine symbol. The apples would represent the two daughters, Marie and Rose, with the ink bottle representing the son, Paul. (The artist is symbolized in several paintings by a wine bottle.) In keeping with the biographical situation, the ink bottle is larger than the apples; a bit too large for the space between them, it may be said to have escaped the confinement of family life. It has moved out of line to a free space in which it stands, graphically, above all the others except the vase. The third fruit, the fifth whole object, would then be the father, Louis-Auguste. The larger of the apples, corresponding to the older sister, Marie, is closer to this last fruit: she was her father's favorite. The apple that represents *Rose* is clearly *red,* and not only smaller than the other but situated slightly to the rear of it; we can suppose that, besides being younger than Marie, she was smaller, and we know she had a modest nature in comparison with Marie, who was assertive and became domineering as time went on. The vase, by its size and color, is of a higher order of importance; the ink bottle is in another place but is like the vase in being man-made and in the realm of art. These several features reflect Cézanne's great love for his mother and her sympathy for his aspirations to be an artist.

The peripheral position of the third fruit suggests that the once domi-

165. *The Blue Vase*, ca. 1886 (V.512)

nant father was no longer central in the family when the painting was made; the date for this is usually given as ca. 1886. Louis-Auguste Cézanne died in 1886 at the age of eighty-eight. The parallelism between the familial status of Cézanne *père* and the placement of the third fruit is supported by the fact that this fruit, painted in a color like that of the table which surrounds it, has a sere *colorless* quality and a *shapelessness* with respect to the other objects. Hence our difficulty in identifying it, although it might yet be, if anything, a pear. The pale highlight on its left side, close to the darker apple, makes little sense as a reflection but much sense when read as a nose on a head; similarly the pale, round top of the fruit may be read as a bald skull. A portrait emerges in the pear if we dot an eye beside the "nose" and dash a mouth below it (fig. 15)—a portrait of Cézanne's father, who indeed had a large hooked nose and was bald (pl. 166). But not absolutely so: a few strands of hair apparently lay across his pate, and these are matched by the lines at the top of the pear that do not quite enclose the color. These free lines are a charming formal device at the same time that they are perfectly descriptive of a secret subject, the father. The dull, shapeless fruit on the right has, then, a large significance that resides precisely in its loose or nondescript character. It tells of the diminution of the father's powers and is in contrast to the centrality and glamor of the vase, the surrogate of Mme. Cézanne *mère,* who was in any case preeminent in her son's affections. And it has two other functions in the painting.

The first two fruits can only be apples, but with a much reduced appleness: they are round and one is red, but they have no stems, their cavities are only suggested, and only the one on the left gives the impression of having volume. In the normal course of formal analysis these qualities would be held to result from artistic license or from a painterly invention

166. Louis-Auguste Cézanne, photograph

that announces the summary execution and flattened rendition of Matisse. But in Cézanne's case, "invention" responds to a thematic need: for if the father/pear is represented as colorless, shapeless, and not easily identifiable, then the fruit beside it must not be rendered with the clarity ordinarily expected. It must be assimilated to the ambiguity of its neighbor, and it is this consideration which elicits the charming flatness of the apple on the right. The one on the left has been given a greater fullness to assimilate it to the relative rotundity of the vase, the most "solid" presence in the painting.

The five whole objects may well be read as the main actors in a family scene. But if the wine bottle, flowers, dish, and screen have a differential function with respect to these five, they also have a positive symbolic status. The end of the screen (if that is what it is), cut off by the painting's right edge, stands as an *L* in a continuous ocher-orange shape; it resonates as *Elle* (She) and surely refers to Hortense. Large and capitalized, it is an affirmation of her ascendancy in Cézanne's imagination. It also seems to answer a question that, as I claimed earlier (in Chapter 5), was implicit in the repeated display of the *aisselle* (armpit). But "*Elle*" is a laconic reply to the question, "*Est-ce elle?*" A full reply would be, "*C'est elle,*" echoing as

203

sept elle (7L). Astonishingly, an inverted *L* looks much like *7,* and ours even has a bar on one side, although the European 7 is completely barred.

Hortense was never fully accepted by Cézanne's family, a fact symbolized not only by the screen's position at the extreme right, but also by its placement off and behind the table, the site of the Cézanne family. As we examine this *L* a number of features strike our attention: the long ascender slants to the left; its right side is not parallel to its left but tips toward it; the general color has been nibbled away at the outer corner of the *L* and along the top of the crossbar at its distal end; this bar slants downward. All of these effects, especially the slant, strike us as charming Cézannisms, yet we note that all are precisely the devices that would be employed to reduce the effect of a vertical, right-angled *L,* while still permitting the impression of that design. It would be naive not to notice that this tension between revelation and concealment is the same phenomenon that Freud discovered in his study of the dream. But we were already in the realm of the dream with the double, the punning, use of the screen.

The plate seems to have a graphic character different from the other objects, one that suggests it was a creation of the artist; that is, that no actual plate was present in the still-life arrangement he faced as he painted. If, in the space behind the vase, the round plate had a depth as great as its width, it could not rest on the table. The plate as a *creation* is an appropriate symbol for Paul *fils,* issue of the union of Cézanne and Hortense. In this painting, which shows two families, the child's double origin is indicated by the two-part plate, placed on the table but at its edge. The part on the left looks like the letter *C.* The portion on the right is not the reverse of this. Its shadow connects it to the apple below; this joint is reinforced by two short, almost vertical lines linking plate and apple— lines whose presence cannot otherwise be explained easily. In short, the

configuration of plate, shadow, lines, and apple constitutes the letter *P* and gives us the other initial of young Paul's name. The plate (*assiette*) is not only symbolic; it also makes an image of a reclining child's head: the portion on the right may be read as the lower part of the face, its two dark elements being the bottom of the nose and a smiling half-open mouth. The associational chain, child–*assiette*-Paul *fils,* appears in a letter Cézanne wrote to Louis Aurenche on September 25, 1903: "*Je suis très heureux d'apprendre la naissance de votre fils, vous allez comprendre quelle assiette il va apporter dans votre vie.*" The very next words, starting a new paragraph, are: "*Paul, qui est à Fontainebleau . . .*" (I am very happy to learn of the birth of your son, you will come to understand what stability he will bring to your life. Paul, who is in Fontainebleau . . .) The term *assiette* has a double reference in French: to the concrete object and to a range of physical conditions.

The letter to Aurenche, taken together with *The Blue Vase,* is another astonishing evidence of the way in which verbal activity and graphic imagery coalesce in Cézanne's imagination. Just as the child's head in the painted *assiette* is an image of baby Paul, so, in a letter written seventeen years later, Cézanne associates the word *assiette* to another newborn boy, and then, ineluctably, immediately mentions his own son, now thirty-one years old, in an unrelated context. Cézanne writes as he does to Aurenche out of experience: his son had brought stability to his own life. That is how the *assiette* got into the picture in the first place.

The association of *assiette* with son Paul is strengthened by the similarity of the French word to the Provençal *aset* (small donkey), a fitting term for the son of a man whose personal emblem was the donkey. It was not long after writing to Aurenche that Cézanne painted *Landscape from Les Lauves* (pl. 56), where we found a cryptomorphic *aset* in the sky.

167. Detail of *The Blue Vase,* pl. 165, at full size

That the plate (Paul *fils*), the ink bottle (Cézanne), and the end of the screen (Hortense) are in a line, with the ink bottle closer to the dish and screen than to any of the four objects which signify Cézanne's original family, is surely a sign, as we shall see, of the recent formalization of his attachment to his own little family. We have remarked that in spite of the focal position of the vase, the size of the screen is a correlative of Hortense's stature in Cézanne's mind. Yet, although nearer to his wife than to his mother, he is still *between* them, a position from which he has not been able to escape. The shapeless pear and the apple that touches it are symbolically isolated from the rest of the family—surely a reflection of Cézanne's view of the matter. The placement of the dish behind the vase is a reminder that Mme. Cézanne *mère* had kept the secret of the child's existence from her husband. Vase and dish together constitute a cross. This is the fourth time that Mme. Cézanne *mère* and the third time that Paul *fils* have been symbolized by or related to a cross, and the second time so related together.

There remains the wine bottle, situated at the extreme left and cut in half by the picture's edge. It is therefore a *demi-bouteille* (half-bottle, with the accent on *mi*) and represents Emile Zola, whose nickname was *Mi* or *Mimile*.[7] Although French wine bottles are only occasionally strawed, Italian ones are typically so. Since Zola's father was Italian,[8] the half-bottle is a fitting image of the half-Italian Zola. Alphonse Daudet, as reported in the Goncourt Journal, repeatedly referred to Zola as "Italian."[9] We thus

find Zola, Paul *fils,* and Hortense symbolized as partial or fragmented objects, situated on the periphery of the Cézannes, a position shared to a certain extent by Cézanne too. Because of his blood tie, Paul *fils* is closer to the Cézannes than Zola and Hortense are. Overlooking the scene is a baldheaded man, a cryptomorph in the loose wrapping at the mouth of the bottle (pl. 167).[10]

Three events of great importance for Cézanne took place in 1886. After receiving from Zola a copy of his recently published novel, *L'Oeuvre,* on April 4 Cézanne wrote him a short letter of thanks which was to be his last communication to his old friend; on April 28 Hortense and Cézanne were married in the presence of his family; on October 23 Louis-Auguste died. The painting was very likely completed after the marriage and probably before the father's death. It shows, as we have seen, Cézanne closer to his wife and son than to any member of the original Cézanne family. Its blue tone, its ease and luminosity may be said to reflect the state of Paul's soul at the time of his marriage and his father's waning powers. We do not know to what extent he was saddened by his father's death. He had become increasingly estranged from Zola, and his disenchantment with him would be complete on finding in *L'Oeuvre* an unsavory account of a painter with many of his own traits. On the evidence of *The Blue Vase,* it appears that after his marriage in 1886 Cézanne felt himself freed from a burdensome attachment to his former dear friend and possibly to his father.

The intensity with which symbolism permeates the picture is demonstrated by a detail. At the extreme right are two parallel strips of red ocher which create an area of striking modernity and sophistication. The lower band (*bande*) makes reference, as we have seen before, to *bander* (to have an erection). The phrase is significant since the *bande* touches the *L* which stands for Hortense. If we see it as coming from the right, it resembles

207

numerous other cryptomorphic and symbolic phalluses that point to the left and to her presence. The matter does not end there: directly above the band is a stripe (*raie*). If in the manner of reading a rebus we combine the French sounds, we get *rébande,* a neologism, indicating a renewal of sexual interest on the artist's part, possibly on the occasion of his marriage.

We can now recognize the blue of the vase and the expanse of blue on the wall in the upper zone as further uses of this color to symbolize Cézanne's mother. The penetration by the ink bottle of the blue region above is the residue of an Oedipal situation evident in the paintings for many years. That the screen borders on this region and incorporates the color is another example of Cézanne's conflation of the themes of wife and mother. But besides the ubiquitous equation of blue sea and mother (one sanctified, in any event, by ancient usage), there is a verbal situation that makes a constant association of the word "blue" and the name of Cézanne's mother, regardless of the object that carries the color. The word *blu* in Provençal means both "donkey" (*âne*) and "blue" (*bleu*). The relation of these terms to the mother's name may be schematized as follows, as they well might be in the mind of a speaker of French and Provençal with Cézanne's symbolizing faculty: *bleu = blu = âne* (Anne). In associating *âne* and *Anne,* Cézanne divests the syllable of its lowly reference to "donkey" and elevates its significance, a project that will continue to occupy him.

An unexpected cryptomorph of Cézanne's father (hatless) leers from the center of *Avenue at Chantilly,* 1888 (pl. 168). The walk or *allée* in the middle of the painting ends in a configuration that resembles a tombstone standing on two flat pedestals. In the mottled pattern on the tombstone we may recognize the lower part of the face of Cézanne *père* as we know it from a photograph; the resemblance is especially evident when the pho-

168. *Avenue at Chantilly*, 1888 (V.626)

169. Photograph of Louis-Auguste Cézanne, reversed

170. *Portrait of the Artist's Son,* 1885 (V.519)

tograph is reversed (pl. 169). The painting was executed two years after the death of Louis-Auguste.

Son Paul is the subject of a studied half-length portrait of 1885 (pl. 170). The bowler he wears certifies him as Cézanne's son, since the artist portrayed himself wearing one at the same time (V.514 and V.515, 1883–7). Freud mentions the hat as a male sexual symbol,[11] and a bowler would seem to be much to the point. Paul is shown against wallpaper that looks like a free variation of a design painted many times before. The elements registered on the canvas are not negligible. On the right, between the boy and the screen, is a group of notations easily read as a phallus, pointing diagonally upward to the left. On the other side of Paul, at the same distance from him and at the same level, is an elliptical shape that, in this context, suggests the female genitals. These shapes are unique in the painting and serve as emblems of Paul's parents and of his begetting. Since they are on a horizontal line that is perpendicular to the axis

210

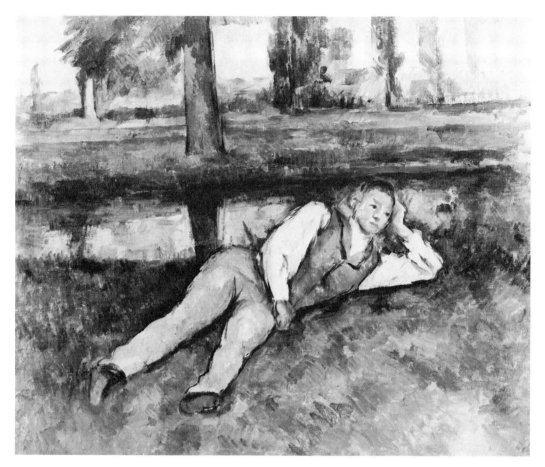

171. *Boy Resting in the Grass,* 1885 (V.391)

of the model, they help to make a virtual cross—the fourth time we have observed this configuration allied to an image of Paul.

In a painting made in the same period, 1885 (pl. 171), young Paul is seen in an informal pose, lying in the grass beside a river. Many years later he claimed that the work was done near the Arc River, in Provence. It seems to me that the setting is along the Seine. Cézanne, Hortense, and Paul spent June and July of 1885 visiting Renoir at La Roche-Guyon; the town is on the Seine. Thirty years later Paul could easily have erred in placing an event that took place when he was thirteen. Typically, the painting has several provocative features. The boy's left leg is oddly fore-shortened; three lines that meet at the crotch could be wrinkles in the trousers, but they cannot fail to suggest a conventional representation of the female genitals; this motif is repeated above the elbow at center. More puzzling is the impression that the large patch of grass in front of Paul— the region enclosed by the curve of his body—does not continue the plane

211

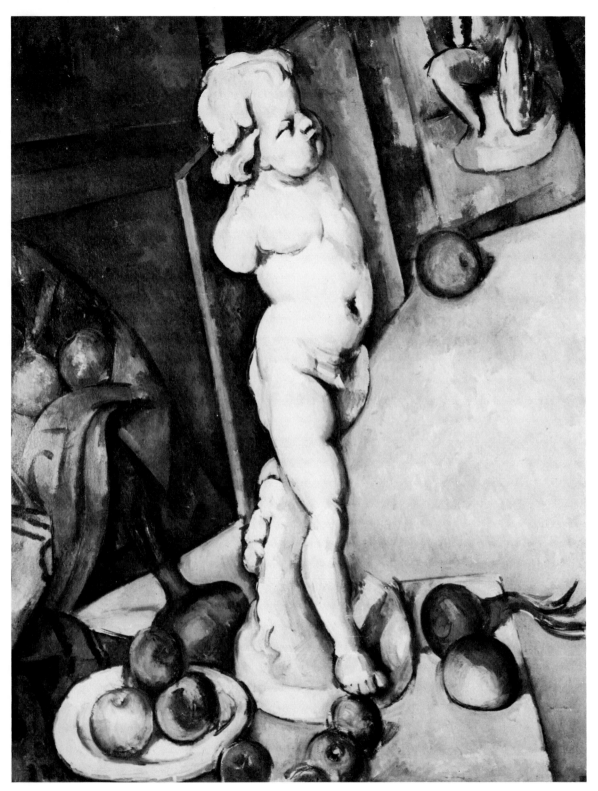

172. *The Cupid in the Studio*, ca. 1895 (V.706)

of the ground established at the left. Not only does it refuse to lie flat, it bulges. Gradually it is seen to resemble a great, gently swelling breast whose nipple is Paul's hand and, we may say, in Paul's hand. "Breast" in French is *sein;* Cézanne, with his meridional accent, would have pronounced the final *n*. The setting, as I have suggested, is a bank of the *Seine.*

The Cupid in the Studio (L'Amour dans l'atelier), ca. 1895 (pl. 172), besides including themes and devices used in other works, achieves an effect unique in the oeuvre: the pervasive shift of the plane of reality on which the depicted objects stand. On the table are "real" fruit and cloth, together with a plaster cast of a sculpture of a male child. Behind and to the left of this group (in the illusionistic reading) is a painting showing the same cloth and fruit, with the "real" cloth touching its image in the painting-within-the-painting. At the far rear is the lower part of a painting of a plaster cast of a sculpture of a man. The circuit of attention begins with an image of a "real" plaster cast and ends with an image of an image of a plaster cast. This movement is reinforced by the powerful illusion of a deep plunging space.

Such spatial jumps and shifts of category are generally seen by modern criticism as pictorial *tours de force, jeux d'esprit*—in fact, as the gambit of Duchamp. But if we have become accustomed to such pyrotechnics in twentieth century art, they accord not at all with our usual understanding of Cézanne or of other nineteenth century developments in art. In this book we have seen that Cézanne's approach to his subjects was never purely constructive, but relied on a correspondence between something seen in the world and something thought or felt; and we may be sure that the reality-shift in our picture is symbolic of a similar shift in personal thought and feeling.

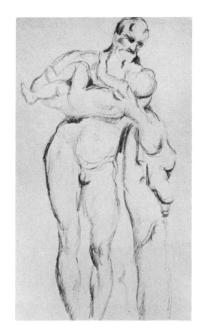

173. *Silenus Holding the Infant Mars,*
ca. 1873 (C.304)

Soon after his son Paul was born, in 1872, Cézanne made a drawing of
the sculpture *Silenus Holding the Infant Mars* at the Louvre (pl. 173). That
the drawing reflects his personal situation is noted even by Chappuis, who
usually eschews this kind of observation. Cézanne, as we know, doted on
his son, and the sculptured *Amour* in his paintings is always a reference to
Paul *fils* as a baby. "*Tu es un amour*" is what the admiring parents would
have murmured as they played with the child.

As for the plaster *Écorché* in the painting-within-the-painting—which
Cézanne owned and drew many times—Gasquet tells us that when Cé-
zanne went to art school he was so sensitive to every remark made to him,
so thin-skinned, that his schoolmates called him *l'écorché* (the flayed
man).[12] Even without this corroborative anecdote it has never been diffi-
cult to see a spiritual self-portrait in the many studies of the tortured
sculpture. Surely the significance of the painting lies in the relation be-
tween the plaster *Amour* (Paul *fils*) and, at a remove, the plaster *Écorché*
(Paul *père*)—its two Pauls (*pôles*).

Near the base of the *Amour* lie some apples and, flanking it, two hand-
some onions. Schapiro has proposed that the contrast of forms and savors
suggests "the polarity of the two sexes"[13]—a view which, perhaps be-
cause of its relative abstraction, does not lead to an interpretation of the
painting. But we can be specific and say that we have here the polarity of
Hortense and Cézanne. Apples, in any case, are constantly associated with

Hortense in the oeuvre, and in the present instance one of them, in the dish at the left, harbors a large pale *C.* If the onions in the foreground stand for Cézanne and if he is in the background as the *Ecorché,* he is shown twice. If the *Amour* in the foreground represents the infant Paul in the early 1870s, the group of red apples and splendid onions near it symbolizes his young mother and vigorous father at the same moment. The painting was made some twenty-five years later; in the background it shows Cézanne as a small headless image of a man, and his wife as a single faded apple.

The deep subject of *L'Amour dans l'atelier* is Cézanne's nostalgia for the beloved infant Paul whom he sees from the perspective of a quarter-century. The telescoping of space on the canvas is thus a metaphor for the depth of time. The *Amour* is conjured by the magic of art which, as it recreates the past, becomes the vehicle of memory and makes its objects present in a transaction between then and now, between reality and its images.

In memory little Paul is larger than life, aggrandized: Cézanne has made the *Amour* in the painting almost six inches taller than the plaster cast in the studio, not his usual practice in depicting still-life objects. But this painting is a paean of praise—in which the onions join. "Onion" is *cebo* in Provençal, as we have seen, and the two at the base of the *Amour* are a kind of chorus, declaiming, *"C'est beau, c'est beau!"*

A late reprise of the theme of Paul holding the nipple of a breast occurs in *Bare Trees by the River,* ca. 1904 (pl. 174). At the end of two branches leaning over the water is an unlikely oval shape. But the tree trunk and its branches look very much like a hand holding that shape between thumb and index finger. It may then be interpreted as the nipple (*bouton*) of a breast (*sein*), which is echoed by the *Seine* below. Chappuis thought the

215

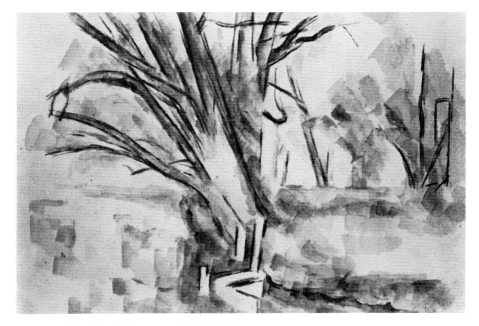

174. *Bare Trees by the River,* ca. 1904 (R.631)

setting was Fontainebleau (on the Seine), where Cézanne worked in 1904, and my interpretation gives us further reason to think so. It so happens that a thumb and forefinger daintily holding a nipple, in a gesture surprisingly like that in Cézanne's branches, is the riveting feature of a famous School of Fontainebleau painting (pl. 175) in the Louvre.[14] The resemblance is not a coincidence but another example of Cézanne's synthesizing or analogizing faculty. His watercolor fuses a personal matter, a place, and a famous painting.

Apparently he was deeply touched by his son's attachment to Hortense; perhaps he was even a bit jealous. Such feelings would help to explain a remarkable aspect of his last manifest self-image, the *Self-portrait with Beret,* ca. 1900 (pl. 176). In this spare, noble work the aging artist records the face that time and the austerity of his calling have set on him. His smock is rendered in a loose, almost scumbled technique; but if we read it as carefully as we read the face, we see in the middle of the lower zone a broad pale area subtended by what amounts to a long, dark, curving edge. This edge is the lower limit of a configuration whose shape, size, and placement are those of a female breast. At the proper place on this breast is the small dark region of the areola (*aréole*); in its center the nipple is rendered in a clear daub of pigment laid on the thinly painted surface around it. This nipple is situated on the central axis of the painting, as is the artist's eye.

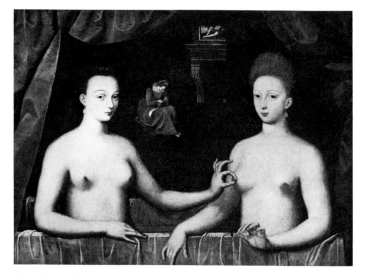

175. *Gabrielle d'Estrées and One of Her Sisters,* School of Fontainebleau

In a touching reversal, the man who earlier boasted of his *"couillarde"*[15] style imagines himself here as a woman. Given his penchant for punning associations, the presence of the breast (*sein*) in this clear, classic portrait suggests *sain* (healthy, sane) and the possibility that the woman who was his wife helped him to maintain his sanity. To the play of the homophones *sein* and *sain* we may add that of *saint*: after exploring the theme of Saint Anthony for three decades in order to lay bare his own erotic torment, Cézanne has portrayed himself as a latter-day saint whose beret is his attribute and halo (*auréole*).[16] The red shape at the right, probably the top of the red chair in which he painted Hortense, may be a further reference to her. I have proposed that *The Large Bathers,* the summa of Cézanne's career, is largely a homage to Hortense; in *Self-portrait with Beret* we have the fantasy of his embodiment of her breast. If we think of the artist in front of the mirror, it is the same breast—over the heart—on which, many years before, Hortense nurses their son (pl. 73) or embodies him (pl. 74).

Cézanne's metamorphosis to a woman—and elsewhere to an element in a still-life, a tree, a Jew, the landscape of Aix, and Mont Sainte-Victoire—is a personal metaphor, a miming in his own body, of that "diversity of nature" which (probably in the 1870s) he saw as the masterpiece of creation. To Emile Bernard he wrote in 1904, "The real and immense task to be undertaken is the study of the diversity of the picture of na-

217

176. *Self-portrait with Beret,* ca. 1900 (V.693)

ture."[17] This attitude was a response to the discoveries of the great natu-
ralists of the nineteenth century, to their fresh perception of the immen-
sity, variety, and depth of the physical universe. Flaubert expressed this
new sense of the natural world on the closing page of *La Tentation de Saint
Antoine* (1874), where the Saint, in his final apostrophe, exclaims:

Joy, oh joy! I have seen the birth of life, its first stirrings. My blood beats so
madly that my veins will burst. I want to fly, to float, to bay, roar, howl. I would
like to have wings, a carapace, a shell,—to breath fire, grow an elephant's trunk,
twist my body like a snake, explode in fragments, be in everything, be a perfume
on the air, unfold like a plant, run like water, thrill like sound, glow like light,
embrace all forms, penetrate every atom, enter the very heart of matter—become
matter![18]

In this ecstatic text, which Cézanne surely knew, Flaubert joins a new
scientific appreciation of Nature to a religious attitude toward Creation.
This double view was Cézanne's too, probably uniquely among the
graphic artists of his generation.

The metamorphoses for which the Saint longs, Cézanne accomplishes
by the magic of Art. Transformation of the self in his paintings is abetted
by the multiplicity of reference in punning, the doubling and tripling of
imagery in cryptomorphism, and the bringing together of different things
in symbolism.

The Boys

The submerged themes of Cézanne's art show him to be most concerned with himself, his wife and child, and with that other family in which he was a son and brother. But they also reflect his relations with the large world beyond the family. Besides his father and son, there were many other men in his life, and they form a considerable presence in his art, appearing in over sixty paintings including portraits of the poet Joachim Gasquet, the art dealer Ambroise Vollard, the critic Gustave Geffroy, a number of Aixois friends, men known to have worked at the Jas de Bouffan, and others who have not been identified. Fellow artists were also among Cézanne's subjects: besides the portrait and drawings of Achille Emperaire (Chapter 3), there is an etching of the painter Guillaumin, and two drawings of Pissarro (pls. 5 and 164), and these and other artists figure as hidden images in several works.

The man whose presence in the oeuvre is much larger than that of any artist is Emile Zola, although his appearance is predominantly cryptomorphic. While an early portrait has been lost (V.19), there exists a double portrait, *Paul Alexis Reading to Zola,* 1869–70 (pl. 177); and we have encountered the writer's symbolic presence in *The Black Clock, Portrait of the Artist's Father* (pl. 29), *The Judgment of Paris,* and *The Blue Vase.* In *Zola's House at Médan,* ca. 1880 (pl. 178), a faithful portrait of Zola may be seen to the left of the central tree. His face floats beside it, the top of his head made of sky and clouds—an appropriate image of a literary imagination—while eyes and beard are composed by the foliage below. A pencil study of Zola's home, of the same date (pl. 179), reveals in the rendering of roofs and gables a number of *Z*'s not found in other such drawings. A still-life in pencil, 1887–90 (pl. 180), includes a feature unique in Cézanne: some legible words printed on a box, *PAIN SANS MIE* (a crusty bread without the soft inner part, *mie*) and *[P]ARIS.* When we recall that Cé-

177. *Paul Alexis Reading to Zola*, 1869–70 (V.117)

178. *Zola's House at Médan*, ca. 1880 (V.325)

179. *Studies of Zola's House at Médan,* ca. 1880 (C.786)

222

180. *Still-life with Carafe,* 1887–90 (C.957)

181. *Roses in a Vase,* ca. 1889 (R.215)

zanne had earlier identified himself with a loaf of bread (pl. 50), and that *MIE* echoes *Mi* (the nickname of *Emile*), the message on the box can be read as: Paul without Emile, or a crust alone—a sad reflection on a broken friendship. The drawing was made in the period following the last letter Cézanne is known to have sent Zola; it is another evidence of his association of Zola and Paris.

A cameo portrait of Zola in profile looking to the left occupies the flower at the upper left of the bouquet in a watercolor, *Roses in a Vase,* ca. 1889 (pl. 181). In the rose immediately to the right is an excellent profile of Alexandrine Gabrielle, the wife of Zola, looking at him, as it were (fig. 16). Now, in 1888 the novelist established a liaison with Jeanne Rozerot, a young woman who had worked in his household; they eventually had two children.[1] We hear *rose* in the first syllable of *Rozerot;* the last is "red" in German, a word that Cézanne, with his linguistic talent, would have known and whose German character he would have emphasized by pronouncing the final *t,* in the Provençal manner.[2] He was no longer an intimate of Zola's, but gossip concerning the famous writer would have reached him quickly. He painted the watercolor not long after Zola entered this new phase of his life.

In *Bibémus,* ca. 1904 (pl. 182), Zola is surely the cryptomorphic presence in the center of the picture (fig. 17), a phantom among other phan-

182. *Bibémus*, ca. 1904 (V.786)

189. Honoré Daumier,
Indiscreet Fauns, lithograph,
ca. 1850

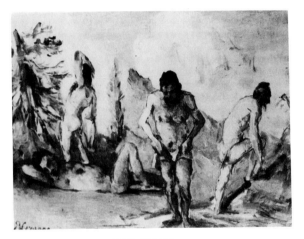

190. *Four Men*, ca. 1876 (V.273)

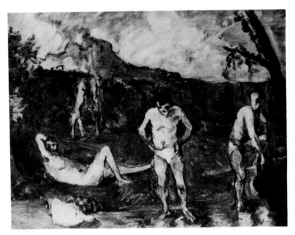

191. *Four Men*, ca. 1876 (V.274)

232

(pls. 190, 191, 192), the last of which is by far the largest. We recognize Baille by his raised arm. Cézanne depicts himself *allongé*. Then the focal standing bather must be Zola: his genitals are covered by a pair of trunks. (His beard, his beardlessness, and his various physiques in the three paintings may carry significance; they are not indexical.) But we recall that in the (later) *Large Bather* (pl. 151) a man wearing trunks and in a similar pose was seen to represent Cézanne. Could it be that the reclining bather in our picture is Zola, and the central one Cézanne? It seems not: since the attribute of erection is personal for Cézanne, it is shown symbolically, as usual, whereas when it occurs in another, it is shown manifestly (pl. 206).

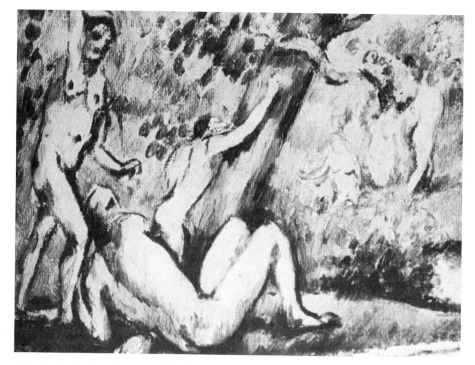

188. *Bathers in the Woods,* ca. 1876 (V.275)

left. Surprisingly, the oeuvre includes nine female bathers in the same attitude and orientation: they are all Cézanne in his female persona, Paule, and are pointed, like Paul, toward Hortense or a sign of her.[7] (We can now identify the reclining woman in *Six Bathers,* pl. 24).

The left-oriented heads of the recliners in *Bathers in the Woods* are the more remarkable since it would have been more reasonable pictorially for a reclining man spying to the right to have his head on the right. This is the orientation of the faun on the ground who spies on two women in a scene by Daumier (pl. 189), which appeared in *Le Charivari* and to which the Cézanne is strikingly similar. But the demands of symbolism are not reasonable in the usual sense: Cézanne's two grounded figures look at the women over the length of their bodies so that the head of one may cover the pubic region of the Zola/bather, while the head of the other is directed toward the Baille persona, whose arm is raised in a manner reminiscent of Hortense. Baille's raised arm surely relates him to Hortense, identified by the same gesture. In one drawing (C.441) Baille is shown with ambiguous genitals and pectorals so enlarged as to resemble breasts; we note his emphatic pectorals in plate 188 and the obvious armpit (a sign of Hortense) and pendulous left pectoral in plate 140.

Painted in the same period, ca. 1876, are three versions of *Four Men*

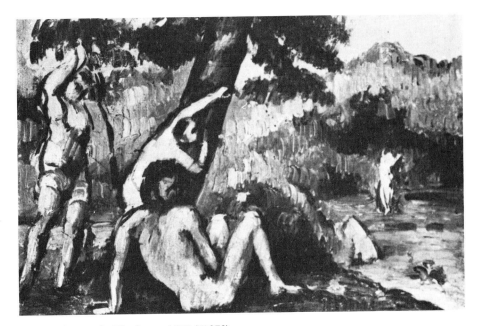

187. *Bathers in the Woods*, ca. 1876 (V.272)

universe of the artist, one of the bathers must be Cézanne; he is, then, the swimmer whose head shows above the water. He stares directly forward, though there cannot be much to see from his position, aware that an upward glance would have him looking at the genitals of the bather above him. A sense of decorum forbids such a glance, which Cézanne the man would relish but which the artist knows to be bold. The Zola/bather's pubic region is the hidden focus of this and other *Bathers*. Cézanne must find a suitable pretext before his bather-surrogate may eye it.

In two *Bathers in the Woods,* ca. 1876 (pls. 187, 188), three men—the inseparables again—spy on women bathing in a pond. The one we identify as Baille is on the left with his yawn-impelled upstretched arm. Zola would be the one who clings to the tree: his pubic region is not revealed. On the ground is Cézanne: in plate 187 he is in a crouching pose derived from a photograph of himself (pl. 157) that he will follow more closely in later pictures. But in plate 188 he displays another index of this persona: he is reclining (*allongé*). The French term, with its sense of "stretched out," is slang for "having an erection."[6] The reclining attitude in the same orientation, head on the left, is taken by nude male figures in five paintings in the oeuvre. The head is on the left apparently because this phallic figure is usually pointed toward Hortense in her canonical place on the

186. *Two Bathers,* ca. 1870 (R.32)

mythical hero is properly larger than Alcestis, but since the sizes are re-versed in the case of short Zola and tall Cézanne, the nude couple has been so oriented that the abductor's torso may hide the large sagging body of his willing captive. *The Abduction,* painted in Zola's apartment, was a gift from the artist[5] and was still in Zola's possession at the time of his death.

Cézanne's offering for the Salon of 1870 was rejected—"as in the past," he said—but a large work of 1869, *Scène d'été* (pl. 185), by his friend Frédéric Bazille was accepted, and Cézanne would have seen it during March or April. The five-feet-square painting was remarkable in its trans-formation of a traditional nude composition into a contemporary subject: four of his eight male bathers in a rural setting wear swimming trunks of the period. The largest of the bathers stands leaning against a tree at the water's edge; he is glancing down at a swimmer near him who is sub-merged except for his head and shoulders, and whose eyes are level with the other's feet and apparently looking at them. These figures are clearly the inspiration of a watercolor only six inches high, ca. 1870 (pl. 186), which initiates Cézanne's long series of male *Bathers.*

When we compare the standing bather of the watercolor with the dark ravisher of *The Abduction,* we see that they are both rendered from the same angle of view, that they have the same idealized physique, and that their legs and left arms are in the same position. If the ravisher stood for Zola, so does the very similar figure in *Two Bathers.* In the self-reflexive

229

185. Frédéric Bazille, *Summer Scene*, 1869

held in February 1864; Cézanne was in Paris during the whole of 1863 and the first half of 1864.[4] In view of his admiration for Delacroix and his many acknowledged versions of works by the master, it is altogether likely that he attended either the exhibition or the sale of the contents of Delacroix's studio. He recalled *Hercules Rescuing Alcestis* in order to memorialize his own situation, for in effect Zola rescued him from his hellish persecutors just as Hercules rescued the queen.

It is plain to see that *The Abduction* is not a direct translation of the Delacroix into Cézanne's personal circumstance: his painting has no hell, no king, nor their counterparts. A shift of meaning has taken place. In adapting the Delacroix to the task of reflecting his own rescue, Cézanne puts himself in Zola's arms, finds that he enjoys the embrace, and transforms his rescue into a ravishment. He even has a personal reason for putting Hercules through a quarter-turn in creating the abductor. The

184. Eugène Delacroix, *Hercules Rescuing Alcestis,* 1862

While *The Abduction* reveals a long-held fantasy of Cézanne's, a set of external circumstances called it forth in 1867. Early in April *Le Figaro* published a mocking article on Cézanne—referring to him as M. Sesame—and we may imagine that the thin-skinned artist was deeply offended. Zola at once came to his defense, writing an impassioned letter that was published on April 12.[3] It was to celebrate this episode that Cézanne embarked on *The Abduction.* The central couple is surely based on the similarly posed pair in a Delacroix painting whose relation to the later picture has been overlooked: *Hercules Rescuing Alcestis* (pl. 184). In Cézanne's work the couple is seen from the abductor's back; in the Delacroix it is shown from the left side of Hercules. In both works the man's left leg is advanced, and the left arm supports the woman's legs while the right holds her body. We see Alcestis and her drooping right arm from her right; Paule's left arm is seen from her left. Delacroix's rockbound setting survives in the distant mountain.

Alcestis was the legendary queen who offered herself as substitute for her husband, King Admetus, when he fell ill and was close to death. Delacroix has registered the moment when Hercules, who had pursued Alcestis and rescued her from the Shades, steps forth from the very mouth of hell with the queen in his arms. The painting was in the Vente Delacroix,

not see his face, but he is broad-shouldered and small in the hips, with slender legs. The face of the pale woman is partly hidden by a prominent shoulder from which her arm dangles. She languishes in her captor's grip where she seems a clumsy burden since she is the larger of the two. His evident strain, her complete submissiveness, the brooding silence, the twilight—every feature is oneiric, otherworldly. Earlier (pl. 141), a nude figure was identified as Zola by the fact that his genitals were not in evidence. Since this is the case for the dark ravisher, let us, in the absence of any other index, identify him as Zola. It may seem improper to do this on the basis of a painting made ten years later, but the same treatment of the Zola persona occurs for at least ten years beyond that. As for the pale woman, she is identifiable as Cézanne by the prominence of her all but detached shoulder (*épaule*), a feature so large that it covers part of her face. We have seen an unusual shoulder many times to be an attribute of *Paul* Cézanne, and several instances of him in the guise of a woman. The hand of the dangling arm—which may easily be imagined in other positions: flung out or back, pushing against the abductor—is shown in close proximity to his genital region. Extraordinary as it may be, *The Abduction* is a dream of Paul as Paule being carried off by his friend Emile. The theme of abduction is usually taken to be a pretext for artistic invention, but *The Abduction* satisfies a very personal fantasy of Cézanne's.

The painting is accompanied by an astonishing verbal play. When Cézanne did the 1866 portrait of his father (pl. 29) he showed him reading *L'Evénement,* which, as we have seen, was a reference to Zola. In the following year he painted *The Abduction* (one of the few canvases that are dated); its French title is *L'Enlèvement.* This word is an anagram of *L'Evénement* with the addition of an *l.* As in *The Blue Vase* (pl. 165), painted almost twenty years later, *l* echoes *elle* (she), in this case, Paule.

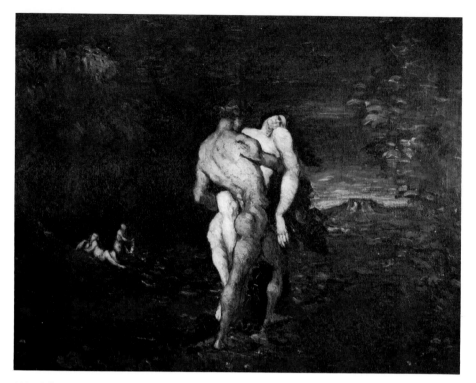

183. *The Abduction, 1867 (V.101)*

toms in the woods. We distinguish the writer's bearded face and his jack-
eted shoulder formed by a large boulder at the right; these are overlapped
on the left by a craggy head and another presence emerging from the
rocks in the foreground. The picture may have been painted soon after
Zola's death in 1902.

But Zola's place in Cézanne's imagination has a more intimate charac-
ter than these examples (and there must be others) would suggest. It has
long been hinted that Cézanne's attachment to his closest friend had an
erotic aspect, but this has never been demonstrated. We shall follow its
manifestations chronologically in works showing the male nude, includ-
ing the extensive series of *Bathers*.

The Abduction, 1867 (pl. 183), is a dreamlike vision at the center of
which a nude man is seen carrying a woman through a somber landscape
in the direction of a mountain resembling Mont Sainte-Victoire. The
painting's title would lead us to suppose a struggle, but this is not the
case. The woman is unresisting, and the witnesses within the scene—two
small female figures far off at the left—neither give chase nor raise an
alarm. Who are the main actors of this dark drama?

The swarthy abductor is shown from the rear at three-quarters; we do

225

192. *Four Men,* ca. 1876 (V.276)

Our three inseparables, then, are here joined on the right by a frequent companion, Numa *Coste,* owner of the dog Black. He is identified by the fact that as he stands in the stream, one of his feet is on the farther bank (*côte,* French; *costo,* Provençal).[8] (We may now recognize the two distant females at the left of plate 183 as Baille and Coste.)

 In plate 190 the reclining man has his arm over his head like the bather behind him. This would seem to relate them, and indeed they appear to be actually linked: the right leg of the upright one may well be read as the left arm of the reclining one. The disturbing implications of this possibility probably account for the raw, even hectic, style of the painting. Once

233

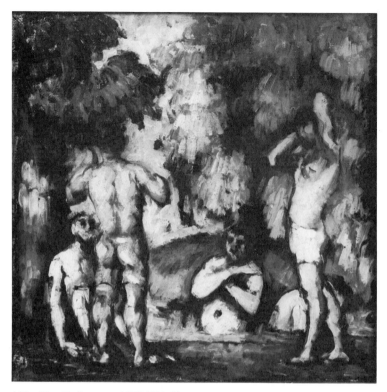

193. *Five Bathers,* ca. 1877 (V.268)

the Baille persona has been moved off to the middle distance (pl. 191), the recliner's foot makes contact with the buttock of the Zola/bather. These problems are resolved in the last painting of the series by the simple expedient of isolation—in an effort that seems to have left the recliner (Cézanne) exhausted. It may be that the suppression of the erotic fantasies of the first two paintings released the remarkable invention of the third.

A new arrangement of the bathers appears in a painting of ca. 1877 (pl. 193). They are seen along a stream that goes straight across the canvas instead of curving back into the landscape, as in *Four Men.* At the extreme left, seated on the ground, is a partly obscured man whom we will soon identify as Cézanne. Beside him, showing only his back, is Zola; at right is Baille, arms on his head. A similar disposition of these men occurs in two other versions of *Five Bathers,* ca. 1880 (pls. 194, 195), where Baille's mouth is open as he yawns (*bâille*), thereby justifying the stretch that accompanies the yawn. The open mouth appears again in a drawing of this bather, ca. 1900 (pl. 196). In the stream to the left of Baille is a half-

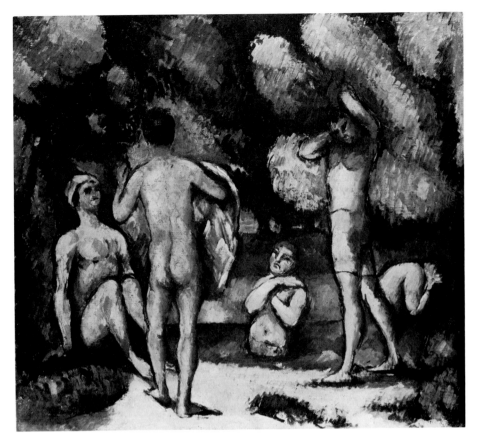

194. *Five Bathers*, ca. 1880 (V.389)

submerged man with arms crossed over the chest. Gertrude Berthold has shown that the pose is derived from an engraving of a painting by Martin Fréminet, *The Baptism of Christ* (pl. 197), reproduced in a book that Cézanne owned.[9] The figure in the stream may, then, be considered a *baptiste,* but since he is a half-figure, hence diminutive, we may call him a *baptistin,* a reasonable neologism. With *Baille* immediately to his right, the two constitute a simple rebus and certify the bather with raised arms as *Baptistin Baille.*

It may seem at this point that our enterprise is a game of identify-the-bather, but it is a game that must be played for a while—and in any case, it has yielded a few insights into the pictures. Many writers have proposed that Cézanne's long series of male *Bathers* was inspired by the sight of soldiers swimming in the Arc River, and that it reflects his happy boyhood spent there in the company of Zola, Baille, and sometimes Coste. But no one has suggested that the youths can be recognized individually. The paintings are taken to be images of a halcyon past evoked in scenes

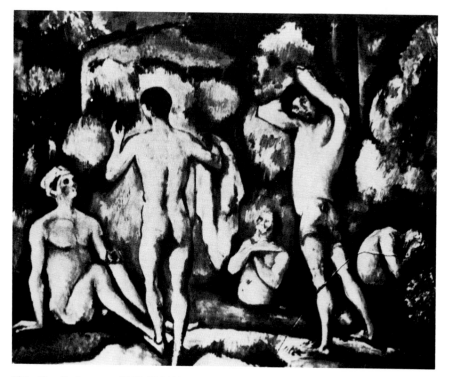

195. *Five Bathers*, ca. 1880 (V.390)

196. *Bather*, ca. 1900 (C.1217)

197. *The Baptism of Christ*,
engraving after Martin Fréminet

of innocent male nudity. Yet they present a rather constant cast of actors, repeated with small variations, who maintain characteristic poses and the same relative positions. This repetition, persisting for over twenty years, was fired by something stronger than nostalgia or the pursuit of formal ends, even if these were present. Rather than a sentimental Cézanne yoked to a rigorous Cézanne, we shall find an artist in the grip of passion, driven to constant invention in the need to give it expression. Until it is recognized that the motive force of the *Bathers* was erotic, personal, and suppressed, there can be no way—as has been the case—of making sense of the long series except as an adventure in stylistic change. In identifying the bathers we find the cipher of a pictorial language and discover the dynamics of individual pictures and of the development of the series as a whole. The series has a discernible content, an evolving subject, neglect of which can only result in a limited view of the artist and these paintings.

To return to *Five Bathers* (pl. 193), it is one of eighteen compositions that Cézanne executed between 1877 and 1900, showing men arranged along a stream that goes across the picture. At the extreme left of every painting is a seated bather with legs drawn up, a version of a similar solitary bather, ca. 1876 (pl. 198), based on the photograph of Cézanne (pl. 157) in that attitude, even to the right arm which hangs to the ground. Standing beside the seated Cézanne/bather is our Zola, known by the view of his back. He is very close to the seated one, which pleases Cézanne the man. But he is uncomfortably close for Cézanne the artist. Besides, he is wearing trunks, like the Baille, because the artist has not yet found reason to justify their removal. In plates 194 and 195 the seated bather wears the white headgear of the lone bather of plate 198; the Zola, still with his back to us, is finally shown quite nude (but not so the Baille)

198. *Seated Bather,* ca. 1876 (V.260)

and with a large white cloth draped over his arm. He carries this cloth in ten paintings and it is surely related to his nudity, although just as surely it is not a pair of trunks or a towel. What can it be?

In *Six Bathers,* ca. 1885 and ca. 1893 (pls. 199, 200), a seated bather is introduced on the far side of the stream; he is our Coste, and he will reappear several times. The next full figure in almost every painting is the one with arms over the head: Baille. From Cézanne's personal point of view it is fitting that Zola be closest to him, with Baille a little further away and Coste on the opposite bank. But there is more here than a properly related group of friends. For the first time the seated one faces the nudity of the one we see from the rear, a nudity the more pronounced because the Cézanne is crouching and the Baille sometimes wears trunks. Reff finds significant the idea that this bather was derived from a drawing by Signorelli, which indeed Cézanne copied (pl. 201). Yet in Signorelli the hands are in positions never those of the Cézanne nude in either the paintings or the studies for them; the hands of his bather are in the air in a variety of gestures.

Everything in plates 199 and 200 leads to the conviction that the bather with the beautiful back was inspired by the splendid nude in Watteau's *Judgment of Paris* (pl. 202) in the Louvre. This provides an arresting rear view of the goddess of love and beauty—*Vénus,* to the French—who displays herself to Paris, having just removed her robe. (It is just possible that the central figure in Marcantonio Raimondi's famous engraving, *The*

199. *Six Bathers*, ca. 1885 (V.541)

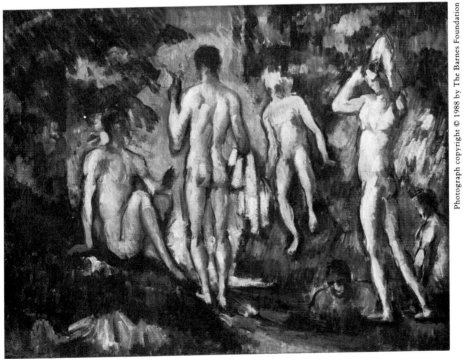

200. *Six Bathers*, ca. 1893 (V.590)

239

201. *The Living Carrying the Dead,*
after Signorelli, 1867–70 (C.182)

202. Antoine Watteau, *The Judgment of Paris*

Judgment of Paris, pl. 203, reproduced in *Histoire des peintres,* was the source of the beautiful male bather. In any case, Watteau's Venus and Raimondi's Minerva are in almost exactly the same pose and both hold a robe aloft.)[10] The Zola/bather spreads his arms in an attitude of self-display, not raising them as the goddesses do.

In these paintings Cézanne has finally achieved his (unconscious) objective of creating a male Judgment of Paris, a beauty contest in which the winner is Zola—whose anomalous drape we now recognize as the robe of Venus. Paris the judge, seated according to the convention, is Cézanne. In his first appearance in what is properly a sequence rather than a simple series (pl. 193), his left arm is not visible. It comes into view in plate 194; in plate 198 the left hand appears; and in plates 199 and 200 it is gradually raised to designate the victor—a progress as orderly as the successive frames of a film. The developing gesture may also be read as a wish to touch. But in this secret Judgment, Paris may not offer an apple. To do so would give the game away and be symbolically jarring to Cézanne, who in his avatars as Paul and Paule is the one who receives apples.

In a male Judgment, with its nude contestants, it has become possible

203. Marcantonio Raimondi, *The Judgment of Paris,* after Raphael, ca. 1510 or later

for Cézanne to face the bared charms of Zola/Venus in a setting sanctioned by tradition. It may fairly be said that he painted a crypto-Judgment so that he *might* indulge the fantasy of looking at his friend's genitals. We do not see them; they are for his eyes alone. This exclusiveness probably accounts for the *X* on Zola's lap in plate 177, an *X* that may well signify *sexe* even while marking the area as out of bounds. Attention to something never seen by a picture's viewer—in the present case, the genitals of the standing nude—may be found in the early work of Picasso, where the same averted features (of the opposite sex) are the focus of, for example, the etching *Salome,* 1905 (pl. 204). As the dancer lifts her leg in abandon, Herod stares at what we cannot see; significantly Herodias looks the other way. Picasso may well have been moved to employ the device of the hidden subject by the example of Cézanne's *Bathers* just as he was influenced by other aspects of Cézanne, who "was like a father to us all."[11]

When we compare the *Judgment of Paris* (pl. 124) with the crypto-Judgments (pls. 199, 200), we see that the consciously intended *Judgment* is idiosyncratic, whereas the later unconscious ones stay close to the conventions of this theme, except of course for the change of sex in the con-

241

204. Pablo Picasso, *Salome,*
1905

testants. We see too that Zola occupied the imagination of Cézanne in the period before the "break" of 1886. Since most of the *Bathers* (twelve works) were painted after the "break," we witness the continuation of a fantasy that persists despite the rupture in "reality." In Cézanne's imagination Zola, the male Venus, remains beautiful and beloved. There was actually in Paris a Venus he would always have associated with Zola: the *Vénus de Milo* (echoing *Vénus d'Emile*). Cézanne drew it many times at the Louvre while thinking of Hortense, and his susceptibility to verbal suggestion (not to mention the propensity to exchange Hortense and Zola, as we shall see) would easily have led him to link the Venus and Emile.

An allusion to Zola is the hidden theme of a late work in the series, *Six Bathers,* ca. 1899 (pl. 205), where the men seem to resemble decorative letters. The Paris seated at the left, when taken entire, may be read as an *M,* and the tilted left side of the second bather as an *I.* Together they make *MI,* a short form of *Mimile,* the nickname of Emile. Let's start again. The body and extended legs of the Paris and the left leg and body of the striding bather (Zola/Venus) together make a *V.* The third bather—crouching, contained, without projections—we read as an *o.* The Baille, his head encircled by his arms, makes an *i;* the tall tree, an *l;* and the two wrestlers, a capital *A.* In the foliage above the last, a pale band slopes down to the

242

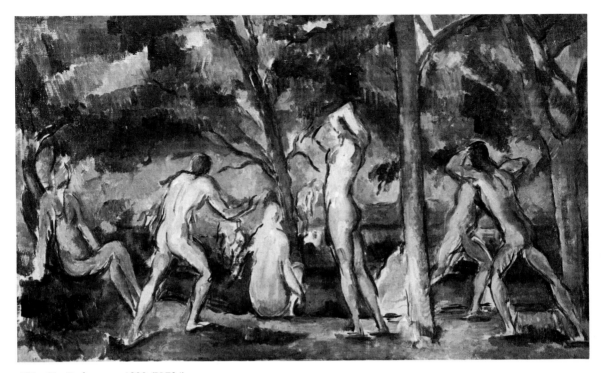

205. *Six Bathers,* ca. 1899 (V.724)

right. Let us take this as an accent mark, and—*voilà* (behold). In 1858, at a time when Cézanne and Zola were sending poems to each other, Paul sent Emile eleven pairs of rhymes for him to use;[12] one was *Zola/voilà,* of which the words in our rebus, *Mi voilà,* are a variant. They surely direct Zola to something in the situation.

An extraordinary event disturbs the late *Bathers.* Their population has gradually increased; in *Six Bathers* their calm is set in motion; and ultimately their numbers are agitated by a kind of turbulence. It seems that someone—not Mi—has had an erection, evident in a watercolor study (pl. 206) on a man who stands beside the seated Paris. Since the Zola is striding to the right, the aroused man must be Coste, who was on the other side of the stream. His upflung phallus, the clearest of the few manifest depictions of the male organ in the oeuvre, is close to Paris' head. In this study a surprised Paris looks up at Coste, avoiding a confrontation esthetically and personally embarrassing to Cézanne. (Michelangelo arranged a similar proximity in *The Fall;* pl. 127.)

The sequence continues. In the larger oil painting, ca. 1900 (pl. 207), Paris turns away, looking out of the painting. His left arm, raised to the nudity of the Venus/Zola earlier, has dropped between his legs—the same arm which seemed to suppress desire for the mother by the same gesture

243

206. *Bathers,* ca. 1890 (R.134)

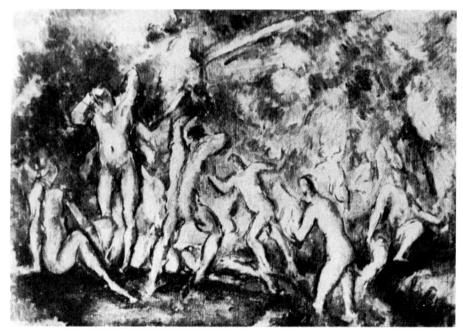

207. *Bathers,* ca. 1900 (V.727)

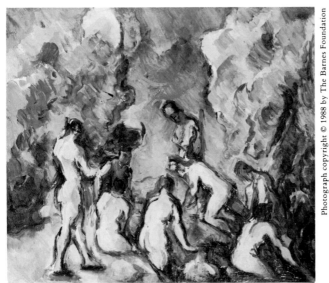

208. *Men in the Woods,*
ca. 1902 (V.728)

(pl. 149). That the painting's theme has acquired a new significance is indicated by the stream, which no longer goes directly across the canvas, but swerves down at the right. The bend appears again in a small, rather abstract version of the subject (V.729). But the shock produced by Coste puts an end to the fantasy of the preceding *Bathers,* unless that end occurs in the darkly suggestive *Men in the Woods* (pl. 208).

The Zola/bather is situated to the right of a reclining Cézanne in *Four Men* (pls. 190–192) and again in the final long series of *Bathers* just examined, where Cézanne is always on the extreme left. In an early work, *Fishing Scene,* ca. 1868 (pl. 209), a Cézanne figure wearing a straw hat sits on the left with a phallic fishing pole directed toward a phallic tree at the right. The hat is called a *pêcheur* (fisher) and so might the man with the pole. *Pêcheur* sounds very like *pécheur* (sinner), the pun being an apt comment on the scene. It must be significant that when Cézanne paints himself in a Virgilian mood (pl. 18), he faces to the left. In several early canvases a symbol for Hortense is on the left, with a phallic element pointing to the left (pls. 64, 65, 70, 130). The series of lone bathers (pls. 145–149) implies

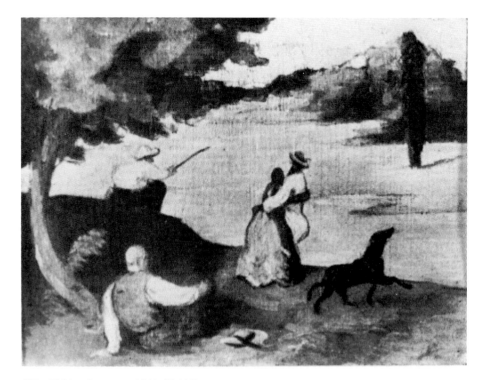

209. *Fishing Scene,* ca. 1868 (V.115)

Hortense on the left of Cézanne and his mother on the right. One phallic arm is directed upward on the side of Hortense, and the other down on the mother's side, the downward arm signifying denial or suppression of the erotic impulse.

From these several examples it would appear that heterosexual love is on the left, whereas the homosexual and incest fantasies are on the right. The donkey, with its distasteful connotations for Cézanne, always faces to the right, whether as manifest image or cryptomorph. It would seem, in sum, that for Cézanne the left is the side of good, and the right, of evil, contrary to a Christian tradition that produces, for example, the terms "righteous" and "sinister."

A source for Cézanne's left/right usage may be found in a poem included in a letter to Zola dated December 7, 1858. Forced by his father to enter the study of law (*le droit*), he writes: "*Hélas, j'ai pris du Droit la route tortueuse / . . . le Droit, l'horrible Droit . . .*" (Alas, I have taken the tortuous path of Law . . . Law, horrible Law . . .). *Le droit,* of course, also means "the right," and in *l'horrible Droit* we may see "the horrible right."

Many of Cézanne's actions as both man and artist are cast in a highly personal mode; his (unconscious) use of left/right symbolism is typically idiosyncratic.

There are fifteen reclining (male and female) bathers in Cézanne's oeuvre. All are left-oriented but one. On the banks of a cove in a decorative panel (pl. 58) are three reclining figures among the female bathers. On the right bank is one, its head pointed to the left; of the two on the left bank, the upper is pointed to the left and the lower, exceptionally, to the right. How to account for this deviation?

The head of the upper *allongée* touches a standing bather who would seem to show Paule in the phallic mode near Hortense. The lower recliner points to no one; the recliner on the opposite shore could only be considered to be directed toward the seated bather, surely not a surrogate of Hortense. The right- and left-pointing bathers seem to have no symbolic dimension. What I think to be the case is that in making a right-oriented bather Cézanne has not altered his symbolic scheme but suspended it altogether in order to make a pair, both female, oriented to the center, and decoratively symmetrical. This symmetry around a central *panne* [pan] is in sharp contrast to the second *panneau* (pl. 59), designed with a marked asymmetry around an off-center *paon* [pan]. The panels are not merely dissimilar but, in their organization, diametrically opposed.

Among many of Cézanne's series of pictures on the same subject, we have noted several in which the culminating—that is, the most significant—version was the last and/or the largest. On closer examination we find that Cézanne is symbolically present at the culmination of most of these series.

247

In *Five Bathers* (pl. 155) he is at the center of the last and largest of nine paintings. He is the solitary occupant of *Bather IV* (pl. 149), last and largest of a series of five. *Self-portrait* (pl. 136) with a cryptomorph of Alexander the Great is the last of a series of six, possibly eight, self-portraits. A cryptomorphic self-portrait occurs in *Mont Sainte-Victoire* (pl. 154), the largest of seventeen late views of the same subject. And in *Four Bathers* (pl. 95), which we have seen to be the last and largest Temptation, he is implied as centered in front of the painting. We have observed similar signs of self-esteem in other aspects of the oeuvre.

In keeping with this tendency, it appears that when a series has no culminating point in either size or significance, its focus is not on Cézanne. Thus, three versions of *The Bay of Marseilles from L'Estaque* (pls. 103–105) vary only slightly in size and composition. The same is the case for the three versions of *Two Cardplayers* (V.556–558), which have only a small variation in size and of which Cézanne is neither the manifest nor the submerged subject. Finally, among three still-lifes concerned with the hiding of Paul *fils* (pls. 75–77), one is slightly smaller than the other two, which have the same size, and the imagery varies from picture to picture. These features are not conducive to a culminating work, and Cézanne is surely not the focus of the paintings.

In Cézanne's symbolic universe an indexical attribute is occasionally transferred from one personage to another who might even be of the other sex. Since this universe is otherwise remarkably consistent, the unexpected deviations must be examined in order to see if they are justified by a higher reason.

The Judgment of Paris (pl. 124) includes a Paris (Zola), a Venus (Hortense), and a woman, Paule (Cézanne). In the two versions of *Six Bathers*

(pls. 199, 200) we find a Paris (Cézanne), a male Venus (Zola), and a male Hortense (Baille). Watteau's *Judgment* (pl. 202) shows Paris and Venus linked graphically at the lower legs, and this is also the case for Paris and Venus in Cézanne's second *Judgment* (pl. 124). That there is the same link between Paris/Cézanne and Venus/Zola in many *Bathers* (pls. 193–195) confirms the theme of the *Bathers* as the Judgment of Paris. Thus, a persistent linkage of Paris and Venus, regardless of the sex or identity of the persons symbolized.

The early *Judgment* (pl. 123) also has a Paris/Zola. He offers the apple to Venus, but his hand is on Paule's shoulder. Paris/Zola in the later *Judgment* offers an armful of apples to Paule, identified by the mother who touches a shoulder. Zola is associated with apples by the famous episode of his schooldays. And Hortense is constantly indicated by apples and ultimately portrayed by them cryptomorphically (pl. 118).

We read the central standing figure in *Four Men* (pl. 192) as Zola. Ten years later Cézanne is in very much the same pose as in *The Large Bather* (pl. 151).

Hortense is *toi de Paris,* and Zola is the "Parisian" to his schoolmates in Aix. Decades later, as *mie* (Mi), he is still linked to Paris on the box of crusty bread (pl. 180). And his association with bread echoes that of Cézanne (pl. 50). Both men are symbolized by bottles (pls. 118, 165).

Cézanne is shown as Psyche (pl. 45), and in the same period Psyche stands for Hortense (pl. 46).

In *The Abduction* (pl. 183) the ravisher (Zola) is based on a Delacroix Hercules (pl. 184). Cézanne later made fourteen drawings, several of them elaborate, of Puget's *Hercule au repos,* in the Louvre, which he seems to have assimilated as a self-image in conformity with his persona as a Turk and his identification with Alexander the Great.

These changes of role may be schematized as follows:

Cézanne Zola	} Paris		Cézanne Zola	} bottles	
Hortense Zola	} Venus		Cézanne Zola	} Hercules	
Hortense Zola	} apples		Cézanne Zola	} standing bather	
Hortense Zola	} city of Paris		Cézanne Hortense	} Psyche	
Cézanne Zola	} bread		Cézanne→woman Hortense↔Baille		

We see that regardless of the contexts in which the role changes occur, they involve Cézanne, his actual and his fantasied lovers. Zola is especially metamorphic, surely so that he may be shown as often as possible. In these circumstances it is understandable that Cézanne should partake of five of his identities and even put himself, in both male and female personae, in an erotic relation to him. How appropriate that three other indexes of Zola—apples, Venus, and the city of Paris—should be shared by Hortense. Only Cézanne changes sex; Zola is as beautiful as Venus, and Baille has some of the charms of Hortense. Love is the agent in all these transformations. In the Cézannian imagination, Eros is metamorphosis.

Amorous exchange of identity is mirrored at another level by pictorial transformation. Cézanne's practice of absorbing the art of others and transmuting it into his own goes far beyond the idea of "influence." He is, indeed, the initiator of, among other things, a large modern tendency

to make "art about art." Not only did he raid the Louvre and the Musée Granet in Aix for pictures, poses, and subjects, and assimilate the work of Delacroix, Courbet, Manet, Pissarro, and other of his contemporaries; but, since his career coincided with a surge in the publication of images, he also made use of photographs, prints, reproductions of all kinds—art fine and popular, in book or magazine—to a degree unequaled in his time.

Metamorphosis is initiated in Cézanne by his very brushstroke. The deposit of parallel strokes makes for constant *passage* and the resulting multiplication of gestalt and fluidity of "reading." Metamorphosis becomes pervasive and critical in the late work as the deposit of strokes gets looser and alternates with large independent touches. When Cézanne went up the Chemin des Lauves to paint his late views of Mont Sainte-Victoire, as he broke off for lunch he would read from Virgil or his Latin copy of *The Metamorphoses* of Lucius Apuleius—that ageless tale of the amorous adventures and spiritual growth of a young man who was transformed into a donkey and finally back to a man again.

Reflections

Many observers of the intricate verbal/visual puns in Cézanne's art find it natural to assume that he knew he was creating them. But as I have stated throughout this book, I think he was completely unaware of them and of the occurrence of cryptomorphism as well. Neither his letters nor the group of aphorisms he helped edit, nor the numerous records of conversation with him reflect any consciousness of the two unusual features. Given their great frequency and the evident frankness of all his statements on art, an explanation of secrecy is unthinkable.

Furthermore, many of the symbolic structures we have examined seem to be too intricate to have been created consciously. If they are conceivable only as the work of the unconscious, this does not mean that Cézanne was not responsible for them. They are the unconscious result of an imagination that at another level created the manifest painting. The effort to hold these levels in tandem resulted in the anxiety that Picasso claimed was the most interesting thing about Cézanne.

The history of art shows many cases of verbal play and double imagery. The former appears as quite self-conscious wit, notably in the twentieth century in the work of Duchamp, Magritte, and the Surrealists, who employed automatic writing and the *cadavre exquis* in their attempts to trap accident and the unconscious. It is no surprise that Magritte and the Surrealists, especially Dali, also show double imagery. The art-historical literature includes a number of studies of the "image found by chance" (imagery found in nature) and of conventions, followed at different periods, of rendering islands as heads or figures, or of painting clouds in human or animal form, or of designing faces composed of foliage like those at Reims. All the examples of humanly produced hidden imagery were made by intention and have been seen as such. Remarkable in all discussion of double imagery is the fact that it contains no hint of the

observation (or indeed the possibility) of its unintentional appearance. In spite of the admission by most artists that they cannot account for most or much of what they do, that indeed they are moved by forces of which they are not conscious, the preponderance of unpremeditated artistic action is never mentioned in criticism, which proceeds as though the work of art were completely and consciously directed. To be sure, we are not often in a position to discuss the unconscious element because of limitations in our perceptions or information. When, as in the case of Cézanne, it becomes accessible, it presents a rare opportunity for insight.

One may well ask why it took almost a century for his wordplay and cryptomorphism to become a public matter. As it happened, the first instance of hidden imagery that I noticed turned out to have been observed and disregarded a short time before in another part of the country. I have overheard conversations during exhibitions of Cézanne in which a viewer pointed out a hidden image to a companion. Even art critics have discussed cryptomorphs as though they were part of the manifestly intended imagery. And I am convinced that the owners of certain paintings containing relatively obvious hidden imagery must have observed it after living with the paintings a short while. Nothing came of these observations because they were scattered and probably unique experiences, explained as oddities in the paintings in which they occurred, or explained away as aberrations in the viewers' vision. For the hidden image to become an object of study, several examples of it had to be seen by one concerned person. And such a viewer turned up, it would seem, only after the paintings had gone through several stages of critical observation and absorption. I consider my own sensitivity to the cryptomorph to be the result of a "pure" view of painting which, paradoxically, is itself the product of

a cult of Cézanne. That is, because of a long-held attitude toward Cézanne, I am so little subject to the ordinary illusions of representation—depth, massivity, the continuous occupation of space—that I am enabled to see that constellation of elements which makes the cryptomorph. It may also be that I have a proclivity to read faces in painting *and in nature* similar to Cézanne's; it was Cézanne, we recall, who said, "The goal of all art is the human face." The human face is by far the most frequent hidden image in Cézanne. The gestalt of the human face is established very early in life, and in many cases apparently never loses its power.

Even psychoanalysis, although it has studied the unconscious products of speech, like the pun, has failed to pursue the possibility of similar products of graphic art. There is however a notable exception to this neglect, an article by Oskar Pfister written in the early years of psychoanalysis. It is mentioned in a long footnote in the 1919 edition of Sigmund Freud's 1910 essay on Leonardo da Vinci. It will be remembered that Freud quotes and then analyzes Leonardo's memory of a childhood dream: that as he lay in his crib a vulture hovered over him, beating his mouth with the end of its tail and then forcing it between his lips. Pfister claimed to have found a vulture in the Louvre's *The Virgin and Saint Anne with the Infant Jesus* by Leonardo, a painting discussed in Freud's essay. The vulture, which is in profile and stands facing the top of the painting, is constituted by a single color of the Virgin's two-colored robe; the tip of an area that serves very well as its tail just touches the lips of the infant, whose face is in profile. Freud introduces a schematic rendering of the painting with these words: "A remarkable discovery has been made in the Louvre picture by Oskar Pfister, which is of undeniable interest even if one may not feel inclined to accept it without reserve." He never referred to it again, nor did Pfister, and the article had no successors. Ernst Kris mentioned it

in a footnote in *Psychoanalytic Explorations in Art* (1952), where he said, "Pfister's attempt to recognize in the painting the vulture of Leonardo's screen memory, analyzed by Freud, has not convinced me." Psychoanalysis has an avowedly literary orientation, yet it must count as a missed opportunity that for decades no one in this discipline has investigated the possibility of cryptomorphic imagery, the graphic analogue of the verbal pun.

Upon reflection it is understandable that the cryptomorph should escape notice. For one thing, we do not ordinarily go to paintings with the expectation of sighting a hidden image. In any case, such an image is elusive since it is usually imbedded in a manifest imagery of great enchantment. It must be so hidden as not to leap out of this imagery, yet revealed enough to be discernible eventually. Occupying a fine region between visibility and invisibility, it probably requires a certain visual imagination or enterprise in order to be perceived. That ultimately it is perceived is testimony to the permeability of minds.

The unusual verbal and symbolic aspects of Cézanne's imagination are intelligible in view of his education, his literary gifts, and his Catholic background. But his extraordinary propensity for imbedding secondary images in his paintings has no easy explanation. Several features of these images are worth noting. They include recognizable portraits. They are never the result of a "lucky" brushstroke but magically emanate from a variety of depictions, always with the painting in an upright position. They are constructed with the same care as the surrounding material, and are in the style of the "conscious" Cézanne. They are usually in a significant relation to the rest of the pictures in which they occur.

There is simply no literature on the unconscious hidden image or

255

cryptomorph, whether in Cézanne or elsewhere—and I have discerned it in a great many artists, from Dürer to de Kooning. In the literature of psychology there is constant mention of a distantly related matter, the duck/rabbit illusion. This ambiguous design raises one, and apparently only one, question: can the two creatures be seen simultaneously or only alternately? There also exists a popular print (among others) of a well-dressed woman admiring herself in a mirror, a drawing that at some moments looks like a death's head. Besides the issues surrounding the *vanitas,* this print raises the same question raised by the duck/rabbit illusion. In being unconscious, the Cézannian cryptomorph surely presents a more subtle problem, and my long attention to it emboldens me to enumerate what I think are its main elements and, in spite of my limited competence in psychology and physiology, to venture a hypothesis concerning its etiology.

Since the cryptomorphs that are recognizable portraits are designed in the Cézannian manner, they cannot have been created by accident. Nor can they be considered to have come into being "automatically" or "by themselves," as though Cézanne's unguided hand could only produce Cézannes. In short, he must at some time have seen and fashioned them. But since he never mentioned them, he "forgot" or "didn't know" he had made them. If the foregoing is the case, what must be explained is how he could know he was doing something and then shortly afterward not know he had done it. The possible mechanisms that seem to lie at hand are hallucination and self-hypnosis or a combination of the two.

What I imagine is that Cézanne, in his intense study of the motif—which I believe was in great part an (unconscious) search for *symbolic meaning* in its forms—briefly hallucinated a significant image within the

motif and assimilated it to the image developing on the canvas. Or alternatively, he "saw" a significant image on the canvas before him and integrated it with the painted subject. The word "hallucination" need not be disconcerting: a dream is a mild hallucination. One may as well say, as I have just done, that Cézanne "saw" the image in the landscape, in nature let us say, or "read" it into the materials on his canvas. Since many paintings and necessarily their cryptomorphs are elaborately constructed, we can suppose several sessions before the canvas. Was there then a repeated "forgetting" and recurrence or "reading" of the significant image? Since it is difficult to imagine a constant repetition of the initial vision or "hallucination," I theorize the (no less difficult?) possibility of self-hypnosis: the artist commanding himself (always unconsciously) to pursue the secondary image on the canvas until it was realized.

A subliminal sense of something mysterious (the cryptomorph) in his work may have been the cause of Cézanne's frequent reference to his "*petite sensation.*" Neither he nor anyone else could claim that his sensation of nature was as acute or faithful as, say, Monet's. The etiology of the cryptomorph is essentially a scientific matter, but the phenomenon becomes an artistic issue in entering the symbolic structure of the paintings, and in being an essential modality of a great painterly imagination. Although the cryptomorph can be shown to be present occasionally in other artists, its prevalence in Cézanne must be considered an aspect of his uniqueness; the absolute sign of his singularity is the rebus, which I have not found in any other artist. When to the formal and expressive accomplishments that have long been acknowledged we add the cryptomorph, wordplay, and the rebus, we must recognize in Cézanne an artistic complexity similar to that of Picasso and Joyce, his contemporaries.

Our examination of specific paintings has surely led to some unexpected conclusions about the painter. On the evidence of the works, Cézanne is, if unconsciously, a symbolical artist, probably without peer as such in the constancy and depth of his practice, one who brings a new meaning to the term "disguised symbolism" used by Erwin Panofsky to characterize an aspect of Jan Van Eyck. Four hundred years later, Panofsky declared Van Eyck's symbolic method had disappeared, but it may be said that in Cézanne it was revived, probably for the last time. Cézanne's considerable skills were in the service of his secret symbolism, his incessant invention and unorthodox means making it possible when traditional techniques did not. To an even greater degree than this book has been able to show, this symbolism relied on Christian elements; he is indeed the last important artist in whose work they figure. His being at the end of a line may account for an imagination capable of great swings from the most exalted themes to the attitudes and language of the street.

The chief focus of his attention is himself; what is unexpected here is the degree of his solipsism. Proud, egotistical, a very Turk, the man who could assume the guise of Pan, a Jew, a woman, the man who painted *Still-Life with Soup Tureen* and the concealment of Paul *fils,* had nonetheless a sense of humor.

Cézanne's imagination eroticizes everything it touches, and his relation to others is essentially sexual. In typical Oedipal fashion he is antagonistic toward his father and fantasizes incest with his mother. Hortense is the permanent center of his reverie on Woman; Zola is the object of an elaborate homoerotic fantasy. Cézanne seems to think of his sister Marie as masculine. His Baille has an evident feminine component. Emperaire and Pissarro are father-figures, equipped with masculine attributes. Pan and

the Turk of course have an important sexual aspect. In all these constructs by Cézanne, man and artist, we witness the inexorable pull of the personal on his high artistic ambitions.

Or is the spectacle one of sublimation of the personal in the purity of painting? Our attention to the cryptomorph, the pun, and the picture-puzzle may have seemed at times a commerce with phantoms, with interlopers upon the actuality of painting, but once we admit their presence and potency, we must reconsider their status. Rather than being accessory, than filling out the picture or being precipitated by it, are they not present at its inception? This is not to give them the rank of *raison d'être:* my study has shown no reason to attribute priority or superiority to either the manifest or the hidden level of the work. Understanding is only possible by considering their mutual reciprocity. Whereas the cryptomorph has a surprising incidence in Cézanne, it occurs occasionally in Van Gogh and Munch, all three artists having been productive in the last quarter of the nineteenth century. Since its appearance is only sporadic in earlier periods, it seems to have a temporal character, coinciding with the emergence of modern theories of the psyche and what has been called "psychological man." It merits attention as a possible feature of advanced art of the last hundred years.

In 1882 an English literary critic, Frederic Harrison, wrote that "Many an ingenious picture is nothing but a painted rebus." This was probably a lucky shot; he gave no examples. I have found the rebus only in Cézanne, but even its existence in one artist suggests that less extreme forms of the verbal/visual linkage will be found among others. A conceptual shift will have to be made in order to perceive them. Our primary interpretive moves usually proceed along a geometrical axis; we place great stock in

the fact that certain pictorial elements fall along a line, or are centered in the picture plane, or are seen to form a triangle or other figure. But the rebus and the less complex manifestations of language exist on a verbal or logical axis, one we are not accustomed to acknowledge because of a "modern" article of faith: the separation of word and image (except when actual words are part of the image). It should prove fruitful to examine modern art, including the various kinds of abstraction, on the axis of the language that presided over its creation.

Appendix · Notes · List of Illustrations · Index

Appendix

fig. 1

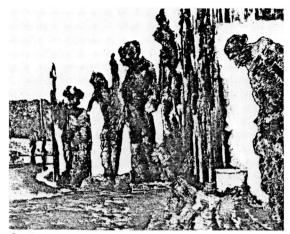

fig. 2

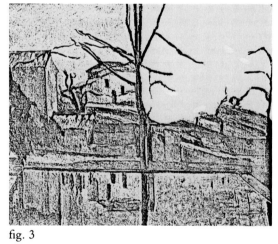

fig. 3

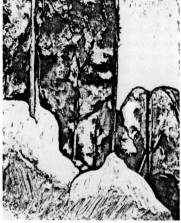

fig. 4

fig. 5

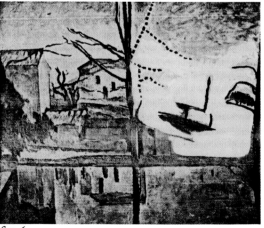

fig. 6

fig. 7

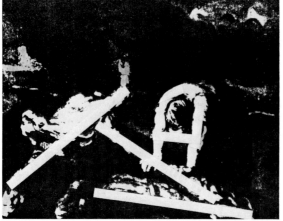

fig. 8

fig. 9

fig. 10

fig. 11

fig. 12

fig. 13

fig. 15

fig. 14

fig. 16

fig. 17

Notes

1. Cézanne the Francophone

1. Theodore Reff, "Painting and Theory in the Final Decade," *Cézanne: The Late Work,* ed. William Rubin (New York: Museum of Modern Art, 1977), p. 39.
2. A neologism created with the help of Helene MacLean.
3. Pointed out to me by Angelika Arnoldi-Livie.
4. Lionello Venturi, *Cézanne, son art, son oeuvre,* 2 vols. (Paris: Paul Rosenberg, 1936), I, at V.680, p. 211.
5. Adrien Chappuis, *The Drawings of Paul Cézanne,* 2 vols. (Greenwich, Conn.: New York Graphic Society, 1972), I, 112.
6. From a text by Jules Borely, written in 1902, published in 1926; quoted in *Conversations avec Cézanne,* ed. P. M. Doran (Paris, 1978), p. 21. All translations from the French are my own.
7. Brought to my notice by Christopher Cairns.
8. "Cézanne and Guillaumin," in John Rewald, *Studies in Impressionism,* ed. Irene Gordon and Frances Weitzenhoffer (New York: Abrams, 1986), p. 107.
9. Marie Mauron, ed., *Dictons d'oc et proverbes de Provence* (Forcalquier, 1965), p. 43.
10. In a letter of November 1882, in *The Complete Letters of Vincent Van Gogh* (Greenwich, Conn.: New York Graphic Society, 1959), I, 482–483.
11. Alfred Delvau, ed., *Dictionnaire érotique moderne* (Basel, ca. 1891). Hereafter cited as Delvau, 1891.
12. PC to Emile Zola, October 1866, in *Paul Cézanne: Correspondance,* ed. John Rewald (Paris, 1978). All quotations of Cézanne's letters are from this source.
13. For similar calculations, see A. Chevalley and M. Chevalley, eds., *The Concise Oxford French Dictionary* (London, 1954), p. v, where words beginning with *p* and *c* account for 21 percent of the 37,000 in the dictionary.
14. M. R. Courbes, Conservateur of the Atelier Cézanne in Aix, has mounted two fragments of painting done on a bedsheet.
15. Gustave Flaubert, *La Tentation de Saint Antoine* (Paris, 1967), pp. 31–32.
16. Ambroise Vollard, *Paul Cézanne* (Paris, 1924), p. 125.
17. Alfred Delvau, ed., *Dictionnaire de la langue verte* (Paris, n.d.). Hereafter cited as Delvau, n.d.
18. Joachim Gasquet, *Cézanne* (Paris, 1926), p. 20.

19. M. C. [Marthe Conil], "Quelques souvenirs sur Paul Cézanne, par une de ses nièces," *Gazette des beaux-arts* 56 (November 1960): 300.

20. Marie Gasquet's reminiscences of Cézanne, in the anthology *Le Tombeau de Cézanne* (Paris, 1956), p. 31.

21. One of a number of sayings of Cézanne published by Emile Bernard in *L'Occident,* July 1904; cited in Doran, *Conversations,* p. 36. Gustave Geoffroy, *Claude Monet, sa vie, son oeuvre* (Paris, 1924; reprinted, 1980), p. 328. Léo Larguier, *Le Dimanche avec Paul Cézanne* (Paris, 1925), p. 133.

2. Father, Father

1. Reported by Antoine Guillemet to Emile Zola, in letter of November 2, 1866, in *Correspondance.*

2. Theodore Reff, "The Pictures within Cézanne's Pictures," *Arts Magazine,* June 1979, p. 91.

3. Pierre Duchartre and René Saulnier, *L'Imagerie populaire* (Paris, 1925), p. 200.

4. Meyer Schapiro, "Courbet and Popular Imagery," *Journal of the Warburg and Courtauld Institutes* 4 (1941), p. 167.

5. Merete Bodelsen, "Gauguin's Cézannes," *Burlington Magazine,* May 1962, pp. 208–211.

6. "Chroniques des arts," *Gazette des beaux-arts,* October 1983, p. 2.

7. Quoted in John Rewald, *Paul Cézanne* (New York: Schocken, 1968), p. 47.

8. John Farmer, *Vocabula Amatoria* (London, 1896; reprinted, Secaucus, N.J.: University Books, 1965): a French-English erotic dictionary, "apparently based," according to the New York Public Library index card, on Delvau, 1891.

9. John Rewald, "Achille Emperaire, ami de Paul Cézanne," *L'Amour de l'art* 19 (1938).

10. "Exclamation . . . as the superlative of beautiful, of good": Alfred Delvau, ed., *Dictionnaire de langue verte* (Paris, 1867); hereafter cited as Delvau, 1867. Also in L. Larchey, ed., *Dictionnaire de l'argot parisien* (Paris, 1872): "Très-bien, très-soignée."

11. Both in Farmer, *Vocabula Amatoria.*

12. Letter of April 30, 1896.

13. On his regard for Wagner, see the letter of December 23, 1865, in *Correspondance.* The portrait is *Mme. Manet at the Piano,* 1867–68, Musée d'Orsay, Paris. Cézanne

might have known that in 1867, during Baudelaire's final illness, Mme. Manet and a friend played Wagner for the poet.

14. Antoine Guillemet to Emile Zola, November 2, 1866, in *Correspondance.*
15. Gasquet, *Cézanne,* p. 14.
16. John Rewald, "Cézanne and His Father," in *Studies in the History of Art, 1971, 1972* (Washington: National Gallery of Art, 1972), pp. 38–62.
17. Farmer, *Vocabula Amatoria.*
18. "*CAGE. La nature de la femme*"; Delvau, 1891.

3. The Donkey in Cézanne

1. Chappuis, *Drawings, I,* 198.
2. The signature is on an early drawing, reproduced in Chappuis, *Drawings,* I.
3. Gasquet, *Cézanne,* p. 110.
4. Ibid., p. 30. The poem is "Quatrain," from Paul Verlaine, *Jadis et naguère,* 1884. Theodore Reff has noted that Cézanne modified the first two lines ("Cézanne: The Severed Head and the Skull," *Arts Magazine,* October 1983, p. 93).
5. Theodore Reff, "Cézanne's Constructive Stroke," *The Art Quarterly* 25, no. 3 (Autumn 1962).
6. The three works are generally dated 1869–70, 1873–7, and 1875–6, respectively; my sequence does not violate this chronology.
7. "Couteau. The *penis*"; Farmer, *Vocabula Amatoria.*
8. John Rewald, "Chocquet and Cézanne," *Gazette des beaux-arts,* July 1969, p. 53.
9. "Three still-lifes . . . could have been . . . commissioned by [Chocquet]"; ibid., p. 55. Also, "I have begun two small motifs that show the sea, for Monsieur Chocquet"; PC to Camille Pissarro, July 2, 1876, in *Correspondance.*
10. Meyer Schapiro, "The Apples of Cézanne: An Essay on the Meaning of Still-life," in *Modern Art: 19th and 20th Centuries* (New York: Braziller, 1978), p. 28. (First published in *Art News Annual* 34, 1968.)
11. The inventory lists "28. Femme andalouse"; Paul Jamot and Georges Wildenstein, *Manet* (Paris, 1932), I, 107. On Cézanne's visit, see Rewald, *Paul Cézanne,* p. 48; the quotation is on pp. 80–81.
12. "Aigipan: the god Pan, that is to say, in his quality of a goat (*aix*)"; C. Kerenyi, *The Gods of the Greeks,* trans. Norman Cameron (London, 1951; reprinted, 1979), p. 28.

4. The Secret

1. I am grateful to John Rewald for making a photograph of the site available to me.
2. Fritz Novotny, "The Late Landscape Paintings," in *Cézanne: The Late Work,* ed. William Rubin (New York: Museum of Modern Art, 1977), p. 107.
3. *Lettres inédites de Paul Alexis à Emile Zola, 1871–1900,* ed. R. H. Bakker (Toronto: University of Toronto, 1971), p. 43: "*Les deux oiseaux se sont envolés—depuis un mois!*"
4. William Old, formerly Scientific Assistant at the American Museum of Natural History, kindly identified the shell as the queen or pink conch (*Strombus gigas*), common to the Caribbean area. He pointed out that the shell does not in nature have a hole where it seems to have one in the painting, but that one could have resulted from an accident. He also explained that the bright color on the shell lips (which is usually a purple-pink and not the bright red shown in the painting) fades after five or six years, so that the shell in the painting may have been a fresh one recently acquired.
5. In a text placed below the painting when it was exhibited in "The Impressionist Epoch," Metropolitan Museum of Art, December 12, 1974–February 10, 1975, Charles Moffett, Associate Curator, stated that "a sexual allusion may be intended by the conch shell." Nicolas Wadley wrote that "the gaping red lips of the shell introduce a macabre and erotic element" (in B. Taylor, *Cézanne,* London, 1968, p. 31).
6. Farmer, *Vocabula Amatoria.*
7. In *Reading at Zola's,* 1869–1870 (V.118), the same clock is depicted with a much smaller face than appears in *The Black Clock.*
8. Lawrence Gowing, "Making Real after Nature," *Times Literary Supplement,* March 18, 1977, p. 299.
9. C. Virmaitre, ed., *Dictionnaire d'argot fin de siècle* (Paris, 1894).
10. See Jean Arrouye, *La Provence de Cézanne* (Aix-en-Provence, 1982), p. 15, where Guillemet is quoted, and p. 8, where Monet is quoted.
11. Theodore Reff, "Manet's Portrait of Zola," *Burlington Magazine* 117 (1975): 35–44.
12. Quoted in Albert Laborde, *Trente-huit années près de Zola: Vie d'Alexandrine Zola* (Paris, 1963), p. 76.

13. V.219 and V.221. And V.220, which shows only a milk pail and bowl, looks as though it was cut and probably also included a lemon originally.
14. Quoted in Rewald, *Paul Cézanne,* p. 113.
15. The screen was exhibited at the Wally Findlay Galleries, New York, October 1974.
16. Specifically, by Charles Moffett; see note 5 above.
17. Suggested by Laurie Schneider.
18. This image was pointed out to me by Helene Valentin.
19. Cézanne's avoidance of a truer rendering and of the implications of the resulting triangle may be explained by one psychoanalyst's theory that avoidance of deep perspective is related to a fear of looking at the female genitals; J. Weiss, "Cézanne's Technique and Scoptophilia," *Psychoanalytic Quarterly* 22 (1953): 413–418.
20. Reff, "Pictures within Pictures," p. 95.

5. Double Trouble

1. Farmer, *Vocabula Amatoria.*
2. Theodore Reff, "Cézanne's Bather with Outstretched Arms," *Gazette des beaux-arts* 59 (1962): 180, n. 22.
3. Delvau, 1867. For *bassin* as an adjective, *"insipide, ennuyeux,"* see Virmaitre, *Dictionnaire d'argot.*
4. See Farmer, *Vocabula Amatoria.*
5. C.581, C.801, C.807.
6. Farmer, *Vocabula Amatoria;* the term is probably still in use, since it is in Henri Bauche, *Le Langage populaire,* 3rd. ed. (Paris, 1951).
7. Cf. Baudelaire: "I confused the odor of fur with the odor of woman"; in *Fusées,* XVII, first published in 1887.
8. Emile Bernard, "Souvenirs sur Paul Cézanne," *Mercure de France,* October 1 and 16, 1907; quoted in Doran, *Conversations,* p. 65.
9. "The woman's pose, arm above head in a gesture once reserved only for sleep but given currency as an embodiment of female allure by Ingres . . ."; Beatrice Farwell, "Manet's Bathers," *Arts Magazine,* May 1980, p. 126.
10. Reff, "Painting and Theory," pp. 41–42.
11. For example, Dominique Fernandez, *Mère Méditerranée* (Paris, 1965). It is of in-

terest that on French maps the bay of Marseilles is designated *Rade de Marseilles,* and its inner region, below L'Estaque, *Anse de L'Estaque.*

12. The full maiden name of Mme. Cézanne *mère* was Anne-Elisabeth-Honorine Aubert. She signed a book, apparently a gift to Cézanne, "H. Aubert, 1850." But context makes it appear that Cézanne reserved the *A* for her and the *H* for Hortense.

13. Mentioned by Venturi, *Cézanne, son art, son oeuvre,* I, at V.426. Also, V.408 is called *La Montagne Marseilleveyre et l'Ile Maire.*

14. Sigmund Freud, "The Most Prevalent Form of Degradation in Erotic Life" (1912), in *On Creativity and the Unconscious,* ed. Benjamin Nelson (New York: Harper and Row, 1958), p. 178.

6. The Girl from Paris

1. Anne H. van Buren, "Madame Cézanne's Fashions and the Dates of her Portraits," *The Art Quarterly* 29 (1966): 115–127.
2. Letter of October 22, 1907, in Rainer Maria Rilke, *Briefe über Cézanne,* ed. Clara Rilke (Frankfurt, 1985), p. 59.
3. Ibid., p. 58.
4. Reff, "Pictures within Pictures," p. 95.
5. See C.700, C.709, C.714, C.726, C.733, C.825.
6. Emile Zola, *L'Oeuvre* (Paris, 1974), pp. 267–324.
7. Virmaitre, *Dictionnaire d'argot.*
8. Quoted in Rewald, *Paul Cézanne,* p. 140.
9. Gasquet, *Cézanne,* pp. 18–19.
10. All quotations of Schapiro in this chapter are from "The Apples" (see p. 269, n. 10); the footnote appears on p. 31.
11. Rewald, *Paul Cézanne,* p. 2.
12. C.307–308, 1872–3; C.306; C.309; C.310, 1872–5.
13. The relevance of the Michelangelo panel was pointed out to me by James Burgess.
14. C.634–637, 1880–6, besides those mentioned above.

7. *The Turk*

1. So named in Venturi; also in Gustave Coquiot, *Cézanne* (Paris, 1919 [written in 1914]), p. 213 and plate opposite p. 212.
2. In the Bührle Collection, Zurich.
3. Ron Johnson, "The 'Demoiselles d'Avignon' and Dionysian Destruction," *Arts Magazine,* September 1960, p. 95.
4. See Emile Littré, ed., *Dictionnaire de la langue française* (1876) and its abridgement by A. Beaujean (Paris, 1959).
5. Emile Zola to Baptistin Baille, June 10, 1861, in *Correspondance.*
6. Charles Baudelaire, *Ecrits sur l'art* (Paris, 1971), vol. 1, p. 184. The term, italicized, appears in chap. 6 in a reference to the painter George Catlin. This subject is also discussed in Sidney Geist, "A Skull in Cézanne's *A Modern Olympia?*" *Iris* 1 (February 1982): 8.
7. The series would include at least V.280, V.290, 1875–7; V.367, V.368, 1879–82; V.371, 1880–1; V.518, V.517, 1883–5.
8. Chappuis, *Drawings,* I, 49–52, where the document is dated "probably from the years 1866–69."

8. *The Rack*

1. "Engraved and also published as a woodcut"; Reff, "Cézanne's Bather," p. 184.
2. Geo Sandry and Marcel Carrère, eds., *Dictionnaire de l'argot moderne,* n.p., n.d.
3. Reff, "Cézanne's Bather," p. 181.
4. Ibid.
5. Farmer, *Vocabula Amatoria.*
6. Reff, "Cézanne's Bather," p. 171.
7. A single sheet, C.713, shows a young bather and two drawings of the head of Paul *fils.*
8. Diane Lesko, "Cézanne's 'Bather' and a Found Self-Portrait," *Artforum* 15 (December 1976): 52–57.
9. Littré, *Dictionnaire de la langue française,* at *Anse.*
10. Furthermore, two photographs of Cézanne seated in front of *The Large Bathers* (pl. 1) were taken by Emile Bernard in 1904 and have often been reproduced. I

have never seen an original, but in reproduction the top of Cézanne's head is always unclear, and I suspect that it was retouched.

9. Family Matters

1. Chappuis, *Drawings,* I, 111.
2. See note 12 to Chapter 5.
3. Pointed out to me by Anne Wyville.
4. "His pious sister, Marie, for instance, is known to have told him over and over again, 'Marry her, why don't you marry her'"; Rewald, *Paul Cézanne,* p. 111.
5. This feature was pointed out to me by Yehuda Safran in the Courtauld Institute Galleries in 1980; it is not present in Roger Fry's copy of the painting in another room.
6. Meyer Schapiro, *Paul Cézanne* (New York: Abrams, 1952), p. 76.
7. Robert Baldick, ed., *Pages from the Goncourt Journal* (London, 1963; reprinted, 1978), p. 331. The latter epithet is used by Zola's wife.
8. Rewald, *Paul Cézanne,* p. 2.
9. Baldick, *Goncourt Journal,* pp. 317, 326, 385.
10. Pointed out to me by Daniel Geist.
11. Sigmund Freud, *The Interpretation of Dreams* (1900), ed. James Strachey (London, 1954; reprinted 1971), pp. 360–362.
12. Gasquet, *Cézanne,* p. 20.
13. Schapiro, "The Apples," p. 11.
14. This pretty suggestion came from Judith Wolfe.
15. Vollard, *Paul Cézanne,* p. 30. The word, slang for "man," is derived from *couilles,* the testes.
16. Suggested by John Rewald.
17. Letter of May 12, 1904.
18. Flaubert, *La Tentation,* pp. 251–252.

10. The Boys

1. F. J. W. Hemmings, *The Life and Times of Emile Zola* (New York: Scribner's, 1977), pp. 138–148.

2. Discussed in Sidney Geist, "Cézanne's Watercolors," *The New Criterion* 3, no. 5 (January 1985): 22.
3. Rewald, *Paul Cézanne,* pp. 64–68.
4. The paintings were exhibited at Hotel Druot on February 16, 1864; the sale took place February 17, 18, and 19. The catalogue lists: "49. (Hercule) Il ramène Alcestes du fond des Enfers." On Cézanne's residence in Paris, see Rewald, *Paul Cézanne,* p. 216.
5. Rewald, *Paul Cézanne,* p. 79.
6. Delvau, 1891, of the verb in the reflexive: *s'allonger.*
7. A male bather *allongé* with head to the left occurs in V.113, 1870; V.273–276, 1875–7. Similar female bathers: V.264–265, 1873–7; V.582 (two figures), ca. 1891; Sandra Orienti, *The Complete Paintings of Cézanne* (New York: Abrams, 1972), 656, 1895–8; V.721–723, 1904–5; V.719, 1906. V.583 shows a third reclining female bather, with head to the right.
8. Frédéric Mistral, *Lou Tresor dóu Felibrige,* 1877, vol. 1. This Provençal-French dictionary lists *Coste* as one of the "noms de famille méridionaux" derived from *costo.*
9. Gertrude Berthold, *Cézanne und die alten Meister* (Stuttgart, 1958), pl. 55.
10. I have been assured by Carla Lord that Watteau could well have had access to the Raimondi print. To my suggestion that Watteau's Venus was derived from Raimondi, Leo Steinberg replied that he has been teaching that "for years."
11. Brassaï, *Conversations avec Picasso* (Paris, 1964), p. 99.
12. See the letter of July 9, 1858, in *Correspondance.*

List of Illustrations

279

287

205. *Six Bathers,* ca. 1899 (V.724)
 10⅝ x 18⅛ in. (27 x 46.4 cm.) The Baltimore Museum of Art, The Cone Collection, formed by Dr. Claribel Cone and Miss Etta Cone of Baltimore, Maryland (BMA 1950.195)
206. *Bathers,* ca. 1890 (R.134)
 watercolor, 5⅛ x 8¼ in. (13 x 21 cm.) Bridgestone Museum of Art, Ishibashi Foundation, Tokyo
207. *Bathers,* ca. 1900 (V.727)
 11⅞ x 17¼ in. (30 x 44 cm.) Formerly, collection of K.-X. Roussel, Paris
208. *Men in the Woods,* ca. 1902 (V.728)
 9 x 10½ in. (24 x 27 cm.) The Barnes Foundation, Merion Station, Penn.
209. *Fishing Scene,* ca. 1868 (V.115)
 10⅝ x 14⅛ in. (27 x 36 cm.)

Index

Boldface type indicates page on which illustration appears.